Landscapes for the People

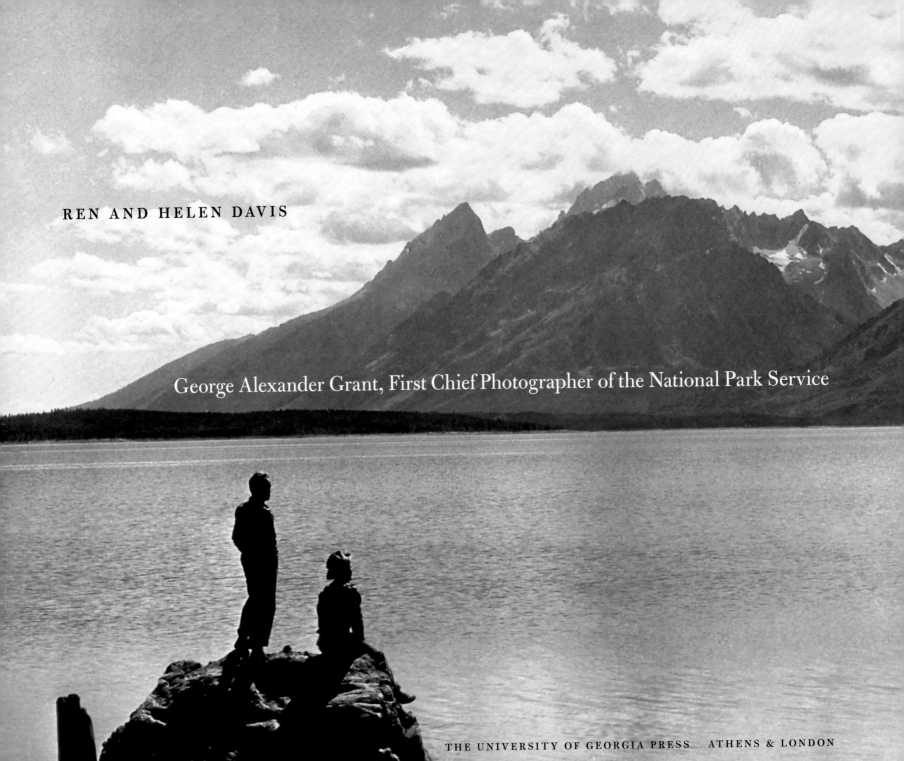

REN AND HELEN DAVIS

George Alexander Grant, First Chief Photographer of the National Park Service

THE UNIVERSITY OF GEORGIA PRESS ATHENS & LONDON

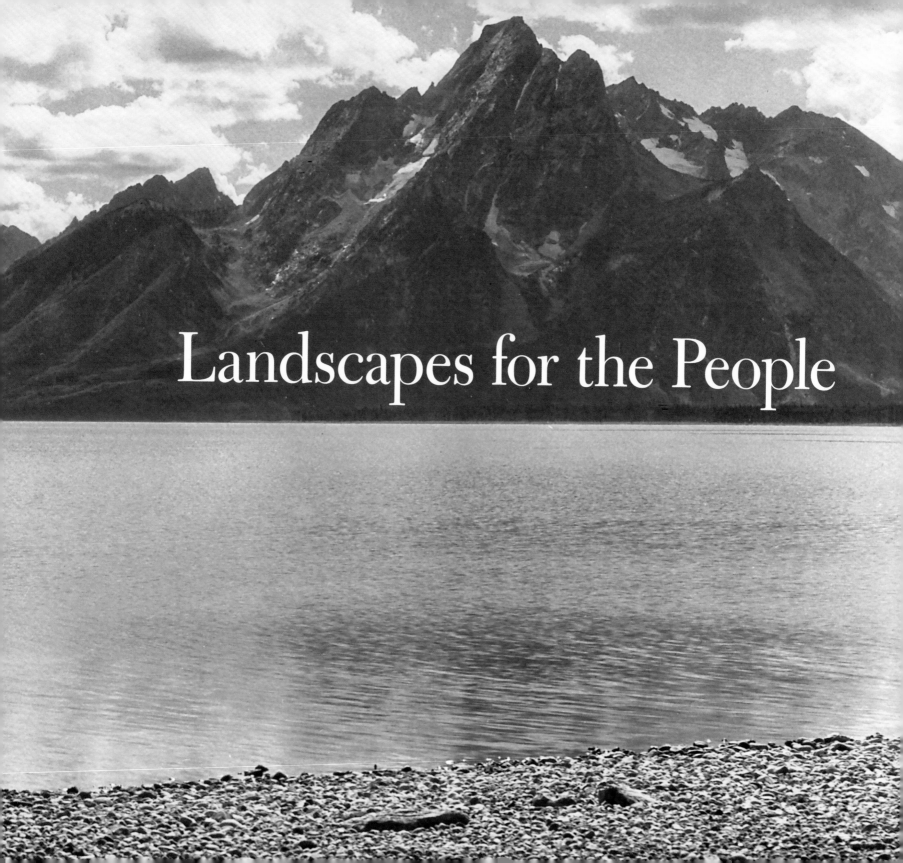

Landscapes for the People

Publication of this work was made possible,
in part, by a generous gift from the University of
Georgia Press Friends Fund.

Designed by Erin Kirk New
Set in Bulmer and Whitney
Printed and bound by Kings Time Printing Press
The paper in this book meets the guidelines for permanence
and durability of the Committee on Production Guidelines for
Book Longevity of the Council on Library Resources.

Most University of Georgia Press titles are available
from popular e-book vendors.

Printed in China

19 18 17 16 15 c 5 4 3 2 1

Library of Congress Cataloging-in-Publication Data
Davis, Ren, 1951–
 Landscapes for the people : George Alexander Grant, first chief
photographer of the National Park Service / Ren and Helen Davis.
 pages cm
 Includes bibliographical references and index.
 ISBN 978-0-8203-4841-4 (hardcover : alk. paper)
1. Grant, George Alexander, 1891–1964. 2. Photographers—United
States—Biography. 3. United States. National Park Service—
History. I. Davis, Helen, 1951– II. Title. III. Title: George Alexander
Grant, first chief photographer of the National Park Service.
 TR140.G724D38 2015
 770.92—dc23
 2014045423

British Library Cataloging-in-Publication Data available

Unless otherwise noted, all photographs courtesy of the National
Park Service Historic Photograph Collection (NPSHPC).

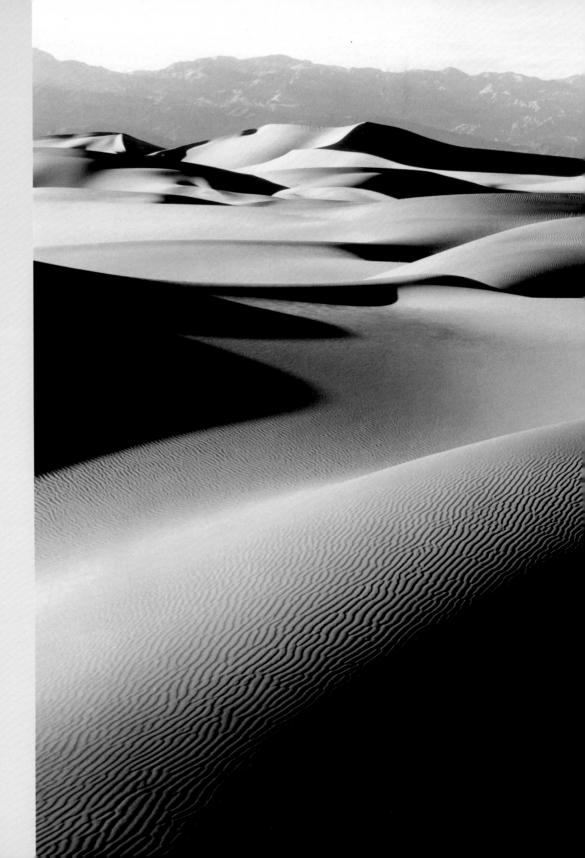

CONTENTS

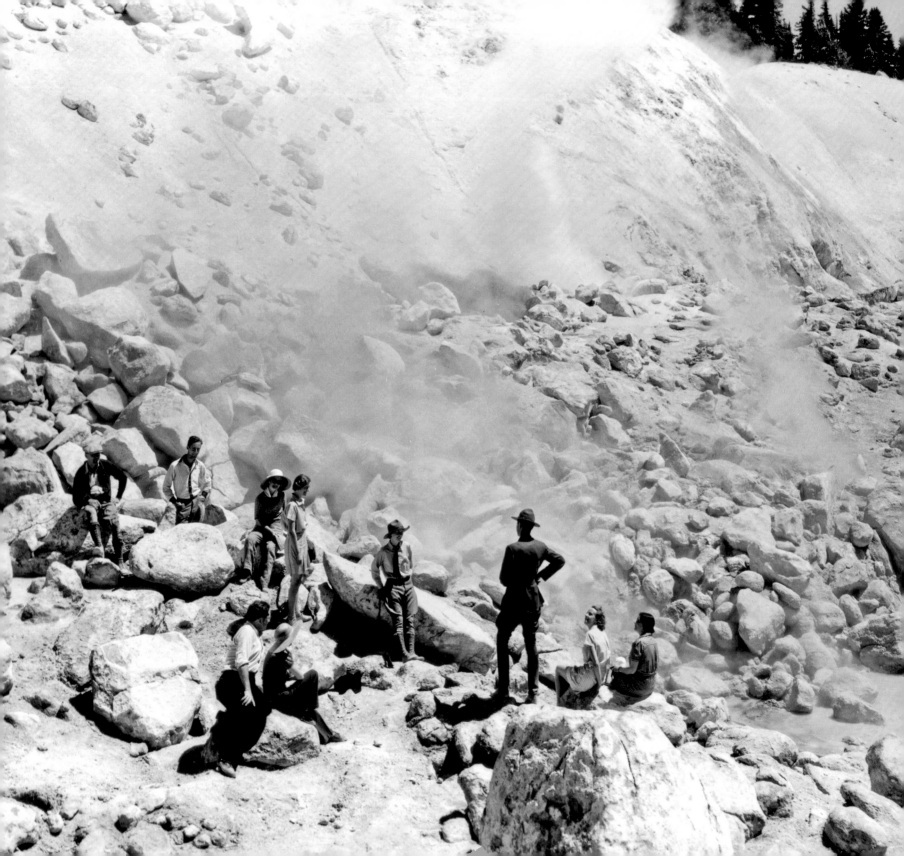

PHOTOGRAPHS

Landscapes

26. Heads of Washington and Jefferson, Mount Rushmore National Memorial (July 30, 1936).

27. Beartooth Mountains, Montana, outside the Yellowstone National Park boundary (August 13, 1936).

28. Ruby Beach, near proposed Olympic National Park (September 1, 1936).

29. Sun streaks in Muir Woods, Muir Woods National Monument (October 13, 1936).

30. Sandstone formations, Arches National Park (November 17, 1936).

31. Brick archway, Fort Pulaski National Monument (March 17, 1937).

32. Original walls of the citadel, Fort Frederica National Monument (March 18, 1937).

33. Archways at Fort Jefferson, Dry Tortugas National Park (March 28, 1937).

34. Lagoon with Spanish moss, Everglades National Park (May 4, 1937).

35. Mount Shuksan, proposed North Cascades National Park (August 19, 1937).

36. Restaurant at Mount Baker Lodge, proposed North Cascades National Park (August 19, 1937).

37. Geological cross section of the Grand Canyon, Lake Mead National Recreation Area (November 4, 1937).

38. Bath House Row, Hot Springs National Park (November 22, 1937).

39. Dream Lake, Rocky Mountain National Park (August 25, 1938).

40. Village of Estes Park, Colorado, outside Rocky Mountain National Park (August 27, 1938).

41. Lakeside view of mountains and trees beneath Hallett Peak, Rocky Mountain National Park (September 2, 1938).

42. Bluff on north side of Mitchell Pass, Scotts Bluff National Monument (September 14, 1938).

43. The Olympic Mountains from Hurricane Ridge, Olympic National Park (October 14, 1938).

44. Sol Duc Falls, Olympic National Park (1938).

45. Stalagmite formation with onyx drapes, King's Palace, Carlsbad Caverns National Park (1938).

46. Yellowstone Canyon and the Lower Falls, Yellowstone National Park (August 20, 1939).

47. Potholes in granite, Separation Rapids, Lake Mead National Recreation Area (October 7, 1939).

48. The Great Sand Dunes, Great Sand Dunes National Monument (1939).

49. View from the Arizona side, Boulder Dam and Lake Mead National Recreation Area (October 3, 1939).

50. The White House (Casa Blanca), Canyon de Chelly National Monument (1940).

51. Yucca bloom in the sand, White Sands National Monument (1940).

52. North side of the Aztec Ruins, Aztec Ruins National Monument (June 13, 1940).

53. Visitors on horseback above Sunrise Lodge, Mount Rainier National Park (August 22, 1940).

54. The Garden Wall and McDonald Creek, Glacier National Park (June 2, 1941).

55. Foliage of Port Orford Cedar, Oregon Caves National Monument (August 24, 1941).

56. Tuzigoot ruin with South Verde River in foreground, Tuzigoot National Monument (November 30, 1945).

People and the Parks

Portraits, Special Assignments, and Technical Images

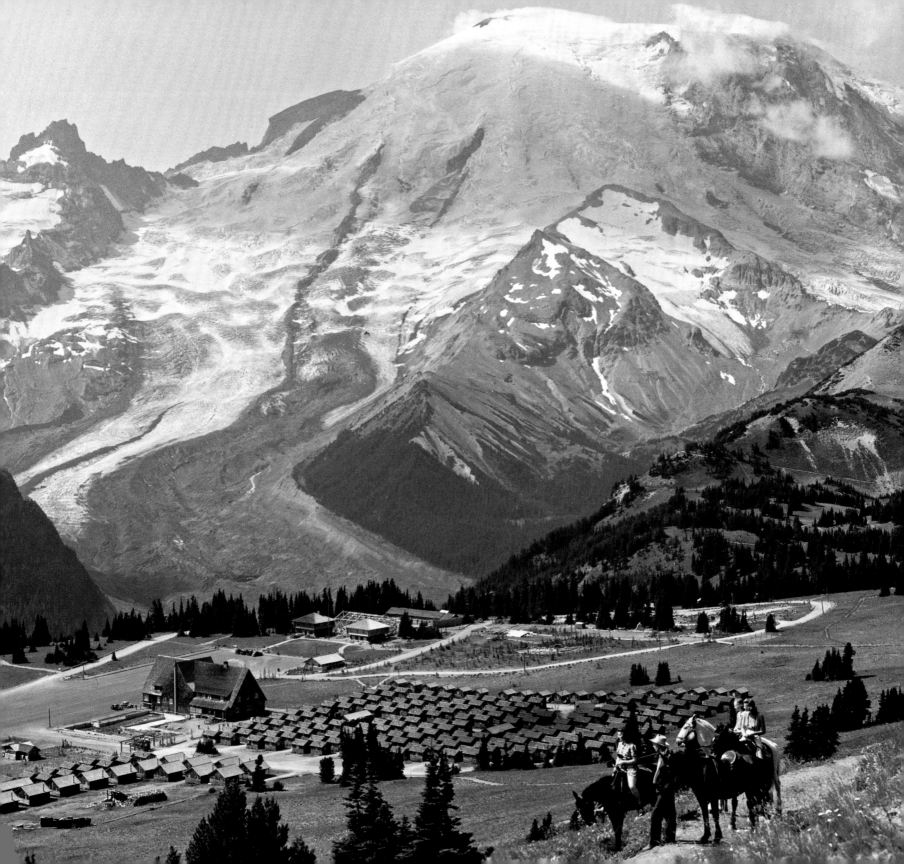

National park photography is such a well-known genre that another book on the topic would hardly seem necessary. From Carleton Watkins's role in Yosemite's authorization to William Henry Jackson's analogous association with Yellowstone and Ansel Adams's monumental oeuvre, the master works of national park photography have received ample academic and popular acclaim. The emphasis on prominent artists and pioneering practitioners is understandable, but this narrow focus provides a limited perspective on an important aspect of American culture. Expanding the field of view to encompass less heralded individuals and overlooked modes of expression can bring new treasures to light and afford fresh insights into the relationship between people, parks, and the photographic medium. While entrepreneurs such as Julius Boysen, Asahel Curtis, and Jack E. and Frank J. Haynes have begun to attract interest, little attention has been paid to the National Park Service's own photographers. The first—and by general acclaim the best—official NPS photographer was George A. Grant. In a remarkable career extending across a quarter century and 140,000 miles, Grant made more than thirty thousand photographs. His subjects ranged from archaeological artifacts and natural history specimens to visitor activities and scenic landscapes. In addition to their innate visual appeal, Grant's photographs exemplify the determination of the newly formed National Park Service to transform its holdings from an eclectic collection of elite retreats to a central component of modern American life.

While reports detailing construction activities and admissions statistics sufficed for official purposes, National Park Service leaders realized that the best way to attract visitors and solidify congressional support was to provide compelling images of scenic attractions and show ordinary people enjoying the resources that the agency was simultaneously preserving and making accessible to the American public. In this sense, Grant had more in common with his nineteenth-century predecessors than with Ansel Adams and other art-world photographers. Adams took myriad commercial assignments, but his artistic

output was unconstrained by employer directives. William Henry Jackson, Timothy Sullivan, and other photographers assigned to western geological surveys subsumed their artistic ambitions to documentary and promotional incentives, in regard to the economic potential of western landscapes and the survey project itself. Like Grant, their work was more likely to be seen as reproductions in government reports or popular periodicals than as high-quality photographic prints. In both cases compositional tactics and technical skills were intended to enhance the message rather than call attention to the messenger. Neither Grant nor his predecessors were devoid of artistic aspirations, of course. Jackson worked closely with the painters Sanford Gifford and Thomas Moran, benefiting from their instruction and pursuing parallel artistic and commercial agendas. Grant's extracurricular ambitions were more modest. One of his infrequent forays into modernist expression garnered first prize in an Explorers Club photo contest (see photograph 22), and he occasionally submitted offerings to camera magazines, but many of his photographs relied on picturesque conventions considered cliché in contemporary art circles. His commitment to topographic exposition and preference for balanced compositions, wide-angle lenses, and exposure and printing techniques emphasizing warm midtone gradations were also more in line with nineteenth-century sensibilities. Given the lag between popular taste and avant-garde aesthetics, Grant's approach may have represented a conscious, or at least fortuitous, strategy. Not only were traditional picturesque images more likely to appeal to the general public, but the abstract formal studies and dramatic juxtapositions of light and shade favored by modernist-inspired photographers sacrificed informational content to aesthetic pretension. Grant's sand-dune series suggests that he may have been intrigued by contemporary currents but constrained by his professional responsibilities.

Grant's superiors would have preferred that he spend less time photographing landscapes in general. A consistent refrain of the correspondence between Washington officials and their roving photographer was the need to take fewer scenic views and more photographs of visitors enjoying the benefits of NPS stewardship. By 1929, when Grant's NPS career began in earnest, it was no secret that the National Park System boasted an unparalleled array of scenic splendors. Occasional reminders were welcome

along with promotional shots of new parks and areas under consideration, but the more pressing need was to underscore the extent to which the park system was answering the needs of the American people. Photographs of visitors enjoying NPS educational programs and newly completed improvements would both advertise these amenities and confirm the wisdom of congressional appropriations. National and local publications also preferred people pictures, especially if the images involved pretty girls frolicking among nature's splendors. Grant was so enamored of the latter aspect that he had to be reminded that families with children were the target audience of the park service.

Despite his seemingly natural affinity for landscape photography, Grant sometimes struggled to produce convincing public-use photographs. Not only were nubile maidens swooning by alpine lakes more suited to amateur art clubs and Maxfield Parrish phantasms than NPS brochures, but his people were often conspicuously posed, undercutting the illusion of documentary authenticity. Grant's reliance on flash photography to minimize the shadows caused by harsh western light had a tendency to heighten the sense of artificiality. When the flash was too strong, it created a theatrical effect, with overly illuminated subjects standing out against flattened soft-focus backgrounds. Photograph 74 is a conspicuous illustration of this phenomenon. The disjunction is so severe that the spectators seem to be viewing an enlarged photograph or diorama within the confines of a museum, countermanding the desired message of visitors comfortably immersed in natural surroundings. The rigidly posed official appears more threatening than accommodating, drawing a disdainful glance from the obligatory young woman. While the lifelong bachelor never forsook his penchant for pretty girls, he refined his approach to public-use photography. More convincing candids alternated with "snapshots" of quintessential park experiences such as trail rides and fishing excursions, elevated by Grant's characteristic fine-grained exposures and propitious framing. In one of his most successful series, Grant brought his landscape sensibilities to bear on the dedication ceremonies for Glacier National Park's Going-to-the-Sun Road. Employing his wide-angle lens and eschewing foreground detail, Grant conveyed both the magnitude of the celebration and the magnificence of the

setting (see photograph 78). On a more subtle level, the Going-to-the-Sun photographs affirmed the NPS's ability to accommodate massive crowds without compromising scenic splendor.

While Grant's landscape compositions are undeniably attractive, the ability to marshal technical and aesthetic skills in support of the agency's agenda is what distinguished him from lesser NPS photographers and contemporaries unconstrained by employer mandates. In some cases the result was simply an artfully composed and technically adept illustration of a new visitor facility, road project, or architectural relic; in others he subsumed the ostensible subject within a scenic set piece, such as the new hotel and housekeeping cabins in Mount Rainier (see photograph 53) and the Zion entrance station (see photograph 3). At his best Grant melded aesthetic and informational imperatives with subtle but significant expressions of NPS ideology. The passage of time has imbued many of Grant's photographs with additional allure, but it has also made these embedded messages harder to decode. What appears to be a straightforward celebration of the Great Smoky Mountains' eponymous feature, for instance (see photograph 142), substantiates the NPS's argument that a road through the western half of the park would traverse an area despoiled by logging and forest fires rather than a pristine wilderness as opponents maintained. Photograph 90 is not just an image of a mounted ranger overlooking a sweeping expanse of stunning scenery, but an affirmation of the NPS's intention to maintain the wilderness quality of Olympic National Park—a key condition of the park's authorization. On a deeper level, it invokes contemporary sentiments about the frontier's impact on the formation of American character and the need for national parks to instill similar values. The ultimate manifestation of Grant's multivalent discourse graces this book's cover. Beyond the obvious celebration of Mount Rainier's majestic beauty as viewed through the standard interlocutory device of enrapt spectators, Grant attests to the NPS's success in making such scenes accessible to the motoring public. At the same time, he underscores the agency's ability to minimize the impact of development. Not only is the automobile confined within an attractively designed rustic enclosure, but the affected area occupies a minute portion of the frame. As the agency grappled with unprecedented popularity, this message had

broad implications but was particularly relevant to Mount Rainier, where NPS officials sought to calm conservationists' fears by insisting that construction would impact a minimal portion of the park—the same proportion, in fact, that Grant allotted to the picturesque parking area. As an emblematic affirmation of NPS attitudes, the image is as resonant today as it was when Grant snapped the shutter of his 5 × 7–inch field camera. The clothes and conveyances may have changed, but Grant's photograph embodies the National Park Service's commitment to preserving America's natural and cultural heritage while making it accessible through constrained and carefully considered development.

Viewed as a whole, Grant's photographs celebrate the richness and variety of the National Park System, as they chronicle its formative years. While Ansel Adams and other self-avowed artists garnered greater acclaim as photographers of national park nature, Grant quietly amassed a comprehensive catalogue of national park landscapes and created an invaluable record of the individuals, activities, and accomplishments associated with the agency's expansion from a diminutive bureau overseeing a disparate collection of western wonderlands to a truly national institution exerting widespread influence on modern American life. His understated style may not have impressed contemporary critics, but the technical and compositional sophistication of his photographs secured his reputation among agency officials and magazine editors, who clamored for his work. Those who make use of NPS photo archives have long admired his images, and a few narrowly circulated publications have feted his accomplishments, but Ren and Helen Davis are to be congratulated for bringing George Grant's photographs to light and affording belated exposure to the life and work of a pioneer in the field of national park photography.

Timothy Davis, PhD

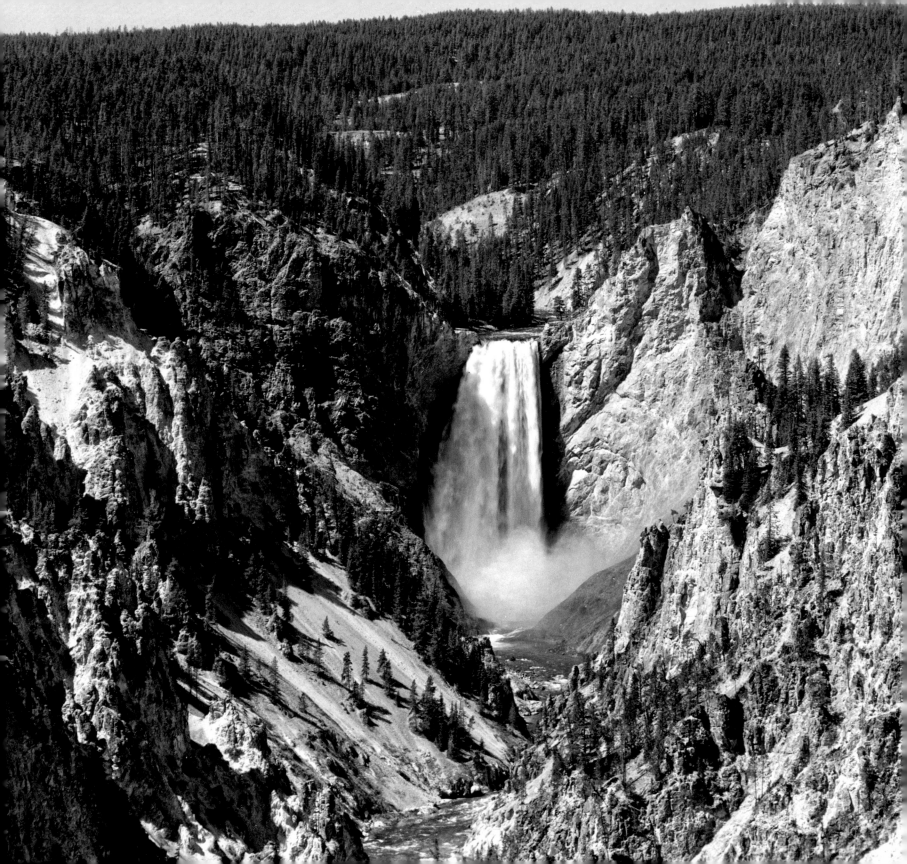

"These images are beautiful. Who is the photographer?" we asked in 2006, while working in the National Park Service's photographic collection with archivist Tom Durant, researching pictures from the 1930s for our book, *Our Mark on This Land: A Guide to the Legacy of the Civilian Conservation Corps in America's Parks*. Tom replied, "These photos were taken by George Grant, the first chief photographer for the National Park Service." So why had we never heard of George Grant?

Grant's images, made while he was a summer ranger at Yellowstone in 1922 and a staff photographer from 1929 to 1954, documented periods of dramatic expansion of the national parks. Yet, we soon learned from Durant, nearly all the photographs he took were credited, simply, "National Park Service." As a result, while millions saw his images in exhibitions, books, and magazines, few outside the park service ever knew his name.

For many who enjoy outdoor photography, Grant may have held the dream job, earning a living photographing in the national parks. Yet, like every blessing, it came at a price. Months on the road, often to remote locations, led to lifelong bachelorhood and periods of loneliness. Countless hours spent loading cameras and processing film in sweltering vehicles or cramped darkrooms contributed to health problems that may have hastened his death in 1964.

After viewing his images, we realized that George Grant was truly an unknown elder in the field of outdoor and landscape photography. He deserved long overdue recognition for the many contributions he made to both his craft and to the visual legacy bequeathed to us of his, and our, beloved national parks.

In 2012 we were back in the National Park Service's photography archives in Charles Town, West Virginia, working with Durant's successor, Wade Myers, to begin a process of viewing, selecting, and scanning hundreds of Grant's photographs, taken

during his quarter-century career with the park service. In this effort we worked from archived prints contained within individual park and project folders. While numbering a few thousand, these photographs represented only a portion of the more than thirty thousand fragile negatives kept in cold storage, many of which have never been printed. We also read every available personal and park-service document we could locate in search of clues to the long road George traveled to achieve his dream of becoming the park service's first photographer. Our ultimate goal was to develop a retrospective of Grant and his work that could be shared with a new generation of readers, park visitors, and photography enthusiasts.

Over the next two years research led us to Maryland and Delaware to meet George Grant's three nieces—his closest living relatives—and a grand niece who organized a family gathering for us to learn about his life and times; to the National Park Service's Western Archaeological Conservation Center in Tucson, Arizona, to scan photographic prints from leather-bound scrapbooks that Grant produced for National Park Service executives; to Penn State University, where George had honed his skills as a photographer in the mid-1920s; and back multiple times to the park-service photographic collection for continued scanning work, where in opening each folder of prints we felt like expectant children unwrapping birthday gifts.

While George Grant may have worked in the shadow of better-known contemporaries like Ansel Adams, Edward Weston, and Eliot Porter, the quality of his images was highly regarded. They were used in park-service documents and museum exhibitions; published in guides, textbooks, newspapers, and magazines—including *National Geographic*—and framed as fine art to grace the walls of government and congressional offices. Nonetheless, in the half century since his death, most of his photographs had been stored away and largely forgotten.

It is our hope that through George Grant's personal story and the accompanying photographs, one may glimpse back to his time when visionaries like Stephen Mather, Horace Albright, Arno Cammerer, Harold Ickes, President Franklin Roosevelt, and many others oversaw the dramatic growth of the priceless treasures that are our national parks.

ACKNOWLEDGMENTS

This book is the culmination of the efforts of many people devoted to introducing George Grant and his photography to a new generation of viewers. Foremost among these was Wade Myers, technical information specialist in art resources management at the National Park Service's Harpers Ferry Center for Media Services. Wade was tireless in his support for this project and always available to locate images, documents, and other materials in the park-service collections. For several of our visits, he was aided by park-service intern Stacy Mason. We are also grateful to National Park Service photography collections manager John Bruksch, who provided additional guidance, and to retired archivist Tom Durant, who traveled from his home in Virginia to Charles Town to spend time with us going through images and files and answering our many questions.

We benefited greatly from the help provided by many others within the National Park Service. Among them were archivists Lynn Mitchell and Khaleel Sabra, who provided access to materials in the Western Archaeological Conservation Center in Tucson; Amalin Ferguson, national library program manager and metadata specialist in the Resource Information Services Division in San Francisco, who offered essential information on documents and resources to review; Deirdre Shaw, museum curator at Glacier National Park, who provided access to documents and photographs in the park's collection; and Ingrid Nixon, chief of interpretation at Mount Rainier National Park, who organized a presentation for her staff about George Grant's photography during our July 2013 visit to the park.

Bryan McGraw and Lori Cox-Paul, with the National Archives and Records Administration, answered questions and provided direction in our search for George Grant's personnel records. Claudia Rice of the Ansel Adams Publishing Rights Trust put us in contact with Leslie Squyres and David Benjamin of the Volkerding Center for Research and Academic Programs in the Center for Creative Photography at the University of Arizona, who provided access to Ansel Adams documents and correspondence.

In an effort to learn more about George Grant's early life and family, retired archivist Elizabeth Knowlton, whom we met at an Atlanta Sierra Club meeting, undertook a wonderfully successful search for Grant's family. Regarding Grant's early career as a photographer, we traveled to the Paterno Library at Penn State University, where archivist Paul Karwacki shared selections from the university's collection of photographs from the 1920s (many may have been taken by Grant, but none were credited), and we interviewed Grant biographer Mark Sawyer, who shared his insights. We also benefited from advice and support from photographer Jet Lowe and architect Jim Vaseff, both retired from the National Park Service's Historic American Buildings Survey and Historic American Engineering Record; from Steve Schwab, owner of the Camera Doctor in Decatur, Georgia, and an expert in the mechanics and operation of medium- and large-format cameras; from Van Hill, an experienced outdoor photographer and fellow member of the Georgia Appalachian Trail Club; and from Jamil Zainaldin, president of the Georgia Humanities Council.

We were also grateful to Dr. Timothy Davis, senior historian in the National Park Service's Historic Structures and Cultural Landscapes Program, who generously took time from his own book project on the historic roads and roadways of the national parks to share his insights on George Grant and his work in this book's foreword. We wish we could claim him as a relative!

Throughout the project we received guidance and help from staff at the University of Georgia Press, especially Lisa Bayer, the director; Elizabeth Crowley, the editorial assistant; Jon Davies, the assistant director for editorial, design, and production; David des Jardines, the marketing director; Amanda Sharp, the publicity and sales manager; Jessica Hennenfent, the marketing assistant; Melissa Buchanan, the assistant editorial, design, and production manager; and Erin New, the designer and art director. We were also fortunate to work with Susan Silver, a gifted copyeditor with an eye for every detail.

Finally, we are sincerely appreciative of the kind support and encouragement from George Grant's nieces—Nancy Grant Lewis, Mary Grant McMullen, and Anne Grant Hastings—and grandniece, Diana Hastings. We wish to dedicate this book about their "Uncle George" to them.

Landscapes for the People

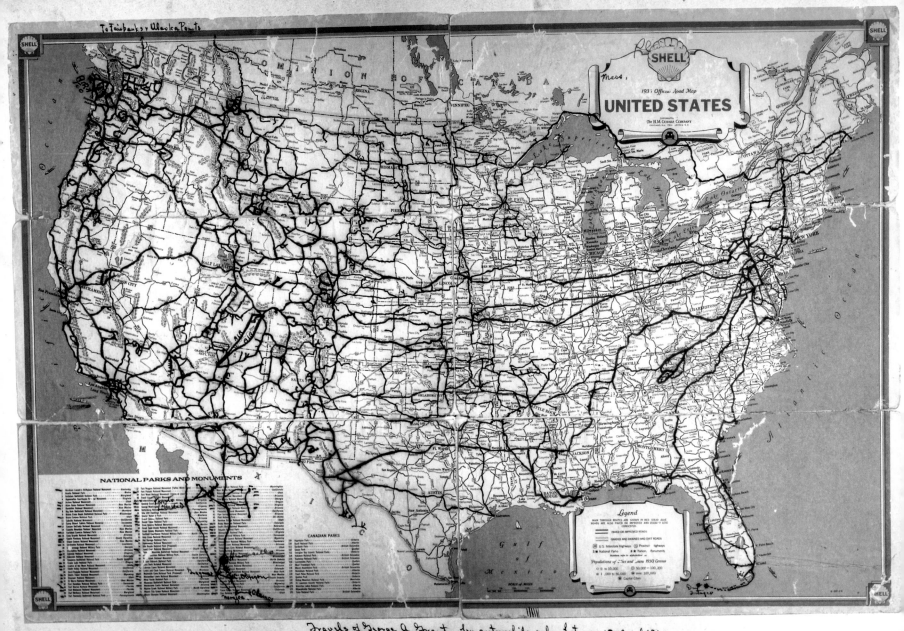

Travels of George A. Grant, by automobile only, between 1929 and 1962.

"Of all the sciences, geography finds its origin in action, and, what is more, adventurous action." Joseph Conrad.

In a conference room at the Saint Michaels, Maryland, public library, Mary Grant McMullen slowly removed an object from a brown paper wrapper. "This belonged to my uncle George," she remarked while revealing a gasoline-station map of the United States, yellowed with age and mounted on cardboard. On the map George Alexander Grant, first chief photographer for the National Park Service, had carefully drawn the routes of his many automobile travels from 1929 to 1962. On the border of the map, Grant had penned the following quotation from an essay by author Joseph Conrad: "Of all the sciences, geography finds its origin in action, and, what is more, in adventurous action."[1]

The old map is tangible evidence of the insatiable curiosity and thirst for "adventurous action" that consumed much of George Grant's adult life. During his quarter century as the national parks' principal staff photographer, he crisscrossed the country numerous times, traveling more than 140,000 miles to capture images in nearly all the national parks, monuments, and historic sites that existed at the time.

As the National Park Service enters its second century, George Grant's work has renewed historical and contextual significance. In concert with the words of the 1916 Organic Act, the service's founding document, Grant's images remain an integral part of the call to "promote and regulate the use of Federal lands to be known as national parks, monuments, and reservations . . . and to conserve the scenery and natural and historic objects and wild life therein and to provide for the enjoyment of the same in such manner and by such means as will leave them unimpaired for the enjoyment of future generations."[2] The images that he made were both timely, reflecting the nearly pristine landscapes of parks as they were becoming popular destinations for millions, and timeless, expressing the extraordinary natural beauty of the lands the nation had the wisdom to preserve.

Highway map of the United States showing hand-drawn routes of George Grant's automobile trips, 1929–62 (no date, Grant family).

Restless

In many ways George Grant's evocative photographs reveal as much about him as of the scenes he so skillfully captured on film. A restless soul, he yearned to travel and was never content to remain in one place for very long. As a youth, George had been an intelligent, if somewhat indifferent, student, preferring to spend long hours boating on the Susquehanna River near his home in Sunbury, Pennsylvania, or imagining himself traveling to faraway destinations, aboard the trains that rolled through his hometown. Wanderlust would come to define his life.

The eldest son of George Ernest and Mary Anne Gaskins Grant, George was born in Milton, Pennsylvania, on March 4, 1891. A younger sister, Katherine, followed in 1892 but died in 1899. A third child, Robert, was born in 1901. Despite the difference in their ages, George and Robert would remain close throughout their lives. As a young man, George would sometimes provide financial support for Robert's college education. Later, as a lifelong bachelor, he would dote on Robert's three daughters, Nancy, Mary, and Anne, as if they were his own children.

George was mechanically inclined with an aptitude for detailed technical work. After graduation from high school in 1909, he found employment in garages and

Metalwork objects handcrafted by George Grant during his employment at the Roycroft Community. Note the object on the left has the initials "RTG" for Robert T. Grant (no date, Grant family).

machine shops in Sunbury and Scranton before moving to Pittsburgh to work in a steel mill. These jobs often paid low wages, and when out of work George would return home to live with his parents. Anxious for a more permanent career, in June 1912 he accepted a position as a metal worker at the Roycroft Community in East Aurora, New York. Founded in 1895 by Elbert Hubbard, Roycroft was a close-knit organization of talented metalsmiths, woodworkers, printers, and other artisans. Working in well-equipped shops and studios, they created exceptional quality furniture and household items reflecting the growing popularity of the arts and crafts movement in America. Grant's tenure at Roycroft served as a foundation for the blend of technical craftsmanship and artist's eye that would mark his photography.

With the United States' entry into the Great War against Germany in 1917, Grant resigned to enlist in the army on September 18, 1917. (Interestingly, Elbert Hubbard and his wife, Alice, were among the 128 Americans who had died in the sinking of the British steamship *Lusitania* by a German submarine in May 1915, an act that eventually led to the nation's involvement in the war.) First serving as an enlisted soldier with the 314th Infantry Regiment at Fort Meade, Maryland, he later was promoted to second lieutenant and transferred to the 61st Field Artillery stationed at Fort D. A. Russell near Cheyenne, Wyoming.

George's first experience with the American West transformed him. He fell in love with the wide-open spaces, the rugged landscapes, the scenic grandeur of the Rocky Mountains, and the sense of freedom that the West offered. At war's end in 1918, he was discharged from the army and reluctantly headed back to the industrial East, making a promise to himself to return someday to live in the West.

Lt. George Grant in military uniform
(ca. 1917–18, Grant family).

Perseverance

Back in Pennsylvania Grant's military experience as an officer landed him a position with the Pennsylvania Highway Department as foreman of a road-grading crew. He later moved to the Susquehanna Silk Mill in Milton to take charge of the printing operations for the metal-engraving department. While the work afforded him a good

living and the opportunity to offer financial help to his family, George's heart was elsewhere.

On January 17, 1921, nearing thirty years of age and with an almost palpable sense of urgency, Grant penned a letter to James McBride, chief ranger at Yellowstone National Park, seeking employment as a temporary ranger for the upcoming summer season. After citing his qualifications, George wrote, "I am sick and tired of inside work, of factories and of industrial communities in general. And when you consider the fact that I've been to the coast three times and almost wept when we left Cheyenne you'll realize the truth of my being very desirous of locating out there permanently."[3] McBride's reply did not offer much hope, but Grant followed up with a letter in May, seeking any opportunity: "With less than a month to report, I assume that the ranger force for the coming summer has been made up. . . . Would you mind forwarding my application to the Superintendent of the Park? Perhaps he has a vacancy I might fill. I have been very anxious to get something permanent with the National Park Service, and have been sitting close for the last few months in hopes that something might come of my application."[4] Nothing came from this plea.

Following another summer working at the mill, Grant learned that McBride was no longer Yellowstone's chief ranger. On December 1, 1921, he wrote an imploring application letter to his successor, Samuel T. Woodring, followed soon thereafter by several letters of reference strongly supporting Grant's application. Woodring forwarded the documents to Yellowstone Park's superintendent, Horace M. Albright, writing in a cover note, "I like the appearance and record of this applicant very much, and believe that his experience in handling men etc. . . . will render him a very efficient man on our ranger force. I should like to consider him for immediate appointment on the permanent force in case [ranger] Bishop is not to return."[5] Woodring wrote to Grant in late December, requesting details regarding his legal residence, marital status, and other information, but he offered no assurance of a position. In early January Grant sent both a telegram and follow-up letter responding to Woodring's questions and indicating his immediate availability should the appointment be approved. He closed with the hopeful comment: "news of my appointment would be very welcome."[6]

In a reply to Woodring, Albright agreed that Grant's qualifications were impressive and that he should be offered a position at Yellowstone for the upcoming summer season. A permanent position, however, was out of the question for the following reason: "[Interior] Secretary [Albert] Fall is much opposed to eastern men being employed in the national parks where they have not had previous experience out here, and his view is a very natural one. . . . I feel that if I would ask . . . the appointment would be turned down."[7]

In a surviving draft of his correspondence with Secretary Fall, Albright emphasized Grant's links to the West, pointing out that "part of his term of [military] service was spent at Fort D. A. Russell, near Cheyenne, Wyo. and while there he learned to like western life and became acquainted with the western viewpoint."[8] Since the establishment of the first national park at Yellowstone in 1872, the military had played a central role in parks management. From the outset the National Park Service perpetuated this culture through the employment of many veterans as rangers and the adoption of military-style uniforms complete with insignia, service chevrons, and other accoutrements (for many years park service employees were even allowed to display military-service ribbons on their uniforms). Albright felt that Grant would fit in, and perhaps his stint in the army put him, figuratively, "over the top."

This was enough to secure the secretary's endorsement, so Albright offered—and Grant readily accepted—a temporary ranger position at Yellowstone for the upcoming summer. Although the salary of eighty dollars per month was substantially lower than his earnings at the mill, and the post was only temporary, Grant was ecstatic. Nearly four years after departing, he finally was returning to the West of his dreams.

A Yellowstone Summer

George Grant arrived in Yellowstone National Park in June 1922 and went immediately to work. While most of his duties at headquarters involved routine tasks such as tallying travel statistics and clerical work, he had opportunities to travel to all corners

Those Darn Bears

According to Horace Albright, early in the summer of 1922 he and Grant were traveling through the park before the tourist season opened and stopped to see Miss Heilwinkle, manager of the Yellowstone Lake Lodge. During the visit, a relatively tame mother bear and two cubs, nicknamed Max and Climax, approached. Heilwinkle suggested that Grant take a photograph of Albright sharing a plate of pancakes with the cubs. After initially refusing, Albright acquiesced. Grant snapped the photos, which would later appear in the pages of the *New York Times*. Within days of their publication, Albright received a telegram from National Park Service director Stephen Mather, who wrote, "No superintendent in the park service shall be seen feeding the bears!"[1] The incriminating negatives were permanently filed away.

1. Horace Albright, foreword to Sawyer, *Early Days*, viii.

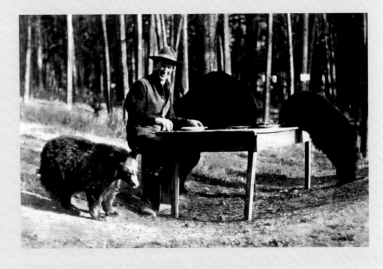

Yellowstone National Park superintendent Horace Albright with bear cubs (1922, NPSHPC).

of the park, visiting the most popular tourist stops as well as remote ranger stations. It remains unclear from existing documents whether Grant brought a camera in his luggage or found one in the park. In either case, shortly after his arrival he began snapping pictures.

Wherever Grant traveled in the park, he took photographs. He taught himself how to develop film and make prints in the darkroom to share with Albright and other senior staff. As his skills improved, he also produced prints from existing negatives in the park's collections. Over the summer Grant became increasingly proficient with the camera, gradually understanding the techniques of composition and exposure and earning compliments from Albright for the quality of his work and its value in promoting the park. Just as he had done in his metalwork at Roycroft, Grant was blending his

artist's eye with growing technical mastery to forge what would become both a future career as well as his passion.

As the summer season drew to a close, Albright offered Grant the permanent ranger position he had originally sought. Responsibilities would require strenuous and extended travel to remote outposts combined with occasional photographic assignments. Grant was not an experienced horseman and, at times, struggled to carry out his duties. In a 1962 interview with former National Park Service colleague Herbert Evison, Grant recalled a significant incident from October 21, 1922:

> [Ranger] Warren Royster and I were sent to the Crevice ranger station . . . to patrol the north boundary of the park there from poachers. . . . I borrowed a horse from an older ranger there, Jimmy Dupuis, and I told him that if I liked the horse and could use him, I would pay him $75. You could have bought a horse up there at

Tourists at Handkerchief Pool,
Yellowstone National Park (1922, NPSHPC).

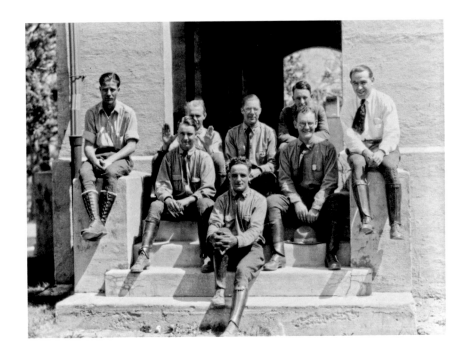

Yellowstone National Park ranger staff with George Grant, seated on the right on the stairs in the second row (1922, NPSHPC).

that time of year for $10, but I had to have a horse; I never owned a horse, you know. So I borrowed him . . . and one day we went up that steep trail from the Yellowstone River to Crevice ranger station, and he bucked me off and went down over the hill and broke his leg, and from that time, I knew he was my horse. . . . I have used lots of horses, but that's the only time I ever owned a horse. . . . I get told about that every time I go to Yellowstone.[9]

Two days after the incident, Grant received his detailed work plan for the season. The accident had convinced him that he was not cut out to be a backcountry ranger, and there was not enough photographic work to keep him busy during the long winter. In a reluctant resignation letter to Albright he wrote, "The proposed plans for my winter work have reached me and in justice to the Park Service that I think they hardly merit the use of a whole winter's time. . . . To spread so little work over so long a period would put me in the light of and make me feel like a pensioner, an office that

the Park Service cannot tolerate in its present stage of development. I therefore ask to be relieved." He continued with a hope that "at some near future date its budget system may even go so far as to support a photographer, a profession that I have fully made up my mind to master."[10] Grant concluded by acknowledging that he had no immediate prospects for employment but hoped to secure a position in the studio of Seattle photographer Asahel Curtis, who was well known for his significant role in the establishment of Mount Rainier National Park. Curtis was also the brother of Edward S. Curtis, a noted photographer of North American Indians.

Unwritten in this correspondence was a possibility that Grant's decision to leave may have been due in part to a broken heart. During that summer George had fallen in love. The object of his affection was Bernice Finney, daughter of Judge Edward Finney, assistant secretary of the Department of the Interior. With her parents, Bernice had vacationed in the park for the season. Grant was not alone in his infatuation, as she had also drawn the attention of ranger Eivind Scoyen. Both men ardently pursued the young woman, but Scoyen, a senior ranger, often assigned Grant to tasks in remote sections of the park, possibly to keep him away from Bernice. In the end, Scoyen won Bernice's heart, and they would eventually marry. Grant put words to his feelings, writing in a January 1923 letter to Albright, "Understand Eivind is now running strong with the crown princess of the Yellowstone. That's hell. Here I thought I was ace high all the time."[11] Despite his disappointment, Grant and the Scoyens would remain friends for many years.

Albright reluctantly accepted George's resignation, while at the same time urging him to pursue a career as a photographer, writing, "At the present time there is no chance of the National Park Service employing an official photographer but an opportunity along this line may open up by next season. . . . Please take pains to keep me in touch with your address."[12] Albright knew that Director Stephen Mather was at work developing a more comprehensive naturalist program within the park service that could potentially include employment of a staff photographer. Encouraged by Albright's words, in early November Grant left Yellowstone and returned to Pennsylvania to visit family and consider his future prospects.

"The Park Service Needs Me!"

The position with the Seattle studio that George had hoped for did not work out. However, in a January 1923 letter to Albright, he reported the exciting news that he had sold several of his photographs with hopes of marketing even more. Anticipating that Albright would be pleased, he wrote, "as you are much interested in Park publicity it may please you to know that the Northern Pacific Railway . . . has accepted practically all of the pictures I took on my own account last summer at Yellowstone."[13] Grant was careful to emphasize that he was always mindful of separating his own work from the photographs he produced for the park service.

Grant expected Albright to be pleased with the news, but he was sadly mistaken. In a stinging rebuke, the superintendent wrote, "I am frank to say that I was very much surprised and disappointed upon reading some of the news it contained. . . . If you had films of your own . . . you should have told me this. . . . I think when you reflect upon the circumstances surrounding the taking of that trip you will realize that you have hardly done the right thing by me." Albright noted that he had planned to give Grant credit for photographs taken during his park service work, but now "I am going to have your pictures credited hereafter simply to the National Park Service." He closed with a demand that Grant retrieve the pictures sent to the Northern Pacific, chiding him that "charity begins at home."[14]

Stunned by Albright's response, Grant quickly explained that his intent had been simply economic, "I was after a job and knew they were spending money for pictorial services, which my summer's work and subsequent experiments have satisfied me I could do. . . . I am, however, very sorry that I did not consult you about them first, but went ahead innocent of the fact that it was likely to be against your wishes."[15] Attached to this letter was a copy of Grant's request to the Northern Pacific for return of the photographs in question. Realizing that he may have overreacted, Albright was more conciliatory in his response to Grant's apologetic letter, writing, "I do not want to be unfair or unjust to anyone, especially a man who has worked for me. I now feel that everything you have done with your pictures has been done with laudable purposes and strictly according to what you feel is the right thing."[16] Albright closed with a question about

Grant's plans for the upcoming summer, perhaps keeping a door open for George's return to the park service.

In his reply Grant expressed doubts about a Northern Pacific job but shared that he had been contacted by Pennsylvania State College (now University) about heading up the photographic department in the school's College of Agriculture. Also, he planned to enroll in a photography course in New York City to improve his chances for securing the appointment. With Albright's endorsement and the additional training, George was awarded the position. As much as he yearned to return to the West, Grant would spend the next five years in State College, Pennsylvania, working near his hometown of Sunbury.

The two men maintained a steady correspondence over the next several years, as Grant updated Albright about the skills he was mastering and how they might be utilized in the National Park Service. A letter from August 27, 1923, illustrated Grant's deepening wish to return: "I have no idea of keeping it [the job at Penn State] forever, mainly because I am keenly interested in the National Park Service and the work they are doing, and try to kid myself into the belief that the Park Service *needs me*, in fact can't afford to get along without me."[17] As if to enhance his appeal, Grant noted that he would soon earn enough in his work to purchase a complete photographic outfit, saving the park service from that expense. Two more years would pass with no progress toward a job with the National Park Service, so George accepted a promotion to a supervisory position in the university's photographic department, where he complemented his picture taking and darkroom assignments with work as an instructor of photography.

George Grant as photography instructor at Penn State (ca. 1925, NPSHPC).

Despite years of disappointment, Grant persisted. By the spring of 1927, his inquiries to Albright had taken on an almost pleading tone: "Although I have been away from you since 1922, not once have I felt entirely removed from interest in the work you are doing; nor can I help feel that some day I might be closely associated with you in it."[18] His efforts appeared to finally pay off when George received a letter from Albright, written at Yellowstone on July 2, 1927, in which he wrote, "I believe that I have found a position in the National Park Service to which you would be suited. This is a new position with the Educational Division and would be under Mr. Ansel F. Hall, the chief naturalist of the Park Service. It is photographic work and while your headquarters would be at

Berkeley, California, you would be required to travel from park to park, getting photographs for the Park Service collection in connection with educational work."[19] Albright pointed out that the position would require the approval of National Park Service director Stephen Mather, along with permission to employ someone not currently on the civil service register. Grant wired his enthusiastic reply the same day the letter arrived, following up a few days later with a second telegram to confirm the original response had been received. Albright replied that the park service would be required to post the position through the civil service, and Grant could be considered only if no eligible applicants applied and were accepted.

Discussions between Albright and Director Mather about the position continued into the fall. In early November Mather wired Ansel Hall, directing the chief naturalist to provide written justification for the position and a detailed job description, along with the status of the request for civil service authority to fill the position. Hall was most happy to comply, noting, however, that "for the past five months I have made every effort to secure a qualified photographer at this low salary [$1,500 per year] but all efforts have been fruitless. . . . Several lists of eligibles for the post of dry-plate photographer are furnished by the Civil Service, but of all the candidates whose papers were examined, not one was found with the proper qualifications. . . . It becomes necessary to request your permission to make a temporary appointment at $200 per month." Hall followed with the job description and closed with this request: "Having received the authority from the Civil Service to make a temporary appointment to this position, I hereby recommend Mr. Geo. A. Grant who may be placed temporarily at my headquarters in Berkeley and who will be prepared to immediately enter on duty as soon as a wire is received from you authorizing the appointment. . . . Mr. Grant has signified his willingness to take an examination for this position when such an examination is offered, serving in a temporary capacity until this time."[20] A few days later Grant completed an employment application, citing his pertinent educational and work credentials, and sent it to Horace Albright, who signed the application on November 19, 1927.

Optimistic that his dream was about to be fulfilled, Grant resigned from his job at the university and drove across the country to California, where he had made

arrangements to stay with friends in Los Angeles. In a letter to Albright on December 15, George excitedly wrote,

> In the meantime if you feel in any way that my appointment is reasonably certain and merely a matter of time, I want you and Mr. Hall to feel free to make use of my services without pay until I have been officially appointed. I mention this because the trip up through the valley will take me close to Sequoia, General Grant, and possibly Yosemite Parks, in which places it is possible you might want some work done. A brand new, completely equipped view camera, which I secured only yesterday, will make it possible for me to do this. At the same time this might enable me to drift on up into Berkeley, where I can obtain permanent quarters for myself.

As if anticipating that the job was not yet confirmed, Grant added, "I might add that you are both at liberty to use me on the above terms without the least obligation in case my appointment does not go through."[21]

George's dream would once again be put on hold. Unbeknownst to him, a December 9, 1927, letter from Director Mather to Chief Engineer Frank Kittredge, with a copy to Horace Albright, noted that Judge John Edwards, assistant secretary of the interior, had questioned the necessity and related cost of a photographer's position within the park service and required more information before he would approve it. Mather outlined Edwards's concern that a photographer's salary was only the starting point and that travel, equipment, room and board, and other expenses would add many thousands more dollars. According to Mather, Edwards believed that needed images could be secured from other sources at lower cost and "under no circumstance would he agree to having . . . a photographer directed by other than an executive officer of the Service."[22] Mather closed by requesting that Kittredge develop a detailed budget for the position, including an outline of Grant's job responsibilities and expected contributions to furthering the work of the park service's Educational Division.

Kittredge asked Ansel Hall to address the issues raised by Mather and Edwards. On December 21, 1927, Hall sent a seven-page letter to Albright, containing a point-by-point analysis of the value of a staff photographer versus the continued reliance on

outside commercial studios for needed images. The following list contains some of the key issues described by Hall:

1. Park operators, with few exceptions, could furnish only stock scenic views. Only the features commonly seen by tourists are saleable and tempt them to make photographs.
2. Park operators could not be expected to make technical photographs of subjects needed by the Park Service, such as physical improvements in parks, geological and biological photographs for use in museums and lectures, etc. . . .
3. Park operators specializing in scenic views are *not equipped* to immediately produce the technical photographs, lantern slides, enlargements, and other material needed by the park service.[23]

Hall went on to point out that while some park operators may be able to produce the required images, they would charge commercial rates for the work, making it prohibitively expensive. He also noted that the work of a staff photographer would be the property of the government and would be immediately available and that the overall cost of production would be low. He further pointed out that a park service photographer employed by the Educational Division could not only process his own work but also produce prints from a large volume of images from other artists: "We could make prints from thousands of negatives owned by friends of the National Park Service. These private negatives would not be available if we handled our work through park operators. I refer to the photographs as those taken by Joseph Le Conte, Ansel Adams, Charles Townsend, and others."[24]

In closing, Hall expressed his long-standing concern regarding a misunderstanding of the value of visual education within the Educational Division, pointing out that the principal function of the office would not simply be to run an "advertising bureau" for the production of scenic views but instead to

extend the use of the National Parks to all the people of the country throughout the whole year. In all parts of the United States big museums and other organizations are realizing the enormous value of their institutions to individuals who cannot

visit them, and therefore there have grown up visual education departments which take these museums to the people in the form of illustrated lectures and other photographic material. Such activities connected with National Parks are only in line with the greater use of these Parks and should not be thought of as unnecessary activities or advertising, but rather as an economic way of greater utilization.[25]

Attached to the letter was an outline of the photographer's proposed work schedule for the six-month period beginning January 1, 1928.

FILE COF

NATIONAL PARK SERVICE

Educational Division

PHOTOGRAPHER'S PROGRAM — January 1, 1928 to June 30, 1928

Time	Station	Activities
Jan. 1 – 15	At Berkeley Headquarters	1 – Survey, classification, repair and storage of all photographic field equipment. 2 – Repair and installation of photographic laboratory equipment. 3 – Compounding of developers and other agents to be used in producing photographs and negatives.
Jan. 16 to Feb. 28	At Berkeley Headquarters	1 – Making of 15000 prints –5 each from 3000 negatives available by loan to National Park Service from private sources. 2 – Making of 300 negatives — copies of best of above subjects for National Park Service negative file.
March 1 – 30	Field work in Yosemite National Park	1 – Making of a series of general scenic views. 2 – Production of special negatives for: A – One general lecture B – One lecture on Geology C – One lecture on Indians D – One lecture on Life Zones E – One lecture on History. 3 – Photographs of all important material in Yosemite Museum, photos of which could be used in lectures. 4 – Copying historical photos, etc., already in Museum files. 5 – Photos of subjects wanted by Landscape and Engineering Divisions.
April 1-15	Field work in Sequoia National Park.	1 – Maximum production of general photographs. 2 – Photographs of special subjects for illustrated lectures. 3 – Photographs of subjects needed by Landscape and Engineering Divisions.
April 16 to May 15	At Berkeley Headquarters	1– Making prints of all negatives made from March 1 to April 15. 2– Filing of above prints. 3– Assembling of apparatus for summer field trips.
May 16 to June 30	Field work in National Parks (with Chief Naturalist)	1 – General photographs. 2 – Photographs of special subjects for illustrated lectures, etc. 3 – Photographs of subjects wanted by Landscape Division and Engineering Division.

Ansel F. Hall,
Chief Naturalist

2

Proposed duties of the NPS photographer for a six-month period, January 1 to June 1, 1928 (1927, NPSHPC).

In follow-up correspondence to Mather, Albright reinforced and expanded on Hall's detailed justification for the position by outlining the current challenges faced by each national park in procuring needed images from commercial operators. He pointed out that the Educational Division, established in 1925 at the University of California in Berkeley, contained war surplus photographic and darkroom equipment and laboratories that could be put to immediate use by a staff photographer. Albright closed with a reminder to Mather that "Mr. George A. Grant, who is now available for appointment, was with the Yellowstone Park staff during the year 1922. He has since been head of the photographic laboratory of Pennsylvania State College. He is a National Park enthusiast and ever since his summer at Yellowstone, has desired to return to the bureau. Recently he left his university position and is now in California awaiting our call."[26] As Grant meandered toward Berkeley in late December, photographing in the parks along the way, he was likely unaware of the issues surrounding this appointment or the efforts expended by Mather, Albright, Kittredge, and Hall to finally create the long sought position.

Writing to Grant at Yosemite on January 3, 1928, Hall urged the photographer to take advantage of time with park naturalist Carl P. Russell to learn all he could about the park's geology and natural and human history, as this would give him a "preliminary view of our work as a whole before going into the actual details of photography." Hall closed with the admonition, "Mr. Albright will probably let you know as soon as he hears from Washington regarding your appointment."[27]

A Red Rag to a Bull

As the days passed, Grant maintained a steady correspondence with Hall and Kittredge, doing all he could to solidify his chances for the position. A late January letter from Hall to Kittredge suggested that George was growing anxious and trying too hard to get hired, even turning down commercial assignments so as to be immediately available if the position was approved. Hall wrote, "I confess that I admire his spirit in wanting to be of service without thinking of compensation, but I want at this time

to place on record the fact that I have not attempted to encourage this attitude."[28] In a letter to Albright, Kittredge remarked, "I have told both Mr. Hall and Mr. Grant that it seems to me such a trip to Yosemite at this time would be like a red rag to a bull. Mr. Grant was already . . . quite concerned about this. . . . I like Mr. Grant's spirit and his eagerness to get in the Park work. . . . I am anxious that he be taken into the service."[29]

Despite the concerted efforts on George's behalf, the position was not approved for the 1928 budget. Nonetheless, Grant appeared to accept this disappointment and, remarkably, remained optimistic. He accepted a few freelance jobs while studying for the civil service examination that would be required if he were to ever have a chance of working for the park service. He took the exam in the summer of 1928 and in September proudly wrote to Albright and Hall that he had earned a score of 85.63, noting that "there is now on the register the name of one person with a higher average than mine." He closed with the hope "that with the Civil Service difficulties overcome there soon may be something stirring."[30] Albright replied with congratulations and urged Grant to "keep up your courage and if your finances will permit keep yourself located so that we can get you on short notice. It is likely that it will be some time before we can call you."[31]

Albright Gets His Man

On November 6, 1928, Horace Albright was attending a Sierra Club gathering in California, watching the presidential election returns in hopes that Herbert Hoover, a native westerner, an outdoorsman, and a strong supporter of the national parks, would be elected as the nation's thirty-first president. During the meeting, he received an urgent telegram that Stephen Mather had suffered a serious stroke and was in a Chicago hospital. The next morning Albright was on an eastbound train to Chicago, deeply concerned for his friend and mentor. A visit to Mather's bedside confirmed for him that Mather's condition was grave and unlikely to improve. Shortly after Albright's arrival at the park service headquarters in Washington, D.C., Interior Secretary Roy O. West appointed him as the agency's acting director. Two months later, on January 12, 1929,

"Neither Fish nor Fowl"

George Grant's challenges in securing a photography position with the National Park Service may have reflected only a small part of significant changes facing the organization in the 1920s regarding its role in the interpretation of each park's natural, cultural, and historical significance. In the beginning the government (principally the U.S. Army) was responsible only for protecting the parks from poaching, mining, and other prohibited activities as well as protecting visitors from attack by Indians or outlaws. Little or no thought was given to, or funding appropriated for, providing tourists with information about the lands they had come to see. For that, visitors often turned to local guides employed by hotels or by the railroads.

In 1911, through collaboration with the Smithsonian and the U.S. Geological Survey, national park superintendents were asked to submit information for each of their units for the publication of basic handbooks. With the outbreak of war in Europe in 1914 closing the continent to wealthy American tourists, the Great Northern, Northern Pacific, and Southern Pacific Railroads sponsored a "See America First" campaign to encourage visitation to the national parks. The following year newly appointed assistant secretary of the interior, and later National Park Service director, Stephen Mather engaged Robert Sterling Yard, a journalist, parks advocate, and personal friend, to aid in promoting the establishment of the park service and to chair a committee on education in the parks. Yard was later appointed chief of education for the new agency and coordinated the publication of the *National Parks Portfolio* in 1916, a richly illustrated book with nearly two hundred photographs from eight national parks and monuments. It was distributed free of charge to influential individuals and members of Congress. The book proved so popular that a second edition was quickly produced the following year.

In his introduction to the portfolio, Interior Secretary Franklin Lane wrote, "It is the destiny of the national parks, if wisely controlled, to become public laboratories of nature study for the Nation."[1] Despite these efforts, Congress demonstrated little interest in funding interpretive services in the parks, leading Yard to remark that "no one in Washington took any interest in it except Mr. Mather. . . . Congressmen smiled over it; and with a very few exceptions, the concessionaires opposed it."[2]

Concerned with the accuracy and consistency of the information presented, Mather continued to urge a more active role for the park service in providing interpretative services. In 1918 Dr. Charles D. Wolcott of the Smithsonian Institution sponsored a National Parks Education Committee to study the role of education within the parks. An outcome of this work was the establishment, with Mather's active support, of the National Parks Association (now the National Parks and Conservation Association) in 1919 to "encourage the popular study of the history, explorations, traditions, and folk lore of the National Parks and National Monuments."[3] Shortly afterward, Yard left the park service to become the executive secretary of the association.

That same year Drs. Harold Bryant and Loye Holmes Miller of the California Game and Fish Commission began conducting field trips and presenting lectures at Yosemite National Park. Milton Skinner, recently employed by Horace Albright as a naturalist at

Yellowstone, led outings, offered lectures, and wrote nature columns for the park bulletin. In 1923, with popularity of these services growing among the general public, Mather appointed Yosemite naturalist Ansel Hall as chief naturalist for the National Park Service, with responsibilities to expand museum services and educational programs across the system.

Critical to this effort was the development of training programs for naturalists that would ensure competence, accuracy, and consistency. The first offering, the Yosemite Field School, organized in 1925 by Dr. Bryant, was an intensive course to prepare naturalists for work in national and state parks, schools, summer camps, and other organizations. Expansion of the park service in 1933 to include national battlefields and historic sites opened up another role for interpretive staff possessing the necessary skills to provide accurate historical information in an engaging manner.

Museum development also gained momentum during this time. In his 1920 annual report, Mather urged that museums be established at each national park. With no federal funding, support for this plan came from the American Association of Museums and its director, Chauncey Hamlin. With the leadership of chief naturalist Ansel Hall, the association would play a pivotal role in the development of museums at Grand Canyon, Yellowstone, Mesa Verde, and Lassen Volcanic National Parks. With the New Deal in the 1930s came additional appropriations for park-service museum and exhibit projects. In 1935 the Branch of Historic Sites and Buildings was carved out of the Research and Education office and, with funding and labor from the Works Progress Administration, the

Guide service sign on the rear of a Rim Caravan Guide Car, Crater Lake National Park (1931, NPSHPC).

Public Works Administration, and the Civilian Conservation Corps, extensive work was undertaken in the construction of national park visitor centers, museums, and specialized exhibits.

In 1928, at the urging of John C. Merriam, a paleontologist, cofounder of the Save the Redwoods League in California, and president of the Carnegie Institution in Washington, Mather requested the appointment of a Committee on the Study of Educational Problems in the National Parks, while at the same time urging the creation of a Permanent Educational Advisory Board with a chief of education based at the park-service headquarters

in Washington, D.C. Chaired by Merriam and underwritten by the Laura Spelman Rockefeller Foundation, the committee undertook a thorough examination of educational possibilities within the National Park Service. Among its recommendations was the establishment of an educational advisory body and the creation of a division of education to coordinate programs across the system. In its final report the committee also noted that educational programs offered by the park service should be limited to only those that could not be cared for by other means, endorsing continuing a role for outside concessionaires and partner organizations to also provide educational services. Following adoption of these recommendations in 1930, the new Branch of Research and Education was established at the Washington headquarters under newly appointed assistant director Dr. Harold Bryant. At the same time Dr. Wallace W. Atwood Jr. was employed to oversee earth sciences education, and a year later Verne E. Chatelain was hired to develop educational programs in the fields of history and archaeology.

Despite the extensive efforts to integrate interpretation into the mission of the National Park Service, the individuals employed for these responsibilities were not always welcomed or accepted by park superintendents and rangers, who often saw them as lacking the skills needed for rigorous outdoor and backcountry patrol tasks. At the same time, interpreters were viewed with disdain by academic naturalists, who described them as "amateurs" and "Sunday Supplement Scientists." In a reflection on his years as a naturalist at Mount Rainier National Park beginning in 1928, C. Frank Brockman noted that "early National Park Service naturalists were neither fish nor fowl."[4] In addition, for many years interpretive staff often found their advancement opportunities within the park service stymied due to their limited role.

Much of the work that George Grant would undertake as the park service's staff photographer was directly in support of these interpretation services through the production of museum-exhibition images, brochure illustrations, prints, lantern slides, and technical or specialized photographs for reports and publications. The lengthy challenges regarding full acceptance of and needed funding for interpretation and museum services in the 1920s may have been the underlying reason why Grant encountered such prolonged difficulty in securing his position as a photographer with the National Park Service. However, he had strong support from a most influential source, Horace Albright.

1. Franklin K. Lane, introd. to Yard, *National Parks Portfolio*, n.p.
2. Robert Sterling Yard to Harold C. Bryant, July 24, 1931, History of Interpretation Files, NPSHFC.
3. MacKintosh, *Interpretation*, 7.
4. Ibid., 16.

with Mather's health continuing to decline, Albright was named director of the National Park Service. Stephen Mather would linger another year, dying on January 22, 1930.

Within days of Hoover's inauguration, Albright and other senior park service officials were asked to submit resignation letters to the new interior secretary and former Stanford University president, Ray L. Wilbur. All were surprised, since Hoover, like his predecessor Calvin Coolidge, was a Republican. Uncertain of a future with the park service, Albright was contemplating a return to his home in California to practice law when he was summoned to Wilbur's office. Upon his arrival, the secretary returned the letter, saying, "Here's this resignation of yours. . . . The president wants you to stay."[32] It is possible that this moment finally opened the door for George Grant's return to the National Park Service.

During this time, chief naturalist Ansel Hall was also actively working to establish a photography position in the Educational Division. Looking beyond government sources, he laid "the matter . . . before a friend of the national parks . . . and sufficient funds were secured to establish a photographic department and provide for its operation to July 1, 1930."[33] With Albright's support and funding secured, on April 8, 1929, Grant received the long-awaited notice from the park service's chief of the Division of Appointments. It stated simply, "You have been appointed by the Secretary of the Interior, upon the recommendation of the Director of the National Park Service, subject to taking the oath of office, a photographer, grade 11, in the National Park Service At Large, with headquarters at Berkeley, California, at a salary of $2600 per annum, effective on date of entrance on duty."[34] A week later, George began work as the first official photographer for the National Park Service. His nearly seven years of writing letters, mastering artistic and technical skills, and simply persevering had finally paid off.

The Long-Awaited Adventure

George Grant wasted little time getting to work. While he had a laboratory and darkroom in the Educational Division offices at the University of California, he would spend most of that first summer, as he would for many future summers, on the road. Loading a

park-service vehicle with his field camera and tripod, black-and-white film and holders, basic development chemicals and accessories, and essential camping gear for extended travel, Grant departed Berkeley in the middle of June with plans to remain in the field until late September. Driving more than four thousand miles, he traveled to thirteen national parks, monuments, and other destinations. At each location he would customarily meet with park naturalists and management staff to discuss their photographic needs and then head into the field to capture the requested images as well as others that would be of value for park-service reports, educational programs, exhibitions, and publications. Given the primitive road conditions and the remoteness of many of the parks, George must have felt exhilarated to finally embark on the adventure about which he had so long dreamed.

That first summer was a whirlwind. Grant arrived at Grand Canyon National Park on June 18 and remained a week before continuing to other Arizona parks and monuments, including Montezuma Castle, Saguaro, Casa Grande Ruins, Tumacácori Mission, and Petrified Forest. He traveled east to New Mexico for visits to Chaco Culture, El Morro, and Aztec Ruins National Monuments before a mid-August sojourn at Mesa Verde National Park in southwestern Colorado. At month's end he was in Utah at Arches National Monument (designated a national park in 1971), followed by extended stays at both Zion and Bryce Canyon National Parks, finally returning to California in late September for a winter of laboratory and darkroom work. While at Zion, George spent time with his friends from his Yellowstone days, Eivind Scoyen, now the park superintendent; and his wife, Bernice, who had been the object of both of their ardent affections in that long-ago summer of 1922.

A surviving letter to the Educational Division headquarters, written by Grant from Zion in late August 1929, recounts his surprise on arriving at the park to discover that a package of requested darkroom chemicals awaiting him contained an X-ray film developer. With a touch of humor, he wrote, "I am having 'my assistant' return to the Eastman Kodak Company in franked packages and am writing them tonight explaining that the entire Park Service personnel is not suffering from broken bones."[35]

It did not take long for the quality of George's work to be recognized. Ansel Hall asked for his help in organizing the First Park Naturalist Conference, to be held in

Berkeley on November 1–30, 1929. Conference attendees would include the six perma-
nent naturalists then employed by the park service (representing Yellowstone, Yosemite,
Grand Canyon, Glacier, Sequoia, and Mount Rainier National Parks), wildlife-research
team members, fire-control experts, researchers and museum technicians, faculty from
the University of California, and others involved in park-interpretive duties. Objectives
of the conference included such topics as the role of education in the parks, museum
planning and exhibit design, interpretive and guide services, and scientific research in
the parks.

The conference program for November 27 was devoted to Photography and
Visual Education, with George Grant as the principal instructor. He gave an in-depth

Ranger naturalists at the First Park
Naturalist Conference, November 1929.
Front row, left to right: Dorr Yeager,
Carl P. Russell, Ansel Hall, and C. A. "Bert"
Harwell; *back row*: C. Frank Brockman,
John D. Coffman, Frank Been, and
Edwin D. "Eddie" McKee (1929, NPSHPC).

presentation on the "Principles of Photography," delving into areas ranging from the selection of camera equipment to the technical aspects of proper exposure and composition. In offering his thoughts on composing images, George remarked to his audience, "The best suggestion I can make is for you to study pictures and get in the habit of seeing pictures. You fellows are living in the most beautiful parts of our country. You have pictures almost anywhere you look. If you haven't already adopted photography as a hobby it is because there must be a screw loose somewhere. A camera in any one of our national parks should soon pay for itself."[36]

After a program by interpreters Dorr Yeager from Yellowstone and Charles Albert "Bert" Harwell from Yosemite on the value of visual materials in the park service's educational programs, Grant followed with a lecture on "The Production of Photographic Materials for Use in the Parks," which described his fieldwork as "accentuating the main objective, which is to secure adequate material for the use of the educational staff in the parks. A secondary objective is to produce scenic views which may be used for publication, advertising, etc., when this use is approved by the Park Service."[37] The day concluded with George leading field demonstrations of equipment and techniques. In 1932 the proceedings of the conference were published for the benefit of all park service interpretive and management staff.

The Great Depression and the Parks

As Grant settled into his new position, he must have felt fortunate at the timing of and private funding for his employment. Through the final months of 1929 and into 1930, the nation's plunge toward economic collapse and the depths of the Great Depression had a profound impact on nearly every facet of American society. Following the apparent boundless optimism of the Roaring Twenties, the financial downturn and a prolonged agricultural recession in the South and Midwest combined to form a crisis of seemingly biblical proportions. Banks closed, factories shuttered, homes were foreclosed, and millions lost their jobs.

All government agencies were dramatically impacted, and the National Park Service was no exception. Park operations and staffing budgets were frozen or cut to austerity

levels, and plans for capital improvements or new acquisitions were placed on hold. President Hoover, unable to grasp the scale and enormity of the problems and cautious of federal intervention in the economy, was painfully slow to respond. For the park service, he approved only limited funds for roads and trails work in the national parks, but this was woefully inadequate to meet the worsening financial conditions.

Despite tightening budgets, in 1930 Grant resumed his summer travels to the western parks. Perhaps due to financial constraints, he traveled only 3,300 miles and visited fewer parks, but he stayed for longer periods at each one. Departing Berkeley in mid-June, he returned to the Grand Canyon for a month-long stay, producing panoramic images from the South Rim as well as from within the depths of the canyon. In addition, he supplemented the scenic views with carefully composed technical photographs of fossils embedded in the ancient rocks.

George Grant's automobile on Trail Ridge Road, Rocky Mountain National Park (1930, NPSHPC).

From the Grand Canyon he traveled to Rocky Mountain National Park for a three-week stay. While there he documented summer construction work on the new Trail Ridge Road that would provide safer access across the mountains. Next he drove to Devils Tower National Monument for a few days of work before making his first visit to the recently established Grand Teton National Park in Wyoming. Much controversy surrounded the new park, as local ranchers and homesteaders vehemently opposed its creation, fearing that they would be deprived of valuable grazing lands. These disputes would not be resolved and the park's final boundaries set until 1950. During his stay at Grand Teton, Grant produced several iconic images of the dramatic mountain landscape as well as a portrait of backcountry ranger and outfitter Adam Keith, whose rugged appearance fit the country he patrolled. By early October George was back in Berkeley for winter darkroom work, confident that he was finally at home in the West he so much loved.

Chief Photographer

The 1931 summer season began with a short visit to Yosemite National Park in June, with plans for an extended stay at Yellowstone in July, followed by a trip to Crater Lake National Park in August. On July 6, as George prepared to depart Berkeley for Wyoming, he received notice from John T. Doyle of the U.S. Civil Service Commission of his promotion to chief photographer for the National Park Service. While George must have been elated with the announcement, it would be a mixed blessing, as it required that he move from the Educational Division in California to the Branch of Research and Education at the park service headquarters at the Department of the Interior in Washington, D.C., before the year was out.

George's two-week stay at Yellowstone was his first visit since his summer as a temporary ranger and fledgling photographer in 1922. Following the years of training and persistent efforts to return to the park service, it must have felt like a genuine homecoming. In addition to iconic images of landscapes and geysers, Grant was also on-site to document the raging Heart Lake forest fire and its aftermath. The conflagration

Heart Lake fire, Yellowstone
(1931, NPSHPC).

consumed more than eighteen thousand acres of woodlands and would be the largest
forest fire in the park until the devastating blazes during the summer of 1988. Following
a brief return to Berkeley to process film and pack his equipment, George drove north
for his inaugural visit to Oregon's Crater Lake National Park.

On September 11, 1931, Horace Albright received a telegram from Arthur E.
Demaray, associate director of the park service, and Dr. Harold C. Bryant, assistant
director for Research and Education, requesting that Grant come to Washington
as quickly as possible to prepare for the 1932 bicentennial activities at George
Washington's birthplace in Virginia. By late October George was back east and heav-
ily involved with work at agency headquarters. He hardly had time to find a place to
live and unpack before receiving an important assignment to accompany a team travel-
ing to Tennessee and North Carolina to survey the planned Great Smoky Mountains
National Park.

Rugged Landscapes and Lightning in a Bottle

For many years naturalist Horace Kephart had urged the preservation of the extraordinary landscapes, flora, and fauna of the Great Smoky Mountains, but little progress was made to bring this dream to reality. Following a 1923 visit to several western national parks, Willis P. Davis, an influential businessman from Knoxville, Tennessee, began exploring the possibility to establish a national park in the Smokies. This simple idea put in motion a monumental effort by civic and business leaders in both Tennessee and North Carolina to create a park along the mountainous border of the two states. Unlike western parks, which had been set aside from public lands, much of the property within the boundaries of the proposed park was privately owned by individual families or commercial logging companies, significantly complicating the planning and acquisition process. Congress authorized establishment of the park in 1926 on the condition that three hundred thousand acres would be acquired by the states. Progress was slow, despite the tireless work of local supporters, the park service, and the generosity of philanthropist John D. Rockefeller. With the onset of the Depression, however, the process accelerated, as many families and commercial interests were struggling to survive and were willing to sell out for hard cash.

With the impetus to move forward, in November 1931 a team arrived from Washington to conduct a survey to determine the best location for the park headquarters. The group was under the direction of Superintendent J. Ross Eakin, who had previously served as superintendent of Glacier National Park during early development of the park's Going-to-the-Sun Road. George Grant's role was to provide visual documentation of the landscape and people living within the future preserve. Today his images of pioneer settlers, dramatic mountains, and heavily logged hills and valleys capture the rich cultural heritage of the rugged area as well as the devastated lands that would later be restored as part of what would become one of the country's most visited national parks.

Among the images taken by Grant during the survey was one of federal-revenue agents standing beside a confiscated whiskey still. The story behind these images, according to Mark Sawyer, author of *Early Days: Photographer George Alexander Grant and the Western National Parks*, was that Grant may have developed an addiction to

Federal officers with confiscated whiskey still, Great Smoky Mountains National Park (1931, NPSHPC).

alcohol from "steadily sampling the local moonshine" during the trip.[38] In an interview with Sawyer, park service archaeologist Arthur Woodward, who accompanied Grant on a 1935 survey trip to Mexico, remarked that the rigors and isolation of work in remote parks led more than a few men to succumb to alcohol use, and George may have been no exception. While Grant may have battled alcohol dependency over the course of his career, there was nothing in his official records or in the quality of his photography that suggested that it had a detrimental impact on his work.

The Great Smokies trip was the first of several that Grant would make to planned or proposed parks over the next decade. At times the destinations were recommended by political leaders or influential constituents hopeful of developing a national park in their state. In his role Grant provided visual documentation of numerous sites, including the proposed Natchez Trace Parkway in Mississippi and Tennessee (1934); Spanish missions in Mexico, Arizona, Texas, and California (1935–39); Big Bend in Texas (1936); Washington's Cascade Mountains (1937), and the Oregon Coast (1938).

Work and Family

By the winter of 1932 Grant was settled in Washington, living in an apartment on Eighteenth Street, just a few blocks from the Department of the Interior. Of George's move, Dr. Harold Bryant and Wallace Atwood reported in *Research and Education in the National Parks*, published in 1932, "The recent transfer of George A. Grant, the official park photographer, from field headquarters to the Washington office should operate to make the photographic department far more valuable to the Service and the public. Mr. Grant has secured several thousand excellent negatives of the parks and is contributing much to the visual education program."[39]

When he moved to Washington, George was forty years of age and a confirmed bachelor, convinced that his work, with its lengthy and difficult travel requirements, made married life impractical. However, the return east had the benefit of allowing him to spend more time with his immediate family, including his aging parents and his younger brother, Robert. He grew increasingly fond of Robert's family, especially the three daughters, Nancy, Mary, and Anne, whom he called "his girls." They lived nearby in Snow Hill, Maryland, and George would visit whenever he could escape work in Washington for a few days. He also enjoyed spending Christmas holidays at his parents' home in Sunbury, Pennsylvania. According to his nieces, George would usually meet the rest of the family in Pennsylvania a few days before Christmas. There, he would learn each niece's wishes for holiday presents and then purchase a hoped-for gift so that it would be under the tree on Christmas morning. The nieces also fondly recalled accompanying their uncle on brisk walks to the Sunbury railway station to watch the trains, just as he had done as a young boy, dreaming of faraway adventures.

At the headquarters Grant's responsibilities expanded from lab and darkroom work to include documentary photography work for park service executives. He also took on a growing schedule of seasonal shoots in eastern locations before returning to the western parks each summer and fall. Among these was the task that brought him east with such urgency in the fall of 1931. Work was moving rapidly ahead on events commemorating the 1932 bicentennial of George Washington's birth. In early November 1931 George traveled to the Virginia Tidewater area to photograph Director Albright and members of

the National Fine Arts Commission during their survey visit to the Washington family cemetery. In May 1932 he returned to document the dedication of Washington's reconstructed birth house, Wakefield, producing images of the home and of the many dignitaries attending the ceremony. (A decade later historians determined that the reconstructed Wakefield was actually on a site north of the exact location of Washington's birthplace. The reproduction structure is now called the Memorial House.)

On the Road Again

In June George packed his gear and headed west for four months of fieldwork, traveling nearly eight thousand miles in a new, specially outfitted panel truck—part home and part darkroom—that he nicknamed the "Hearse." A memorandum dated May 24, 1932, from Associate Director Demaray to Chief Engineer Kittredge, outlined how Grant would be reimbursed for expenses incurred during his summer travels: "Mr. George A. Grant is starting on a field trip which will take him to various of the national parks in the West and it is desirable that Special Disbursing Agent Brown make payments for certain supplies and materials which Mr. Grant will purchase. We are setting aside $500 for the payment."[40]

In June, following short visits to Chimney Rock and Scotts Bluff National Monuments in western Nebraska, he continued to eastern Wyoming to photograph decaying ruins at Fort Laramie, once among the most important army posts on the western frontier. Efforts to preserve and restore Fort Laramie would culminate with its acquisition by the park service to be set aside as a national monument in 1938, and in 1960 as a national historic site. Grant returned to photograph the fort in 1949, providing visual documentation of the restoration efforts since 1932. Grant next visited Yellowstone, where, among other tasks, he photographed the dedication of a plaque in memory of Stephen Mather, surrounded by park superintendent Roger Toll and his ranger staff.

From Yellowstone George traveled north for his first visit to Glacier National Park in Montana. There he produced three types of images that reflected the broad scope

Yellowstone ranger staff at the dedication of the plaque in memory of Stephen Mather (1932, NPSHPC).

of his park-service assignments. He documented continuing work on the Going-to-the-Sun Road, the remarkable scenic highway that would soon link the eastern and western sides of the park; captured dramatic landscape images; and photographed tourists enjoying horseback trips into the park's remote backcountry. These photographs illustrated the multiple requirements of the park service, from promotional materials to internal documents and technical reports. Such work required long days of photography, followed by hours of film processing and camera loading for the next day's shooting. In his 1962 interview with Herbert Evison, Grant recalled the rigors of these assignments: "Sometimes I would go a hundred miles to get one or two subjects, and I couldn't afford to take only one [photograph]—too risky. You could never tell when your bellows was leaking or your camera had gone haywire or your shutter wasn't working, and so the thing to do was to take two or three; sometimes I would make four or five, if it was an unusually good shot."[41]

George Grant viewed his work as principally documentary in nature, intended to complement the larger story of the role of parks. His assignments often reflected the park service's sometimes conflicting mission to preserve the natural landscapes and, at the same time, to promote increased visitation through the publication of visually rich brochures, articles, and other media. In his essay from *Observation Points: The Visual Poetics of National Parks*, John Gareth noted that photographers, other artists, and historians "long understood the agency of landscape to evoke powerful, cultural, political, and social sentiment. . . . Landscape functions as a medium for communication."[42]

Unlike many of the fine-art images produced by his contemporaries, Grant preferred to capture straight images without substantial manipulation of the negative in the darkroom. Often, he would combine assignments by taking several landscape photographs, followed by shots from the same locations that included people for context, perspective, and scale. There is a whimsical *Where's Waldo?* quality to many of Grant's images, in which he appeared to invite the viewer to find individuals who are dwarfed by or nearly hidden within the natural landscape. Grant may have been adapting a convention long used by artists of including people in miniature as a way of expressing the grandeur of the natural landscape. Three nineteenth-century American landscape masters who frequently used this technique to great effect in their paintings were Albert Bierstadt, Thomas Cole, and Thomas Moran (who had accompanied photographer William Henry Jackson on Ferdinand Hayden's expedition to Yellowstone in 1871, which led to the area's establishment as the first national park the following year). Excellent examples of Grant's skill in using this convention include a 1932 image of visitors enjoying a vista of Mount Rainier, a 1933 photograph of enrollees in the Civilian Conservation Corps (CCC) on the banks of Jackson Lake in the Grand Tetons, and a 1941 picture of tourists at Lava Beds National Monument.

A New Deal and a Golden Age for the Parks

Shortly after Grant's return to Washington, D.C., New York governor Franklin D. Roosevelt won election to the presidency, ushering in his New Deal for the American

people. Within months the administration had created a number of new government agencies and implemented multiple initiatives in a concerted effort to reverse the economic decline and accelerate the nation's recovery from the Great Depression. For the National Park Service, the New Deal would bring both profound changes and challenges.

As with the Hoover election in 1928, Horace Albright and other senior park service officials were prepared to submit their resignations if that was the wish of the new administration. In their book, *Administrative History: Expansion of the National Park Service in the 1930s*, Harlan D. Unrau and G. Frank Williss wrote of this situation, "From the beginning the Service had stood above partisan politics. Despite the fact that he diligently sought to preserve that tradition, Horace Albright had become identified closely enough with the Hoover administration that he harbored some concern that he would be replaced by the incoming administration. . . . Harold L. Ickes, President Roosevelt's choice for Secretary of the Interior, asked Albright to stay on. . . . Within a short time, Albright would emerge as a close and influential advisor to the irascible Secretary of the Interior."[43]

In his memoir, *My Trips with Harold Ickes: Reminiscences of a Preservation Pioneer*, Albright recalled those first meetings with the new interior secretary: "Mr. Ickes was a Republican member of the Illinois state legislature, so the secretary was lonely and began asking me to join him in off-duty hours. We spent a great deal of time together. This gave me the chance to get to know him well and to promote my philosophy on conservation and preservation, not only for the National Park Service and other bureaus in his department, but well beyond this area."[44] Through his cordial relationship with Ickes, the director successfully secured the secretary's endorsement for a proposal that had long interested him—the transfer of many national monuments from the Department of Agriculture and of national battlefields and military parks from the War Department to the National Park Service (a plan already endorsed by Secretary of War George Dern). All that remained was President Roosevelt's assent for the plan to move forward.

Albright's opportunity came on April 9, 1933, with an invitation to join the president's party for a visit to former president Hoover's Rapidan River Camp retreat within the boundaries of the planned Shenandoah National Park. At the end of the afternoon, Roosevelt invited Albright to join him for the return to Washington. Albright jumped

at the chance, using the time to share with the president stories of the nearby Civil War battlefields and to urge consideration for the proposed transfer of the aforementioned sites to the park service. The president heartily agreed that this should be done and instructed Albright to submit the proposal to Lewis Douglas, his chief of staff for government reorganization activities.

Albright and other park service officials feared that their efforts might be scuttled when Roosevelt later met with Pennsylvania governor Gifford Pinchot, a longtime friend who had advised Roosevelt on forestry legislation in New York in 1912 and was a seminal influence on the president's conservation philosophy. The first chief of the U.S. Forest Service, Pinchot, considered by many as the Father of the National Forests, was a utilitarian conservationist more than a preservationist. He held contrarian views of the national parks, believing that only a few true national parks were warranted and that these should be managed by the forest service under the Department of Agriculture, a position perceived by both Stephen Mather and Horace Albright as a direct threat to the survival of the National Park Service.

It is possible that this meeting was Pinchot's last attempt to persuade the president to take this approach. Whatever was said in their discussions, Roosevelt chose to proceed with Albright's plan, and on June 10, 1933, he signed Executive Order 6166, which included the following statement: "All functions of administration of public buildings, reservations, national parks, national monuments, and national cemeteries (with some exceptions) are consolidated in an Office of National Parks, Buildings, and Reservations in the Department of the Interior."[45]

With a stroke of a pen, President Franklin D. Roosevelt nearly doubled the size of the National Park Service. Of the impact of the order, Unrau and Williss wrote, "it is clear that no event in NPS history, save passage of the enabling act itself, had a more profound impact on the National Park System and the bureau that administers it. In terms of size alone, the number of units more than doubled—sixty-seven to 137. The number of natural areas increased from forty-seven to fifty-eight while the number of historical areas nearly quadrupled, increasing from twenty to seventy-seven."[46]

Director Horace Albright got not only what he requested but much more. In his 1971 book, *Origins of National Park Service Administration of Historic Sites*, Albright

George Grant and the Civilian Conservation Corps

Beginning in the summer of 1933, George would be called on to chronicle the substantial work in several of the national parks by enrollees of one of President Roosevelt's most popular New Deal programs, the Civilian Conservation Corps (CCC). Over its nine-year existence the CCC would employ more than three million men, mostly young workers from impoverished families but also unemployed World War I veterans and Native Americans, who would make tremendous contributions to the restoration of America's natural and cultural resources. Nearly a quarter of their projects would be within the national parks and fledgling state park systems, where men carried out reforestation, trail building, fire protection, campground development, facilities construction, historic site restorations, and myriad other projects.

To provide consistency in the quality and construction of thousands of park features, from cabins and picnic shelters to water fountains and comfort stations, the National Park Service utilized CCC funding to produce a series of architectural design and plan books for use by engineers, landscape architects and work supervisors. The three-volume 1938 edition, *Park and Recreation Structures*, features hundreds of schematics, floor plans, and photographs of structures in both state and national parks. Although the images in the book were not credited, it is likely that a number of the national parks pictures were taken by George Grant.

Through increased financial appropriations and CCC labor, many national parks that had been faced with drastic budget cuts would have the resources needed to undertake long anticipated projects, while states would have the impetus to develop systems of state parks for the use and enjoyment of all their citizens. From scenes of camp life to images of men hard at work, George Grant would often document their efforts in the national parks, monuments, and historic sites.

CCC workers clearing debris from the Jackson Lake area, Grand Teton National Park (1933, NPSHPC).

wrote, "The order of June 10, 1933, did at least three very important things for the Department of the Interior and its National Park Service:

1. It made the Department and the Service the Federal agency charged with administration of historic and archeological sites and structures throughout the United States.
2. It expanded their influence in most states of the Union. Prior to the Order, this had been limited largely to a few states in the west.
3. It effectively made the Park Service a very strong agency with such a distinctive and independent field of service as to end its possible eligibility for merger or consolidation with another bureau."[47]

For George Grant, the changes meant that he would be spending more time in the field, both in the West and in the East, capturing needed images of many of the new park-service units.

With his position and that of his superiors secured, Grant was asked to produce official portraits of senior park-service officials in their Washington offices. In an August 1933 letter to a friend, Horace Albright wrote of his flattering image: "From time to time as I have been on field trips, or as our executives have been here in Washington, I have had requests for autographed photographs. For years, I have tried to obtain satisfactory pictures, but I have never had one taken that satisfied my family. It remained for our own photographer, George Grant, to do what is regarded by all the Washington Office as a successful job in making an acceptable photograph" (see photograph 123).[48]

On the Road Again

In late spring of 1933 George again packed the "Hearse" with necessary gear and supplies for the long drive west. His first destination, in late May, was Rocky Mountain National Park in Colorado to photograph new CCC recruits at work, including one showing men clearing heavy snow from high-elevation roadways. Grant moved on to

CCC workers clearing snow from a high-elevation roadway, Rocky Mountain National Park (1933, NPSHPC).

Montana for images of Devils Tower National Monument and Little Bighorn National Cemetery, site of the 1876 defeat of Gen. George A. Custer and the troopers of the Seventh Cavalry by Sioux warriors (the site would become a national monument in 1946). He continued to Glacier National Park, where, on July 15, he photographed the dedication ceremonies marking the grand opening of the Going-to-the-Sun Road. Grant's photographs captured the excitement of the sun-drenched crowd of more than four thousand, who filled roadsides and parking lots near Logan Pass, the road's highest point, to hear Montana governor Frank H. Cooney proclaim, "There is no highway which will give the sightseer, the lover of grandeur of the Creator's handiwork, more thrills, more genuine satisfaction deep in his being, than will a trip over this road."[49] Among the most notable participants in the ceremonies were Native American representatives from the Blackfoot, Kootenai, and Flathead tribes, who passed the peace pipe and posed for George's camera.

In Yellowstone Grant documented CCC projects, produced landscape images, and photographed tourists, among them North Dakota senator Gerald P. Nye and his family, enjoying a summer in the park. While there, George had his picture taken, astride a horse near Old Faithful, in preparation for a journey into the backcountry. The image clearly shows the grinning photographer, eager for adventure, with a smaller 120 roll film camera (easier to transport on horseback than his bulkier 5 × 7 field camera), tripod, and other gear that he would need to capture images in the remote areas of the park. During his visit to nearby Grand Teton National Park, Grant photographed CCC workers clearing tons of storm-downed and dead wood from the banks of Jackson Lake. He also met and photographed engineer William O. Owen, who had surveyed the Wyoming Territory in the 1890s and, in 1898, organized the first ascent of the Grand Teton, dubbed the American Matterhorn. Nearby Mount Owen, the second highest peak in the Tetons, was later named in his honor. Grant finished the summer with brief visits to Sequoia National Park and Muir Woods National Monument in California before making the long journey back to Washington.

On August 10, 1933, Horace Albright, George Grant's mentor and supporter for more than a decade, resigned as director of the National Park Service to enter private business. His longtime associate, Arno B. Cammerer, was named as his successor despite a lack of support from Secretary Ickes, who had unsuccessfully offered the post to Newton Drury, the executive secretary of California's Save the Redwoods League. Ickes and Cammerer suffered a strained working relationship throughout the director's tenure, driven in large part by Ickes's progressive views on civil rights and integration—he had once served as president of the Chicago chapter of the National Association for the Advancement of Colored People. Ickes criticized Cammerer's perceived caution in the recruitment of African Americans into the CCC and on the integration of the national parks. There is no evidence that Cammerer was himself prejudiced, and his lack of action may have possibly been due to fears of backlash by southern political leaders on whom President Roosevelt relied to pass New Deal legislation. Despite these difficulties, Cammerer was well suited to implement the many changes brought about by the 1933 expansion, to coordinate the ongoing work of the CCC, and to further the mission of the National Park Service.

George Grant in Yellowstone, preparing to embark on a backcountry photography trip (1933, NPSHPC).

For George Grant, Cammerer had been a staunch ally. An accomplished photographer who had advocated for the creation of a photography position within the park service, Cammerer had supported Grant's appointment in 1929. Under his leadership, George would be busier than ever before. By 1940 Cammerer's health had declined under the relentless strain, and, without his prior knowledge; Ickes again offered the directorship of the park service to Drury, who accepted it. Soon after, Cammerer agreed to step down to serve as Eastern Region director in Richmond, Virginia, where he worked until shortly before his death in 1941.

Promoting the Parks in Stamps and Pictures

In 1925 Director Stephen Mather first advocated the production of postage stamps to promote the national parks. While officials from the Department of the Interior and post office agreed that this would be worthwhile, no action was taken. Then, in early 1933, Floyd Merrill, editor of the *Greely Tribune Republican* (Colorado) posed the question, "While the seaboard flocks to Europe on vacations, Uncle Sam misses a great opportunity by not issuing series of pictorials on the National Parks. It would be Federal advertising paid for many times over by philatelists."[50] Soon afterward, Interior Secretary Ickes approached Postmaster General James Farley about producing national parks stamps. Farley replied that stamp designs for the year had already been adopted, but it might be possible to undertake the project sometime in the future. Not to be dissuaded, Ickes declared 1934 to be "National Parks Year" and continued to press Farley to have stamps designed to commemorate the event. According to Max Johl, author of *The United States Commemorative Stamps of the Twentieth Century*, "It is reported that Secretary Ickes took up the subject of a National Park series of stamps with President Franklin D. Roosevelt [himself an avid stamp collector] and Postmaster General Farley at the weekly cabinet meeting on March 9th. . . . It was later reported that at a conference held at the Department of the Interior on March 29th, an agreement had been reached."[51]

On May 16, 1934, the post office announced the authorization of a series of ten stamps, from one-cent to ten-cent values, celebrating National Parks Year. Director Cammerer asked George Grant to oversee the selection of the photographs to be adapted for use as stamps by artists from the post office and the federal Bureau of Engraving and Printing. It is unknown how many images Grant examined before selecting the finalists, but those chosen were iconic depictions of the parks. Of the ten selections, two were by highly regarded photographer Ansel Adams (Yosemite and Yellowstone), three were chosen from commercial collections (Mount Rainier, Great Smoky Mountains, and Acadia), and five were by Grant (Grand Canyon, Mesa Verde, Crater Lake, Zion, and Glacier). In his 1962 interview with Evison, Grant recalled the challenge of choosing the images: "We had an awful time making those selections. We even reduced those things, by copying down to stamp size. Secretary Ickes was quite interested in it at the time. . . . He was a stamp collector also."[52]

One-cent postage stamp featuring El Capitan, based on a photograph by Ansel Adams (1934, U.S. Postal Service).

The first stamp, Adams's image depicting El Capitan in Yosemite, was released on July 16, and before the day was out more than 250,000 were purchased and 26,000 covers cancelled inside the park, with many thousands more stamps sold across the country. Sales of subsequent stamps, issued between July 30 and October 2, 1934, were also very successful. The series was reproduced several times and eventually millions were sold, becoming one of the most prized stamp sets ever produced by the post office (see photograph 147).

Creation of the stamps was only one part of a concerted effort by the Roosevelt administration to utilize multiple media resources to encourage all Americans to visit their parks. Articles and advertisements published in newspapers and magazines promoted national and state parks, national forests, and historic sites as "a combination of the best fun and relaxation for the family and a display of patriotism during an economic crisis."[53] Grant's images were sometimes featured in such works. One especially notable example was a pictorial article, "Western National Parks Invite America Out of Doors," featuring thirteen of Grant's images, which appeared in the July 1934 issue of *National Geographic* magazine. In May 1936 *National Geographic* published a lengthy article, "Utah, Carved by Winds and Waters," which also included images by Grant

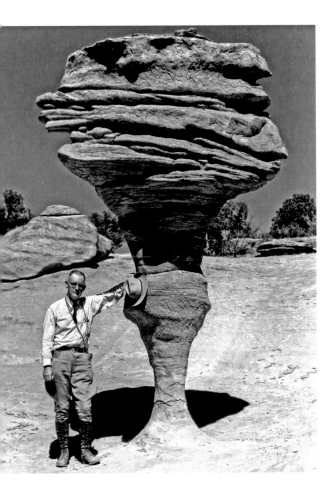

George Grant beside a rock formation at Natural Bridges National Monument. Photograph by Grant's assistant, Zeke Johnson (1934, NPSHPC).

as well as a rare published photograph, taken by assistant Zeke Johnson, of George standing by a rock formation in Natural Bridges National Monument.[54]

In a nation still in the throes of the Great Depression, the Roosevelt administration and the National Park Service—through these articles featuring work by Grant and others—sought to transform the image of parks from remote retreats only for the wealthy with the means and time to visit them to essential components of the nation's patrimony that rightfully belonged to every citizen. Thomas Patin, the editor of *Observation Points*, noted that parks "stand for a seemingly untouched natural world, that act as sites of national identity."[55]

Destinations New and Old

The impact of the 1933 expansion of the National Park Service was reflected in a number of new destinations among Grant's travel assignments for 1934. In late April George made the short drive from Washington to Colonial National Monument, which had been established in 1930 (it would be designated a national historical park in 1936), to photograph notable sites at the Jamestown settlement and in nearby Yorktown. From there he traveled to Petersburg and Fredericksburg National Military Parks and to other Civil War battlefields in Virginia that had been included in the transfer from the War Department the previous year. (According to National Park Service archivists, over the next few years Grant would travel to many of the historic battlefields across the east to photograph the landscapes and monuments; however, most of these images have, over time, been lost.)[56]

By June 1934 George was back for a third summer of photography in Glacier National Park. From there he continued northwest for his first visit to Washington's Olympic Peninsula to photograph the dramatic mountains and lush rainforests within Olympus National Monument. Grant's pastoral images of the rugged, snow-capped mountains and blue lakes stood in stark contrast to nearby clear-cut areas that had been heavily logged for the valuable forests of

hemlock, Douglas fir, and spruce. The area had been embroiled in a contentious twenty-five-year battle waged between the forest service and the park service over the future of this magnificent landscape and its vast timber resources. Since 1909, when President Theodore Roosevelt had set aside 615,000 acres as Olympus National Monument, every effort to make the site a national park had failed due to the powerful influences of the timber industry and the forest service. While Grant's assignment logs have been lost, it is likely that his task in the Olympics in 1934, and again during a return visit in 1936, was to produce evocative images to provide visual documentation for park service efforts to enlist public support for creation of an Olympic National Park. In 1937 President Franklin Roosevelt journeyed to the area to see the ground for himself. During a speech in Port Angeles at the conclusion of his visit, he declared, "I think you can count on my help in getting the national park."[57] A year later Congress finally passed legislation creating Olympic National Park. Possibly, Grant's images played an important part in this decision.

Next, George traveled south for a first visit to Lassen Volcanic National Park, the site of a violent volcanic eruption only two decades before, in northern California. Grant captured images of tourists exploring the park's thermally active areas, and he posed models enjoying mountain lakes beneath simmering Mount Lassen's denuded slopes. From late August to October George was back in the Southwest, an area that was becoming his favorite, to photograph at Casa Grande, Aztec Ruins, Tumacácori, El Morro (where he documented more than three centuries of inscriptions carved into the rock face by travelers), Chaco Culture, and Petrified Forest National Monuments. He also made inaugural visits to Canyon de Chelly, Bandelier, and White Sands National Monuments, before traveling to New Mexico for photography within the depths of Carlsbad Caverns National Park. This would be his first endeavor to meet the challenges of photography in the depths of a cave, and the experience would be valuable for future assignments at Mammoth Cave, Wind Cave, and Oregon Caves. In addition to photographing landscapes and historic sites on this trip, George produced portraits of notable individuals, including Jim White, discoverer of Carlsbad Caverns, and George Coe, a pioneer rancher from New Mexico who rode with Billy the Kid during the Lincoln County War in 1878.

In December Grant concluded the year's extensive travels by accompanying a park-service team surveying the route for a proposed Natchez Trace Parkway to follow the trail of the historic trading path from southwestern Mississippi to central Tennessee. As part of the journey, he visited Louisiana to photograph the Chalmette Battlefield and National Cemetery, site of Gen. Andrew Jackson's victory over the British in the 1815 Battle of New Orleans (now part of Jean Lafitte National Historical Park and Preserve); and to Vicksburg National Military Park, where he documented CCC enrollees restoring the grounds of this pivotal Civil War battlefield. In January 1935 George traveled to Kentucky to photograph within and around Mammoth Cave. Like the Great Smoky Mountains, Mammoth Cave, authorized by Congress in 1926, would be established as a national park only after privately owned land was acquired and visitor facilities developed. Much of this work would be completed with CCC labor, and the park would open in 1941.

Back in Washington for winter work, Grant had the opportunity to meet and photograph pioneer landscape photographer William Henry Jackson. The ninety-two-year-old Jackson was a Civil War veteran who had accompanied the Ferdinand Hayden expedition to explore the Yellowstone region in 1870 and 1871. His remarkable images of the area, along with paintings by Thomas Moran, were instrumental in Congress's decision to establish Yellowstone as the world's first national park the following year.

Missions in Mexico

Following a full schedule of travel in the summer of 1935 to western and southwestern parks, Grant joined a National Park Service survey expedition in October to record historical and structural information about several seventeenth-century Spanish missions in northern Mexico and to produce detailed photographs of each site. The team's objective was to document these missions to gather needed information for ongoing preservation work at southern Arizona's Tumacácori Mission National Monument (now Historical Park) and for construction of an architecturally appropriate visitor

center. Writing in *The Missions of Northern Sonora: A 1935 Field Documentation*, historian Buford Pickens summarized the project's goals: "the National Park Service . . . having urgent need for firsthand architectural data in planning the new buildings for Tumacácori National Monument in Arizona, arranged to send an expedition of professional experts to record the remains of twelve missions from the 'Kino circuit' in northern Sonora. These are missions established by the Jesuit missionary Eusebio Kino in the late seventeenth and early eighteenth centuries."[58]

With $7,000 in funding for the Tumacácori Mission Restoration Project, the expedition team assembled in Tucson, Arizona, in early October 1935. Led by architect Scofield DeLong, the group included architect Leffler B. Miller, archaeologist Arthur Woodward, engineer J. Howard Tovrea, naturalist Robert Rose, and Grant. Traveling in George's panel truck and one other vehicle, the men crossed the border into Mexico on October 12 during a period of violent civil unrest and federal government

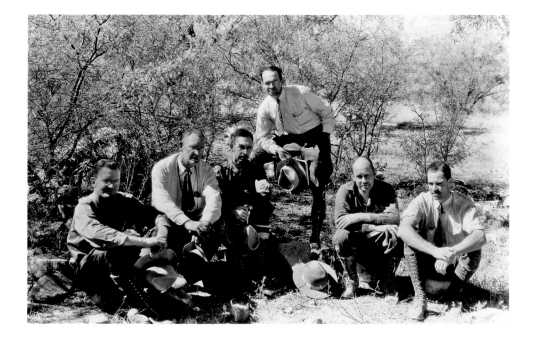

Members of the Sonora Missions Expedition. *Left to right*: Robert Rose, George Grant, Leffler Miller, J. Howard Tovrea, Arthur Woodward, and Scofield DeLong (1935, NPSHPC).

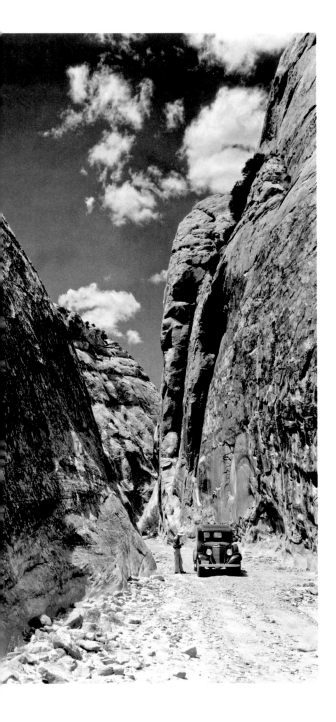

suppression of the influential Roman Catholic Church. On the day after the team's arrival in Hermosillo, the Sonora capital, the *presidente* and chief of police of the nearby city of Santa Ana were both murdered. Despite these incidents and the imposition of martial law, the park-service team, with support from Mexican soldiers, was able to travel to its destinations and carry out project work without undue delays.

Over the course of two weeks, the men visited twelve mission sites. Some structures were in relatively good repair, while others were collapsed ruins. In those churches still intact, many of the valuable objects had been removed from the sanctuaries for safekeeping during the period of unrest. While the architects and archaeologists conducted basic excavations and took field measurements, Grant produced more than three hundred images, which would be invaluable contributions to the project. Despite the challenges and limited time available, the team was very successful in accomplishing its objectives, both in documenting historically significant and threatened sites and providing the information needed for construction of the facilities at Tumacácori.

On his return from the trip to Mexico, Grant spent much of the fall and early winter in his laboratory in Washington, D.C., processing images from the expedition. Some would be used to illustrate the first two of the team's three reports, focusing on site archaeology and architecture. The third was composed largely of Grant's visual documentation of the sites and structures that could then be applied toward the restoration and construction project. In addition to the work in Sonora, over the next few years George would expand this portfolio of photographs of Spanish-era missions with images of other historic mission structures in Texas, Arizona, and California.

While most of Grant's images in the parks and on the Sonora expedition focused solely on natural landscapes and historic structures, a few photographs from that season were among the first to include images of the Hearse—the specially outfitted panel truck he relied on to carry camera equipment and camping gear to remote areas. The black vehicle, sometimes dubbed the Black Maria, also doubled as a rolling darkroom,

The Hearse, in the Narrows of Capitol Wash Road between Fruita and Notom, Utah (1935, NPSHPC).

where Grant spent countless evenings mixing chemicals and processing film sheets from each day's shoot, before loading unexposed film into holders for the next day's work with his preferred 5 × 7 field camera. These cramped quarters precluded the use of an enlarger, so if prints were needed immediately, he would take additional time to produce direct contact prints from the negatives. In the 1962 interview Herbert Evison asked George if he had some rough times in getting needed pictures. Grant responded with candor, "Oh, yes, it's quite a—in fact it sometimes worked the other way and I was glad when it rained and I couldn't get any. I got tired of it, it got kind of stale once in a while. . . . You need a little respite. Darned near every night I had to change films in some darned make-shift place, because my holders would all have exposed film and I would have to reload them, and keep track of them, too."[59]

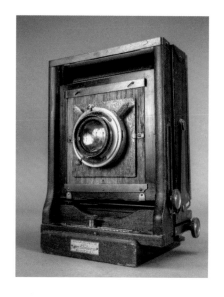

Agfa 5 × 7 field camera and lens. This model is similar to the equipment used by George Grant (2014, NPSHPC).

Big Bend, the Badlands, and Beyond

In 1933 the Big Bend region along the Rio Grande River in southwestern Texas had been set aside as Texas Canyons (later Big Bend) State Park, but there was much interest by local rancher Everett Townsend, who first visited the rugged Chisos Mountains in 1894, in its designation as a national park. Townsend used his contacts in Washington to secure several CCC companies to develop roads, trails, and facilities, but the state legislature did not approve funds to purchase additional lands for the proposed national park. Undaunted, Townsend urged consideration by both the U.S. and Mexican governments for creation of an international park spanning the border, much like Waterton Lakes and Glacier National Parks on the border between the United States and Canada. After much discussion, a team of park service and Mexican government officials visited the area in February 1936 and concluded that an international park was a possibility.

Tragically, expedition team leader and longtime park-service field director Roger Toll, who had succeeded Albright as superintendent of Yellowstone National Park, was killed, along with naturalist George Wright, in an Arizona automobile accident on their return from the trip, putting plans for the park in jeopardy. In an effort to sustain

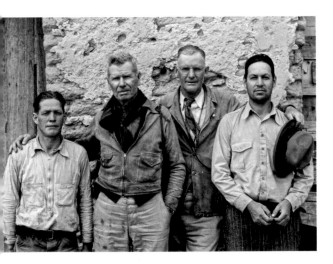

Big Bend photographic team and local guides.
Left to right: Jaime Vela, Everett Townsend,
George Grant, and Luis Urbi (1936, NPSHPC).

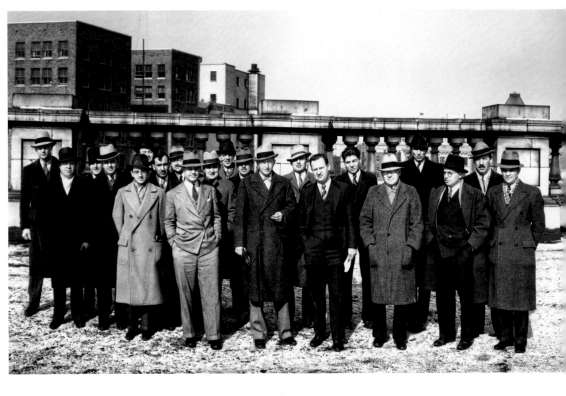

Conrad Wirth with personnel from the State Parks Division of the CCC.
Wirth is pictured in the front row, center, without a hat; to his right is Herbert Evison
and to his left are Lawrence C. Merriam and Herbert Maier (1936, NPSHPC).

interest in the plan, Herbert Maier, a park-service architect and assistant regional director, instructed George Grant to travel to Big Bend in early March to capture images of the area that could be used to promote the proposed national park during the upcoming Texas Centennial Exposition in Dallas. In a telegram to Maier after his arrival, Grant described "the Big Bend country to be as big as Yellowstone [National Park] and even more varied," concluding that "I think this Big Bend project is the most important thing that we [the park service] have on the docket at the present time."[60] While this effort did not succeed, the Texas legislature did finally appropriate funds for the park in 1943, and Big Bend National Park became a reality the following year.

Following his return to Washington, D.C., Grant took a group portrait of officials from the Branch of Planning and State Cooperation, the office within the National Park Service responsible for selection, coordination, and oversight of CCC work projects in state parks across the country. An essential role of this group was to bring the principles and practices employed in landscape and facilities designs within the park service to the growing state parks systems. Included in this group was division director Conrad L. Wirth, who would go on to serve as director of the National Park Service from 1951 to 1964, and landscape architect Herbert Evison, one of Grant's closest friends in the service.

In the spring of 1936, all NPS photographic activities were consolidated under a Division of Motion Pictures, and Ellsworth C. Dent became George's new boss. In a memo dated June 3, 1936, to Acting Associate Director Hillary Tolson, Dent noted that "Mr. Grant will be largely responsible for determining his itinerary, as well as the other field cameramen."[61] Prior to the 1936 field season, Grant tackled assignments at George Washington Birthplace and Shenandoah National Park. In July, he traveled west for extended visits to Badlands National Monument (designated a national park in 1939), Wind Cave National Park, and Jewel Cave National Monument in South Dakota; he also took time to produce a few images of the still-incomplete carving on the face of Mount Rushmore. From there he headed to Oregon Caves National Monument, followed by a return to the Olympic Mountains of Washington. In his 1962 interview with Evison, Grant recalled his experiences traveling through that rugged backcountry by horse, especially during a visit when he was accompanied by park-service editor-in-chief Isabelle H. Story: "The worst place I've ever had the use of horses was up in the Olympics. The damn wasps, you know . . . they just raised hell up there; they would drive the horses frantic. Miss Story was hurt on one one time because of that; she broke her leg . . . on account of one of the horses throwing her. Oh, that's a nasty place to ride horseback."[62]

In early autumn Grant traveled to California for work in Sequoia National Park and Joshua Tree National Monument (designated a national park in 1994), before journeying eastward to New Mexico's White Sands National Monument. He concluded his western journey with visits to Arches and Natural Bridges National Monuments in

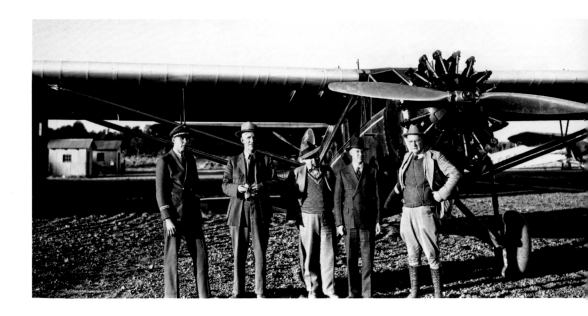

George Grant and other park-service officials at the Grand Canyon Airport (1936, NPSHPC).

Utah. Images of the former were made from an airplane, possibly the first known aerial views of a park taken by Grant.

Awards and Eastern Destinations

George Grant rarely sought public accolades for his work. He did, however, submit an image to the New York Explorers Club's inaugural photography competition held on May 25, 1937. His caption for the photograph from Death Valley National Monument (now National Park) was "Sand Dunes near Stove Pipe Wells." It was awarded first prize from nearly three hundred entries (see photograph 22), demonstrating that Grant had the skill and artistry to produce fine-art images. Interestingly, during the same event, William Henry Jackson exhibited prints from his travels to Yellowstone, the Grand Tetons, and the Rocky Mountains in the 1870s.

The focus of Grant's work shifted in 1937. In the spring he traveled more extensively than before to destinations across the east and south, documenting several of

the recent additions to the National Park Service. Among his stops were Everglades National Park, remote Fort Jefferson National Monument (designated Dry Tortugas National Park in 1992), Fort Matanzas National Monument, and Fort Marion National Monument (designated Castillo de San Marcos National Monument in 1942) in Florida, as well as the Fort Frederica and Fort Pulaski National Monuments on the Georgia coast.

Late summer found Grant at the far western end of the country, working for the first time in the Cascade Mountains of Washington State, where he spent a month with a survey team exploring an area that would not become a national park until 1968. As with the Olympics, Grant's images may have been intended to draw attention to the natural beauty of the rugged and remote mountains and valleys of the Skagit River that were, at the time, heavily impacted by extensive logging of their vast evergreen forests.

In August 1937 Grant was transferred from the park service to the photography office in the Department of the Interior's Division of Information. This change, recommended by Cammerer to Ickes, was likely intended to broaden the scope of George's assignments beyond the parks. By mid-October George was on one of those assignments in Nevada to photograph the ongoing construction of Boulder (now Hoover) Dam impounding the Colorado River to form Lake Mead (designated a national recreation area in 1964). He would return in 1939 for the dedication of the massive dam. During his long drive back east, Grant paused for a few days to take photographs of the grand bathhouses and streetscapes within Arkansas's Hot Springs National Park.

The Final Prewar Years

In the summer of 1938 George Grant returned to the Pacific Northwest to produce exceptional images of newly established Olympic National Park's extraordinary and diverse natural landscapes, from the heights of Hurricane Ridge to the lush rainforests along the Sol Duc River. From there he traveled to Crater Lake National Park and to the Fort Clatsop area (part of the Oregon Coast survey and now within Lewis and Clark National Historical Park), before steering the Hearse eastward toward Rocky

Mountain National Park in Colorado and Scotts Bluff National Monument in Nebraska. At the conclusion of both the 1938 and 1939 seasons, George left the Hearse at the Santa Fe headquarters and boarded a train back to Washington. The heavily used vehicle would undergo a complete overhaul prior to another summer of hard use the following year.

For the 1939 and 1940 travel seasons, Grant continued work at Boulder Dam and returned to both familiar and new destinations in the West and Southwest. A few photographs from 1940 are especially notable for demonstrating his versatility in depicting more than landscapes. On July 17, 1940, he composed a whimsical photograph in Sequoia National Park, showing an automobile traveling through a tunnel carved in the massive trunk of a downed sequoia tree (see photograph 105). Another, taken in the Southwest, portrays two individuals apparently dwarfed by the rugged natural beauty of the massive dunes in New Mexico's White Sands National Monument (see photograph 107).

War Years

A few of Grant's images from the summer of 1941 portray Americans, finally recovering from the decade of the Great Depression and enjoying the national parks in increasing numbers. One photograph depicts a family happily car-camping beneath towering evergreens at Mount Rainier, while another captures a group on a ranger-led hike above Crater Lake. Seen today, these are glimpses of a soon-to-be-lost era of relative innocence, coming only months before the Japanese attack on Pearl Harbor and the country's entry into World War II.

In 1940 park-service director Arno Cammerer stepped down and was succeeded by Newton Drury. The former executive secretary of the Save the Redwoods League in California had no prior administrative experience in the park service but would steward the agency during the difficult period of World War II. As the government mobilized for war, the service returned to near-subsistence budgets, similar to those from the early days of the Depression. In August 1942 the Department of the Interior, including the

National Park Service headquarters, relocated from Washington to Chicago to free up space in the department's massive building for vital defense agencies.

George Grant's role within the park service during this time remains something of a mystery. He was too old for military service, and there is no evidence that he moved to Chicago with other headquarters staff. Agency archives contain only a small number of his wartime images, including a few from eastern national battlefield sites such as Manassas, Fredericksburg, and Gettysburg and one taken in 1943, possibly from the top of the Washington Monument, featuring a panoramic view of the National Mall filled with temporary wartime office buildings.

It is conjectured by National Park Service archives staff that Grant's travel was dramatically curtailed by the austerity budgets, gasoline rationing, and lack of film and other supplies that were more urgently needed for the war effort. It is possible that he may have spent time carrying out such routine tasks as cataloging prints and negatives, tackling photographic or darkroom projects for other agencies, and even taking pictures of individuals for government identification cards.[63] He may have also found time to submit a few of his images to photography competitions. One document in the park-service collection is an excerpt from the 1943 *U.S. Camera* photography annual, featuring two images by Grant among the more than a hundred photographs selected by editor and noted photographer Edward Steichen (who would later become director of photography at New York's Museum of Modern Art).[64]

Other landscape photographers also struggled with wartime rationing and restrictions. Ansel Adams, commissioned in June 1941 by Secretary Ickes to produce a series of large mural images of the national parks, saw the project come to a halt in 1942 (it would not go on display until the 1960s). To make ends meet, Adams oversaw military darkroom and laboratory work, photographed Japanese American internees at California's Manzanar Relocation Center, and produced images for the government of military personnel on leave visiting the national parks.

Perhaps among Grant's peers, Steichen had the most notable wartime assignment, serving as director of the U.S. Navy's Photographic Unit (a role similar to one he held for the Army Air Service in World War I). Commissioned a captain, Steichen and his

team of expert photographers produced powerful images of the war in the Pacific from early 1942 until the Japanese surrender in 1945.

As the war drew to a close, Americans yearned to relax and enjoy life again. For many, this meant packing their automobiles and traveling to see their national parks. In 1945 George Grant was also on the move, with a long-awaited return to the West, relocating to the park service's regional office in Santa Fe, New Mexico. For George, this early period following the war represented a new facet of his photography. With only a very few known exceptions, Grant had always preferred to photograph in black and white, but in 1946 he produced color images of Aztec Ruins National Monument in Arizona and Rainbow Bridge in Utah, with later color images taken at Glacier National Park. These photographs suggest that Grant may have chosen to shoot in color when needed for an assignment, but he had no apparent plan to abandon black-and-white photography.

After the war a new personnel security system was initiated by the government to better classify all federal employees and to confirm their loyalty to the United States as the Cold War with the Soviet Union was unfolding. As part of this program, George Grant was required to complete a Civil Service Commission application form to continue his employment with the park service. On the form completed by Grant in August 1946, he was asked to list at least three unrelated persons as references who have "definite knowledge of your qualifications and fitness for the position for which you are applying." In addition to his former supervisors at Penn State, George Grant listed two of the period's most renowned photographers: Edward Steichen of Greenwich, Connecticut, and Ansel Adams of Yosemite, California.

While the link to Steichen may be traced to the 1943 *U.S. Camera* photography annual, if not earlier, Grant's association with Ansel Adams remains elusive. His inclusion as a character reference indicates that the two men, who shared a common love for photographing the American landscape, especially the national parks, knew each other. While they were occasionally assigned projects by the same park-service officials and may have attended planning meetings together, no records could be located in the National Park Service archives or among Adams's personal papers housed in the Center for Creative Photography at the University of Arizona that directly linked the two men either professionally or personally.

Missouri River Basin Project

The Missouri River Basin (MRB) Project, authorized in 1944 and implemented in 1946, was a multibillion-dollar undertaking to provide flood control, irrigation, municipal and industrial water supplies, and recreational facilities across the more than half-million square miles in the drainage basin of the upper Missouri River in ten states: Nebraska, Montana, South Dakota, North Dakota, Wyoming, Kansas, Missouri, Colorado, Iowa, and Minnesota. Seven major dams would be constructed on the main Missouri River, and another eighty on its tributaries. Recognizing that rising waters from the river dams would lead to the irretrievable loss of important archaeological and historic sites across the region, the Bureau of Reclamation provided limited funds for the establishment of the Interagency Archeological Salvage Program, to be jointly operated by the National Park Service and the Smithsonian Institution. Through extensive fieldwork by park-service technical staff and Smithsonian archaeologists, hundreds of sites would be excavated and examined and artifacts cataloged before they would be forever lost.

In February 1948 Grant received orders from Howard W. Baker, acting regional director of the park service's Region II headquarters in Omaha, Nebraska, assigning him to serve as a photographer for the river basin project and instructing him to relocate to Estes Park, Colorado, as it would be closer to project work sites. In a March 1948 letter to John A. Whittle of Eastman Kodak, George wrote, "Please be advised of my change of address, due to transfer from the National Park Service, Santa Fe, New Mexico, to the same, Estes Park, Colorado. I am assigned to the Missouri River Basin, a territory about the size of Siberia. My headquarters and laboratory are being established here because of our more central location in this region."[65]

Two years later, as project work was concentrated in more northern sites, George was again asked to relocate during the work seasons, this time to Yellowstone National Park, where he would be closer to the field excavations. In an August 1950 memorandum to Grant, regional director Lawrence Merriam noted, "There are a number of very important projects in the MRB program in the northern part of the basin on which it is essential that we have first-class photographs." Merriam continued, suggesting that

basin work would not be Grant's only task: "Just as Superintendent Canfield has benefited from your being at Rocky Mountain to obtain pictures at Dinosaur and the other areas . . . this shift will make it possible for Superintendents Rogers and McLaughlin to obtain your assistance at Yellowstone and Grand Teton-Jackson Hole, as your work schedule permits. . . . I am sure that both Superintendents . . . will be extremely glad to have you nearby to assist them."[66]

While Grant traveled to Yellowstone and the nearby work sites, he maintained his residence in a cottage in Estes Park, returning there at the conclusion of each fieldwork season. In May 1951 George received the following notice from Harvey Benson at Region II headquarters, "An emergency situation is confronting us at the Canyon Ferry Reservoir on the Missouri River near Helena, Montana. . . . Work on clearing the reservoir area is proceeding quite rapidly and as a result several historic structures mentioned in our Recreational Reconnaissance Report of the reservoir are in jeopardy. We had hoped that it would be possible to obtain the services of an architect to obtain measured drawings of the structures but this does not now appear possible."[67] George was immediately dispatched to the work site near Helena to document structures in the area before they would be lost beneath the waters. While on-site, George was also instructed to travel the short distance to document the seventy-fifth anniversary commemoration ceremonies held on June 25, 1951, at the Little Bighorn National Monument (Custer Battlefield) east of Billings.

These assignments were purely documentary in nature, differing in purpose and photographic output needs from Grant's past projects for the park service. As a result, he requested permission to purchase a smaller Leica IIIF 35 mm camera outfit, including a flash attachment, which would be less cumbersome than his heavier and more bulky 5 × 7 field camera. The equipment was purchased and used by Grant for river basin–project work and a few other assignments over the final years of his career. During the course of his assignment to the Missouri River Basin Project, Grant produced several thousand pictures of fieldwork. Most were routine photographs of excavation sites along with technical images of objects recovered; few were personally credited to him.

Leica III 35 mm camera similar to the one used by Grant for the Missouri River Basin Project (2014, NPSHPC).

While the images Grant produced for this project did not reflect the level of artistic skill and composition of his traditional parks photographs, he nonetheless enjoyed the work. In his 1962 interview George recalled, "I did a lot of work with the Omaha boys on the Missouri River Basin Studies. That river is now just a series of lakes from Yankton on up damned near its source. I got in there to make a lot of pictures of places that are covered up with water now, all the way up. . . . Whole towns, you know, are submerged now. But it was quite interesting just on that account; it was a nice experience."[68]

From the outset, budgetary conflicts among the operating agencies, combined with the nation's involvement in the Korean War, complicated the objectives of the Interagency Archeological Salvage Program. The resources available for project work peaked at $222,600 in 1951 ($77,155 for the National Park Service) before dramatically

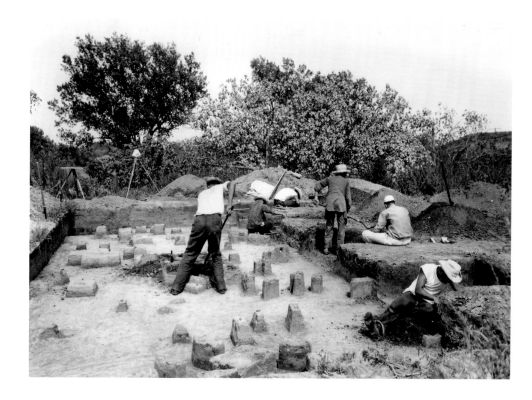

Field archaeology work as part of the Missouri River Basin Project. The location is not identified (ca. 1948–53, NPSHPC).

declining over the next few years. In his book, *Men against Time: Salvage Archaeology in the United States*, Robert Silverberg wrote of this challenging period, "The Korean War was over; but government economy drives continued to hamper the cause of salvage archeology. A government that thought in terms of billions of dollars could not manage to find $250,000 or so that the River Basin Surveys needed to finance its yearly rescue work. The discouraged archeologists, watching site after site slip from their grasp for all time, concentrated on the most immediately threatened areas."[69] As a consequence, each subsequent year fewer staff were hired or retained, and many sites were abandoned or never surveyed before being lost. By fiscal year 1954, the total project allocation was only $95,000 ($17,750 for the park service), leading to even more draconian cuts in work projects, which would have a dramatic impact on Grant and his work.

Retirement

Throughout his life George Grant preferred to live simply and quietly. Toward the end of his career, however, he became increasingly reclusive when not working. Leaving his small cabin near Estes Park, Colorado, he spent an increasing amount of time photographing in the Rocky Mountains backcountry or tucked away in his darkroom. He would occasionally make extended treks alone into the mountains, and close friends expressed growing concern about his behavior and his safety. By the early 1950s it was also becoming increasingly apparent to those who knew and worked with him that George's health was failing—possibly the consequences of years of smoking, strenuous work, exposure to harsh photographic chemicals, and perhaps alcohol use.

The end of George's National Park Service career came in a letter, dated October 13, 1954, from Region II acting director Stanley Joseph, who wrote,

> It falls to my painful lot to advise you that we have just received details concerning a limitation that may be spent for salaries out of MRB funds during the 1955 fiscal year. . . . Instructions regarding the necessary reduction in force as a result of this limitation have been received from the Washington Office, and you in turn

will shortly receive a formal notice regarding your termination due to reduction in force. . . . Your long record of service has been an enviable one and we are truly sorry that there is no way that we know of to continue the services of your photographic position either on the MRB staff or elsewhere. . . . Again, we wish to express our regret that this action has become necessary.[70]

The following day, Grant received the official notice from Joseph that his current position was being eliminated and that "there are no National Park Service positions in your competitive area occupied by employees in lower retention subgroups for which you are qualified."[71] He was instructed to immediately notify the Civil Service Commission for placement under the Separated Career Employee Program if he wished to continue federal employment.

Whether or not Grant's declining health and other issues, or the drastic budget cuts alone, contributed to this action is not known with any certainty. George's October 15 reply to Joseph's letter was both poignant and painful: "This matter I have been anticipating for some time, so that I was not surprised, or even disappointed, to receive this notice. If this work was ever to be developed into something worthwhile for the Service, thought would have been given to it years ago. From my point of view, frustration is about complete, and it is with a sense of relief that before very long I shall have to face no more of it."[72]

Despite the tone of the response, Grant assured Joseph that he would complete his assigned work. He further urged that his equipment be kept intact for use by a future photographer if one was to be employed (according to park service archivists, Grant's 5 × 7 view camera would be converted for copy-stand use before being discarded in the 1960s[73]) and that his large inventory of MRB project negatives be properly cataloged and stored. Originally kept in the archives of the Nebraska Historical Society and later sent to the Department of the Interior, most of the original images have been lost or misplaced during the subsequent sixty years since they were made.

Possibly in an effort to soften the blow, Regional Director Baker sent a request to park-service director Conrad Wirth, noting that "Mr. Grant has done some outstanding photographic work during the course of his career as a photographer. We believe

that his accomplishments in this field deserve special recognition through issuance of a Meritorious Service Award upon his retirement."[74] Director Wirth concurred and George was notified in December 1954 that he had been selected as a recipient of the award, to be presented in March 1955. The citation accompanying the award acknowledged his lasting contributions:

> The popularity and wide distribution and acceptance of his photographs are a tribute to the artistic talent and technical perfection represented in Mr. Grant's work. The work . . . has been of such high quality to serve as a major source for illustrations of official National Park Service publications. Many of his pictures have attained wide national and international recognition in leading journals, magazines, newspapers, and learned publications. Mr. Grant's photographs have been widely used by concessioners, railroads, transportation companies, and travel promotion agencies in publicity benefiting the National Park Service. Enlargements of Grant photographs now grace the walls of numerous offices of high officials of the Executive Departments of Government, and are in frequent demand for the offices of members of Congress. . . . Mr. Grant's constant enthusiasm for his work, his willingness to devote long hours and arduous efforts beyond the normal call of duty to obtain particular subjects or to meet urgent needs of the Service, and his spirit of geniality and cooperation toward his fellow workers and supervisors have added to his value as an employee of the Department and of the Service.[75]

Once his work was completed, George packed his personal belongings, closed up the cottage, and boarded an eastbound train with immediate plans to return to live in his brother's home in Snow Hill, Maryland, where he had enjoyed so many family gatherings over the years. Robert's two older daughters, Nancy and Mary, were now grown and married, but his youngest, Anne, would recall with fondness spending time with her uncle George.

It is notable that Grant's position as chief photographer remained vacant following his retirement. While other photographers continued to provide images for the park service, it was not until 1958, when Jack Boucher joined the service, that Grant had a true successor. Boucher served as a principal photographer for the National Park

United States Department of the Interior

Honor Award

George A. Grant

is hereby awarded this certificate of honor for

Meritorious Service

Given under my hand and seal this twenty-sixth day of November 1954.

Douglas McKay
Secretary of the Interior

Grant's Meritorious Service Award
certificate (1954, NPSHPC).

Service until he was appointed chief photographer for the Historic American Buildings
Survey in 1963, a position he held for more than forty years.

By 1958 Grant was yearning to return to the West. He had remained in contact with
his close friend, David Canfield, former superintendent of Rocky Mountain National
Park, who had retired to Santa Fe, New Mexico. The divorced Canfield happily
extended an invitation for George to come live with him, which was readily accepted.
Grant moved to Santa Fe, where he would live for the better part of the next six years.
With their shared love for the West, the two men spent much time traveling to favor-
ite destinations and visiting many old friends from their National Park Service days.
Entries in Grant's journals from the final two years of his life also suggest that both men
may have struggled with an addiction to alcohol.

Asked in the 1962 interview if he still took photographs, George replied with a hint of melancholy, "I don't take any at all anymore. In fact, it's beyond my financial capacity; it takes a lot of money to follow a hobby like that, you know. I turned all the stuff in, most of it, most of my field equipment."[76]

By the summer of 1964 Grant's health was rapidly worsening. During an August trip with Canfield to Rocky Mountain National Park, George fell ill with a severe respiratory ailment. The two men returned to Denver, where George's condition improved enough for him to board a train for his brother's home in Maryland. Within a few days of his arrival, Grant suffered a relapse, and he was admitted to the Veterans Administration Hospital in Baltimore, where he died on October 11, 1964.

George Grant's Legacy

On August 4, 1934, during his first visit to Glacier National Park, President Franklin D. Roosevelt gave a radio address to the nation from the park's Two Medicine Chalet. He told his listening audience, "There is nothing so American as our national parks. The scenery and wildlife are native. The fundamental idea behind parks is native. It is, in brief, that the country belongs to the people . . . for enrichment of the lives of all of us. The parks stand as the outward symbol of this great human principle."[77] It was, in many ways, for this purpose that George Grant documented the national parks—for their natural beauty, for the vestiges of wildness they preserved, and for their essential qualities as retreats for all the people.

Over the course of his twenty-five-year career with the park service, Grant visited more than a hundred parks and produced over thirty thousand images, many of which were never printed or published. Interestingly, beyond their artistic and historical significance, Grant's photographs have continued to prove valuable to National Park Service scientists and historians, who have examined selected images to ascertain the impacts on the parks from climate change and from growing human use through the three-quarters of a century or more since many were taken.

In his introduction to *Trains, Trails, and Tin Lizzies*, Montana naturalist and photographer George McFarland, who met Grant near the end of the photographer's career, summed up the enduring significance of his work: "George Grant photographed to document that the West of the imagination was not all gone; that it still existed in the national parks and environs. His pictures furthermore showed that whether one was an outdoor expert or novice there is a national park experience for everyone."[78] Taken in a broader context, these words express the historical importance of Grant's photography across the entire national park system.

Unlike contemporaries such as Ansel Adams, Edward Weston, and Eliot Porter, who perhaps enjoyed greater artistic freedom to capture images that inspired their creative imaginations, Grant worked toward the more basic goals of documenting for his employer the many different facets of the parks. From iconic images of pristine backcountry areas and photographs of everyday Americans enjoying their natural heritage to visual support for historical, architectural, or archaeological research, George tackled every assignment with technical skill and unsurpassed artistry, with little thought given to personal acclaim or recognition.

For much of the half century following his death, George Grant's photographs were largely overlooked or forgotten, while Adams, Weston, and Porter continued to produce beautiful images, and a new generation of photographers, including Philip Hyde, David Muench, John Shaw, Galen Rowell, and others, created dramatic new perspectives of the American landscape, many in vivid color.

Beginning in the 1980s Grant's work was rediscovered and featured in several books. Two of them, *Those Who Came Before: Southwestern Archeology in the National Park System* (1983) and *Early Days: Photographer George Alexander Grant and the Western National Parks* (1986), reproduced some of his exceptional images from the parks and monuments in Arizona and New Mexico. In 1987 the Glacier Natural History Association published *Trains, Trails, and Tin Lizzies*. In 1993 the University of Arizona Press released the full report of the expedition to Mexico in a single volume, *The Missions of Northern Sonora: A 1935 Field Documentation*, richly illustrated with

The Artist and the Craftsman

Given that the western national parks represented so much of both their portfolios, comparisons of the work of George Grant and Ansel Adams seem inevitable. A number of their images focus on the same subjects, occasionally from nearly the same vantage points. Both were adherents of what was described in the early twentieth century as "straight" photography, emphasizing sharpness, maximum depth of focus, and honesty in representing subjects. Both took up photography as young men, and each was transformed by his first experience in the parks, Adams at Yosemite in 1916 and Grant at Yellowstone in 1922. Yet each one's approach to the profession was built on a different foundation.

Only a few years out of high school and working in the Roycroft Community, George Grant developed the technical and artistic skills of a master craftsman, producing fine products of practical utility. Ansel Adams spent much of his youth training to become a classical pianist. Each brought these skills and perspectives to their photography. For Grant, photographs provided visual context to a more in-depth narrative of his subjects, while Adams's images were likened to visual symphonies of light and shadow—art that could stand on its own merit without further explanation.

Both Grant and Adams were at home in the parks, often traveling in their own specially outfitted vehicles in search of iconic images. Each was dedicated to mastering the artistic and technical aspects of his craft, and both kept detailed field journals denoting locations, subjects, exposure information, and so on. While Adams notebooks survive, all but two of Grant's thirty-four journals have been lost.

In his introduction to *Observation Points*, Thomas Patin describes "visual rhetoric"—of which Grant's and Adams's images would be one component—as strategic functions "used in addressing an audience in order to accomplish some kind of goal (to create emotional affect, persuade, make sense, form attitudes, induce action, build community or consensus, negotiate policies, etc.)."[1] In support of Patin's premise, the objectives of both Grant's and Adams's photographs were to have an impact on viewers' emotions and, to some extent, motivate them to action. For Grant it may have been to convey to everyday Americans that the parks were theirs to explore and enjoy, while Adams hoped that his dramatic photographs of wild places would encourage Americans to protect and preserve them for posterity.

While Adams's dramatic landscapes appeared beyond the skills of the average photographer, Grant's images of landscapes and people may have been viewed as more approachable and reproducible by park visitors armed with their own Kodak Brownies or other consumer-level cameras. If so, then George Grant's photographs may have been akin to a bridge, linking family snapshots with fine art.

Grant's love for the parks was clearly articulated through his images, yet there is no existing evidence that he was outspoken on broader environmental or preservation issues, while Adams was well known for utilizing his work in actively supporting greater protection of environments both within and beyond the parks.

Finding a tangible link between these two exceptional photographers, beyond Adams's listing as a character reference in Grant's 1946 personnel form, has proven elusive. As a result, we are left to speculate if or when the men crossed paths professionally—perhaps within the parks—and if they enjoyed viewing each other's work. It is evident that Grant admired Adams's photography, but it will likely never be known if he felt envious of Adams for the personal recognition and acclaim his images received. Perhaps George in his quiet way was satisfied that the parks they both loved so much would be the true beneficiaries of their talents and dedication.

1. Patin, *Observation Points*, xiv.

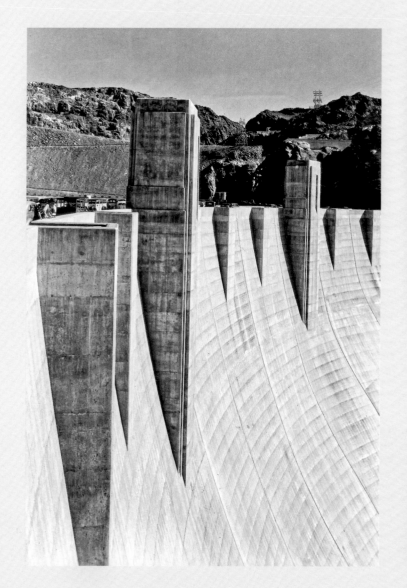

Image of Boulder Dam taken by Grant (1939, NPSHPC).

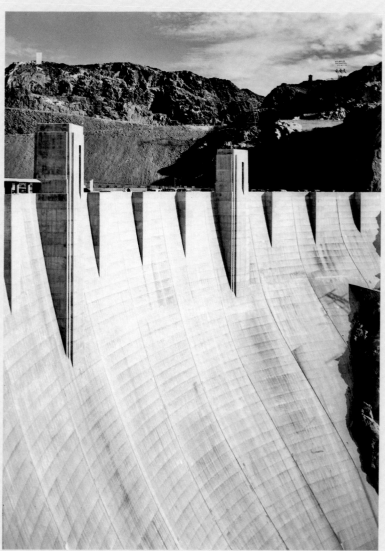

Image of Boulder Dam taken by Ansel Adams (1942, National Archives and Records Administration).

George Grant in his park-service uniform with an 8 x 10 field camera (No date, Grant family).

George's photographs. Undoubtedly, many other books—from travelogues to textbooks—have featured George Grant's exceptional photographs, often under the credit line "National Park Service."

Today George Grant is among a few selected staff photographers who have been recognized by the National Park Service as "Eminent Photographers." At the agency's centennial, Grant's images continue to serve as tangible reminders of the fragile yet exquisite natural beauty of the parks that we, as a people, have chosen to preserve for ourselves and our descendants. For this, George Grant deserves his rightful place among the finest landscape photographers that America has produced.

1. Conrad, "Geography and Some Explorers," 241.
2. *Organic Act of 1916*, 16 U.S.C. § 1, 39 Stat. 535 (1916).
3. George Grant to James McBride, January 17, 1921, National Park Service Harpers Ferry Center for Media Services Collections, Charles Town, W.Va.; hereafter cited as NPSHFC.
4. Grant to McBride, May 14, 1921, NPSHFC.
5. Samuel T. Woodring to Horace M. Albright, December 28, 1921, NPSHFC.
6. Grant to Woodring, January 3, 1922, NPSHFC.
7. Albright to Woodring, January 17, 1922, NPSHFC.
8. Albright to Secretary Albert Fall, Department of the Interior, draft, n.d., NPSHFC.
9. George Grant, interview by Herbert Evison, Santa Fe, N.Mex., December 10, 1962, reel 4, side 2, George A. Grant, NPSHFC, 5–6.
10. Grant to Albright, October 23, 1922, NPSHFC.
11. Ibid., January 12, 1923, NPSHFC.
12. Albright to Grant, October 26, 1922, NPSHFC.
13. Grant to Albright, January 12, 1923, NPSHFC.
14. Albright to Grant, January 18, 1923, NPSHFC.
15. Grant to Albright, January 20, 1923, NPSHFC.
16. Albright to Grant, January 23, 1923, NPSHFC.
17. Grant to Albright, August 27, 1923, NPSHFC.
18. Grant to Albright, May 10, 1927, NPSHFC.
19. Albright to Grant, July 2, 1927, NPSHFC.
20. Ansel Hall to Stephen Mather, November 12, 1927, NPSHFC.
21. Grant to Albright, December 15, 1927, NPSHFC.
22. Mather to Frank Kittredge, December 9, 1927, NPSHFC.
23. Hall to Albright, report, December 21, 1927, NPSHFC, 1.
24. Ibid., 2.
25. Ibid., 4.
26. Albright to Mather, December 27, 1927, NPSHFC.
27. Hall to Grant, January 3, 1928, NPSHFC.
28. Hall to Kittredge, January 27, 1928, NPSHFC.
29. Kittredge to Albright, January 27, 1928, NPSHFC.
30. Grant to Albright, September 15, 1928, NPSHFC.
31. Albright to Grant, September 21, 1928, NPSHFC.
32. Albright, "Reminiscences," 280.
33. Hall, *Educational Division Report*, 2
34. Chief, Division of Appointments, to Grant, April 8, 1929, NPSHFC.
35. Grant to Brown, August 29, 1929, NPSHFC.
36. George Grant, "Principles of Photography" (proceedings, Park Naturalist Conference, Berkeley, Calif., November 1–30, 1929), NPSHFC, 202. The complete text of Grant's presentation may be found in appendix 1.
37. George Grant, "The Production of Photographic Material for Use in the Parks" (Park Naturalist Conference), NPSHFC, 204.
38. Sawyer, *Early Days*, 10.
39. Bryant and Atwood, *Research and Education*, 57.
40. Arthur Demaray to Kittredge, memo, May 24, 1932, NPSHFC.
41. Grant, interview by Evison, 4.
42. Gareth, "Image/Text/Geography," in Patin, *Observation Points*, 143.
43. Unrau and Williss, *Administrative History*, n.p.
44. Albright, *Trips with Harold Ickes*, n.p.
45. Unrau and Williss, *Administrative History*, n.p.
46. Ibid.
47. Albright, *Origins*, n.p. The service's responsibilities were more fully implemented through the Historic Sites Act of 1935.
48. Albright to Mr. and Mrs. Edward D. Freeland, August 8, 1933, NPSHFC.
49. Frank H. Cooney, quoted in *Glacier National Park Press Kit*, n.p.
50. Floyd Merrill, quoted in Johl, *United States Commemorative Stamps*, 287–88.
51. Johl, *United States Commemorative Stamps*, 288.
52. Grant, interview by Evison, 1.
53. Young and Young, *Great Depression*, 565.
54. "Western National Parks"; Borah, "Utah."
55. Patin, "Introduction: Naturalizing Rhetoric," in Patin, *Observation Points*, xxi.
56. Media specialist Wade Myers and retired archivist Tom Durant, interview by authors, National Park Service Historic Photographic Archives, Charles Town, W.Va., August 7, 2013.
57. Franklin Roosevelt, quoted in *Bugler*, Summer 2003, 1.
58. Pickens, *Missions of Northern Sonora*, xxii.
59. Grant, interview by Evison, 3. See appendix 2 for information on the use of view cameras in the field.
60. George Grant, quoted in Welsh, *Landscape of Ghosts*, 76.
61. Ellsworth C. Dent to Hillary Tolson, memo, June 3, 1936, G. Grant RG 79, E10, 2nd ser. B259, NPS Records, National Archives, College Park, Md.
62. Grant, interview by Evison, 6–7.
63. Myers and Durant, interview by authors.
64. Steichen, *U.S. Camera, 1943*.
65. Grant to John A. Whittle, March 5, 1948, NPSHFC.

66. Lawrence Merriam to Grant, memo, August 18, 1950, NPSHFC.

67. Harvey Benson to Grant, memo, May 10, 1951, NPSHFC.

68. Grant, interview by Evison, 7–8.

69. Silverberg, *Men against Time*, 68.

70. Stanley C. Joseph to Grant, October 13, 1954, NPSHFC.

71. Joseph to Grant, October 14, 1954, NPSHFC.

72. Grant to Joseph, Region II, memo, October 15, 1954, NPSHFC.

73. Myers and Durant, interview by authors.

74. Howard W. Baker to Conrad Wirth, November 4, 1954, NPSHFC.

75. Citation for Meritorious Service Award, March 2, 1955, NPSHFC, 1–2.

76. Grant, interview by Evison, 3.

77. Roosevelt, *Public Papers and Addresses*, 358.

78. George McFarland, introd. to Glacier Natural History Association, *Trains, Trails, and Tin Lizzies*, n.p.

George Grant's Photographs

During the course of his career with the National Park Service, George Grant made thousands of photographs, as he carried out varied and often challenging assignments. Often working in remote locations and under harsh conditions, he produced needed images for park-service documents, reports, promotional materials, exhibits, and other projects. Despite many challenges, Grant's work was consistently of the highest standards in both artistic quality and composition. It is estimated that he produced more than thirty thousand images during his career, yet only a small percentage of his photographs were published. The following examples, in three broad categories—Landscapes; People and the Parks; and Portraits, Special Assignments, and Technical Images—represent some of his finest and most enduring images.

Landscapes

Capturing the essence of ruggedly beautiful landscapes and historically significant places within the nation's parks, monuments, and historic sites was a principal objective of George Grant's photography. The images in this section, from grand panoramas of majestic mountains and intimate details of southwestern deserts to ancient Native American dwellings and long-abandoned fortresses, illustrate the wide range of subjects that Grant documented during his quarter century with the park service. Many of the images evoke a sense of timelessness, depicting a natural, almost uninhabited and untrammeled landscape. Others include evidence of human activity—structures, tour groups, equestrians, hikers—to lend scale to the surroundings and a sense of engagement with nature at a defined moment in time.

People and the Parks

Grant's tenure with the park service coincided with dramatic changes in the national parks. At the outset parks were primarily remote destinations accessible only to those with the means and the time to explore them. During Grant's busiest years in the 1930s, expansion of the National Park Service brought many more units into the system, many in both the East and West that were more accessible through the benefits of improved transportation, better roads, increased ownership of automobiles, and a growing awareness of the importance of outdoor recreation for physical and emotional health. During the Great Depression, Grant was called on to capture images of Americans from every walk of life as they enjoyed camping, hiking, and touring throughout their national parks. Also, Grant visually documented Civilian Conservation Corps enrollees toiling in the parks, developing facilities for visitors that grew in numbers each succeeding year.

In keeping with his broad charge as the park service's chief photographer, these images capture the simple pleasure and, at times, wonderment of Americans as they experienced the extraordinary beauty of the national parks.

Portraits, Special Assignments, and Technical Images

By some accounts, George Grant was a quiet and introverted man who often preferred to work in the remotest corners of the parks, far from people and crowds. Yet he was often called on to produce portraits of National Park Service executives, groups, and historical figures. Additionally, he was dispatched on special assignments—from the Great Smoky Mountains and the Sonoran Desert to the farthest reaches of the Missouri River—to document proposed parks, projects, and programs. Additionally, Grant took photographs of historical artifacts, ancient petroglyphs, fossils, construction projects, and other subjects to illustrate technical and scientific reports and operations documents. The images featured in this section represent a small sample of the valuable contributions that Grant made to further the work of park-service public relations staff, planners, historians, and archaeologists.

Landscapes

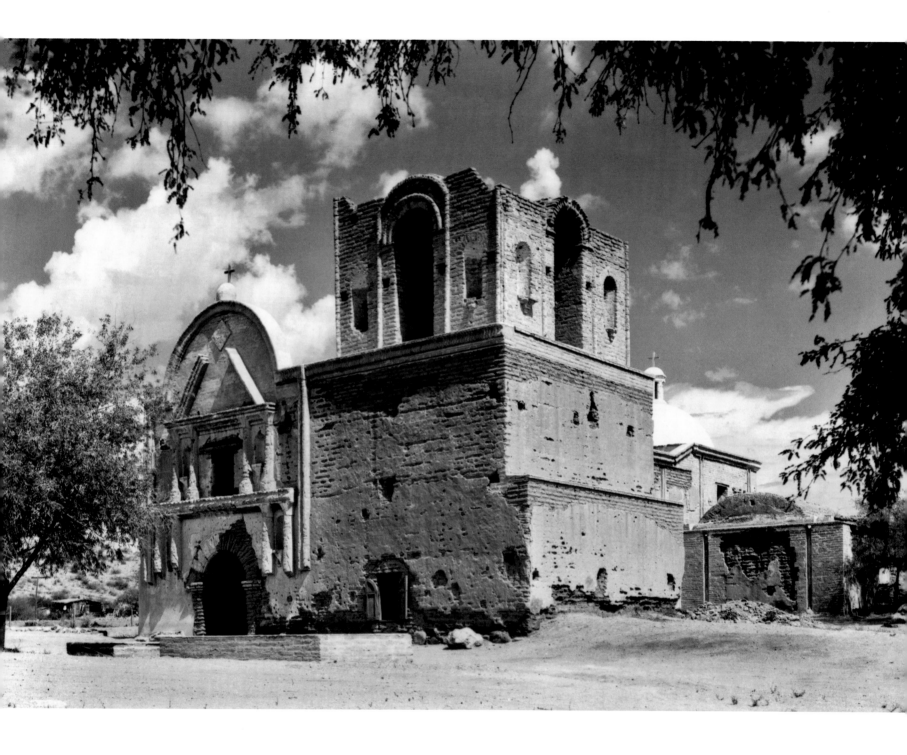

1 Ruins of the Tumacácori Mission from under a tree (July 9, 1929).

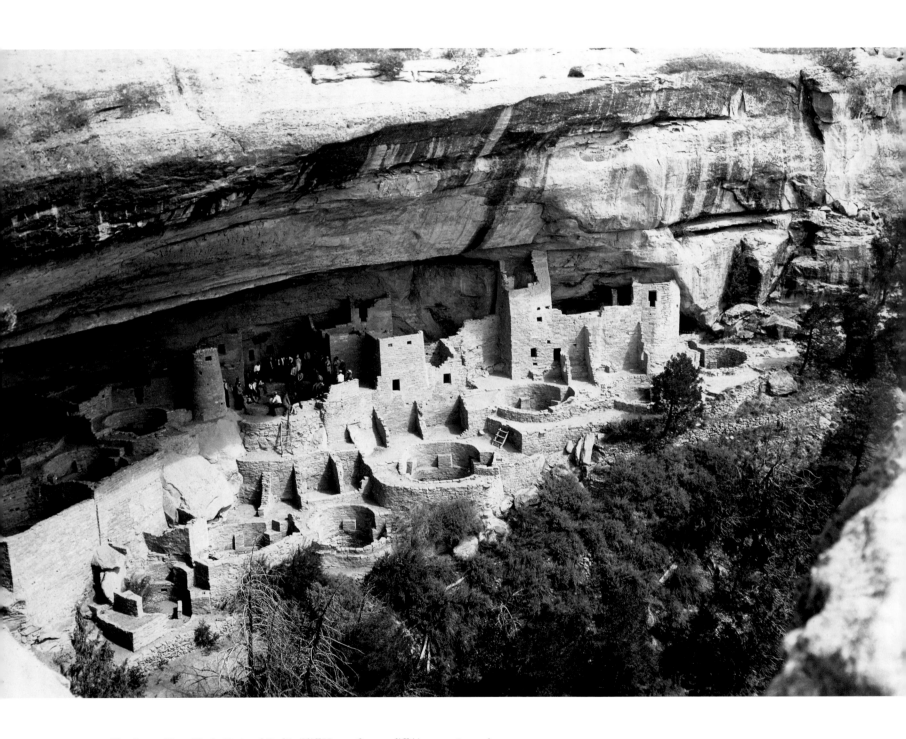

2 Tourists at Mesa Verde National Park's Cliff House from a cliff (August 16, 1929).

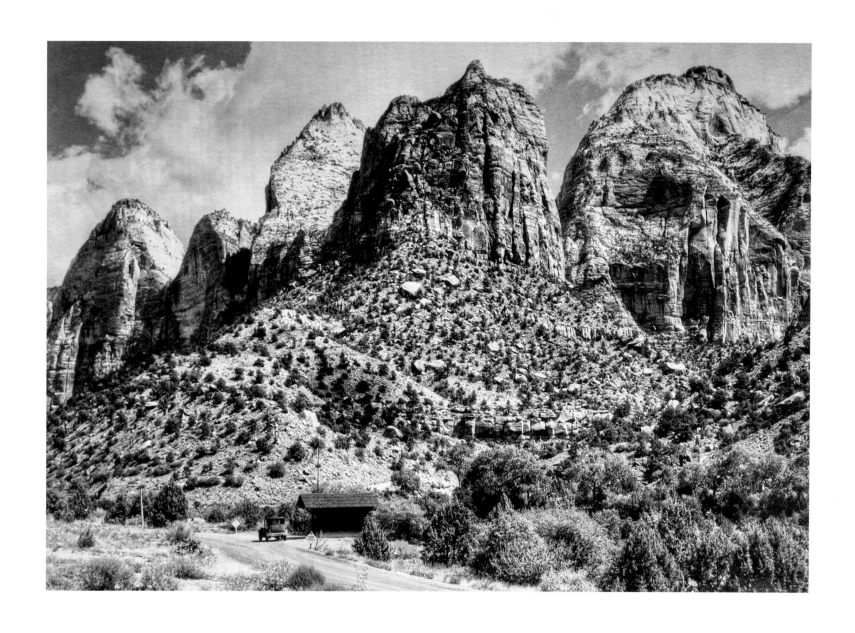

3 The Three Wise Men and the East Temple with an entrance check-in station in the foreground, Zion National Park (September 8, 1929).

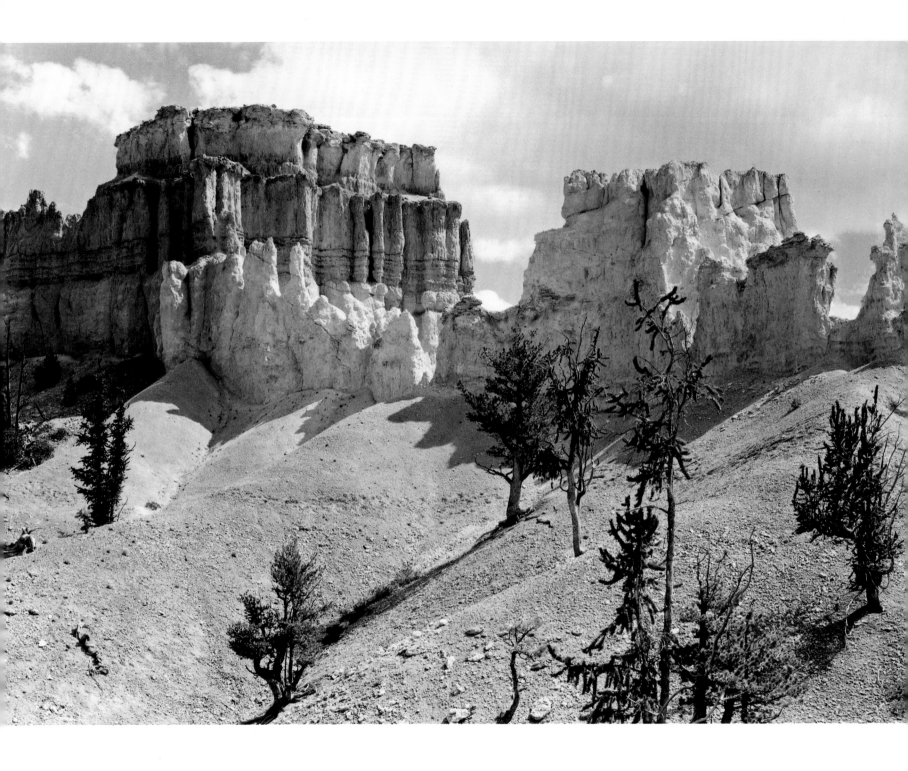

4 Bryce Temple, Bryce Canyon National Park (September 21, 1929).

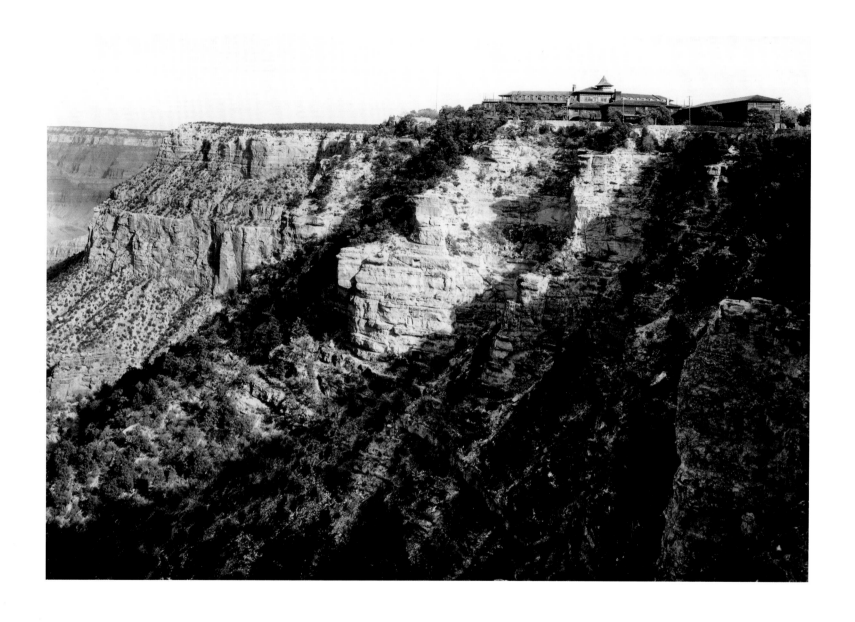

5 El Tovar Hotel atop South Rim, Grand Canyon National Park (1930).

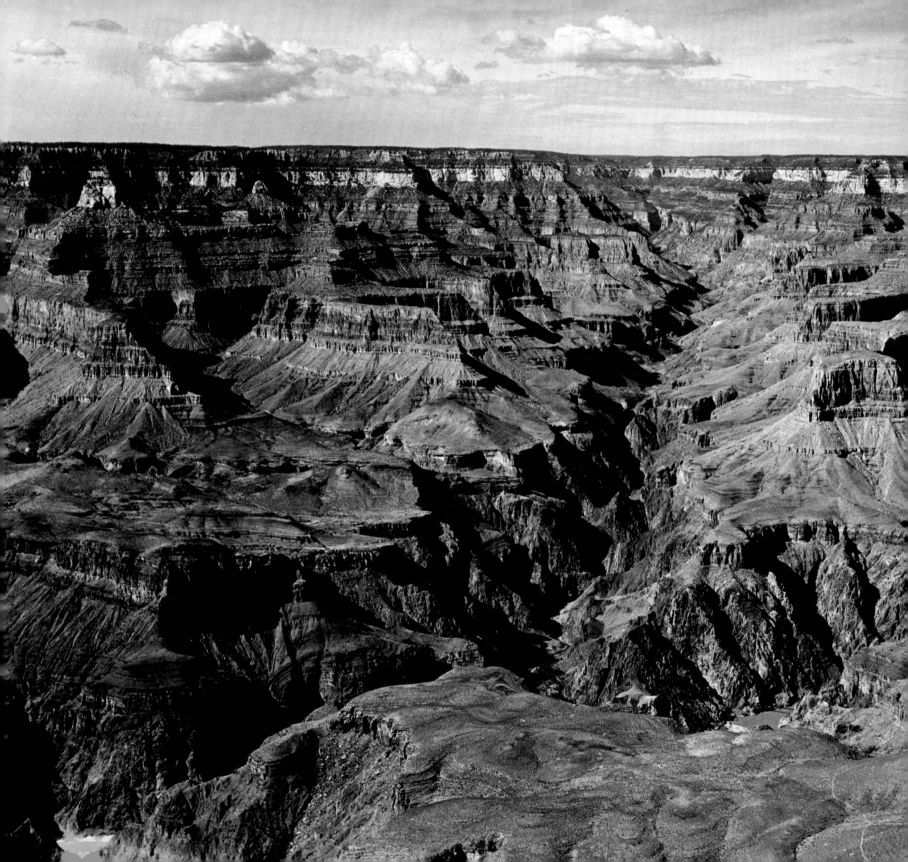

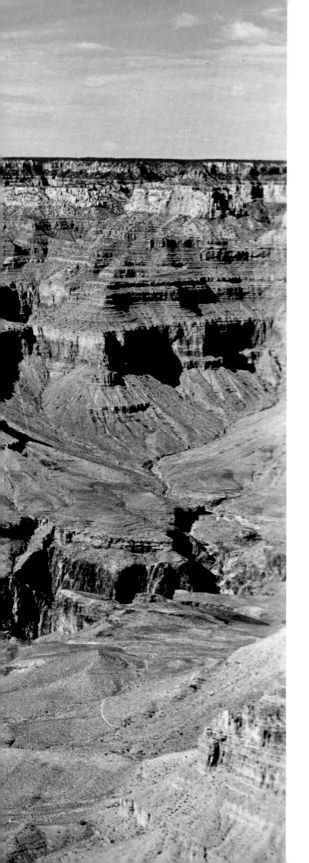

6 Bright Angel Canyon from the Yavapai Museum. Trail leads to the inner gorge and Phantom Ranch. Part of the river may be seen on the extreme left, Grand Canyon National Park (June 17, 1930).

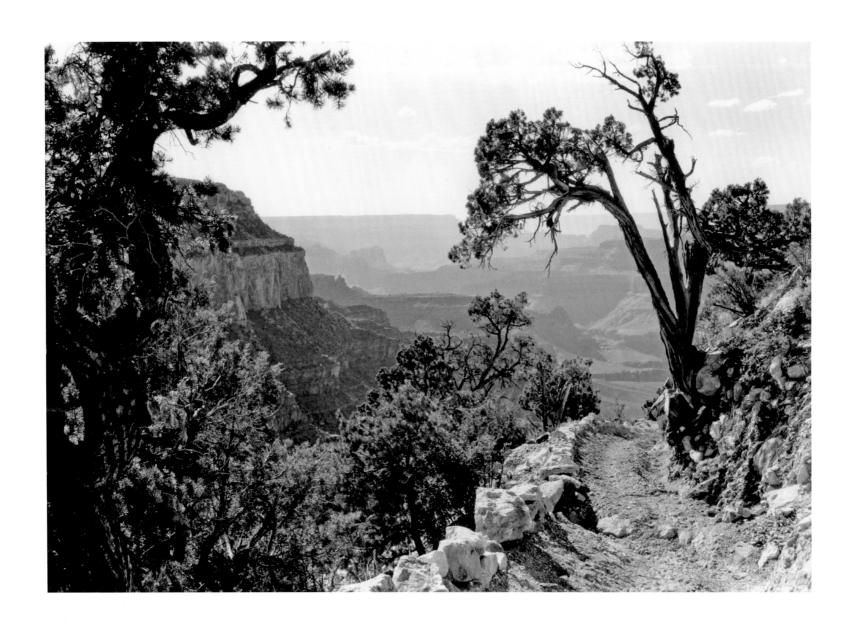

7 Bright Angel Trail, Grand Canyon National Park (1930).

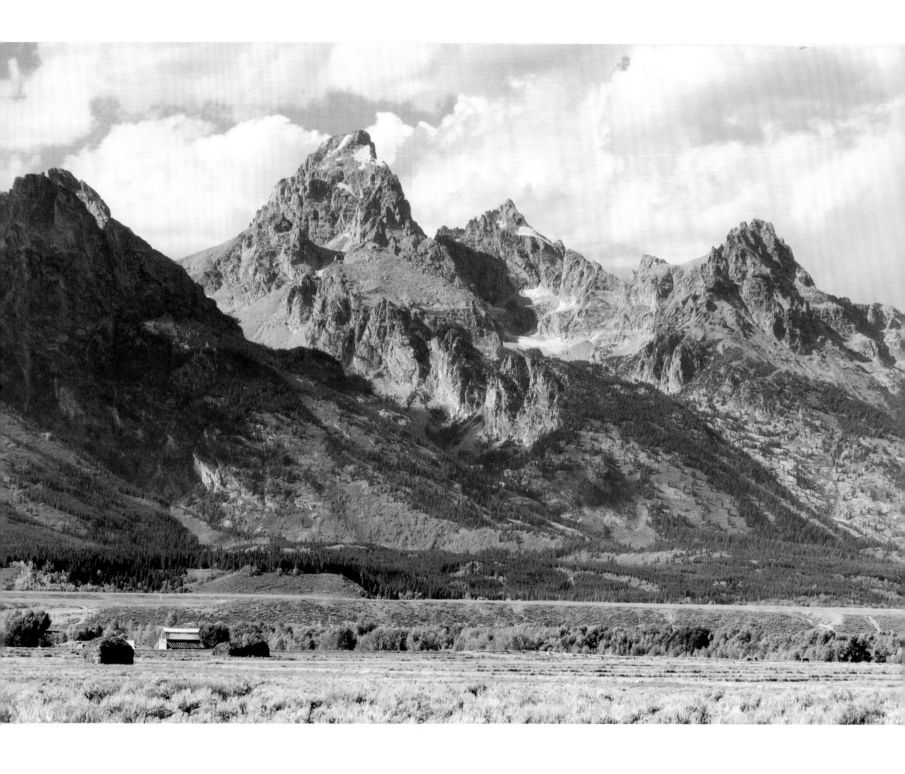

8 Tetons from the north end of Blacktail Butte, Grand Teton National Park (September 10, 1930).

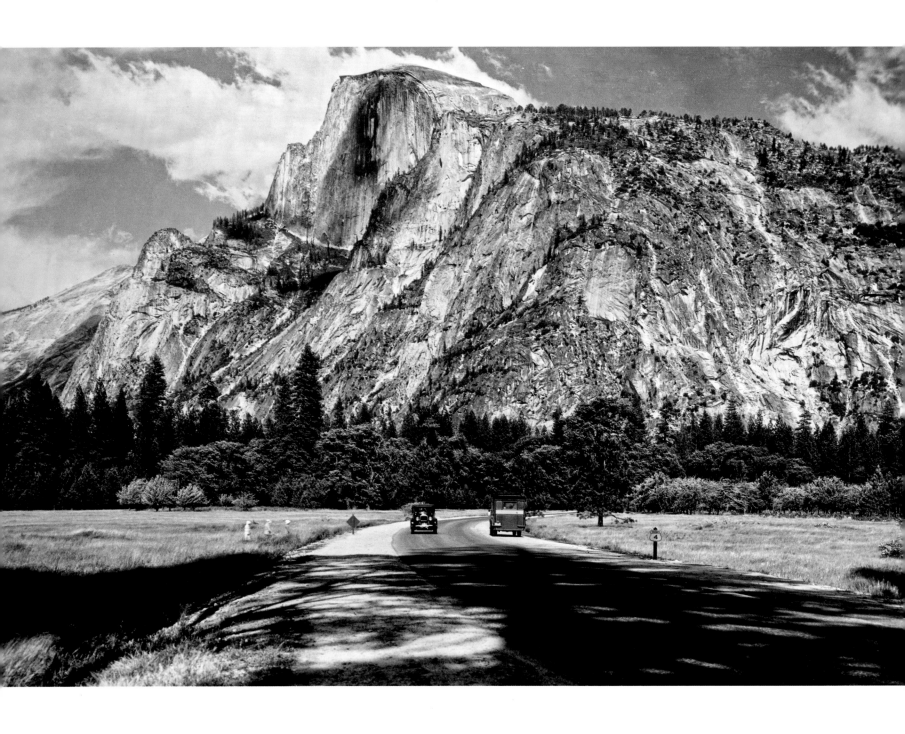

9 Half Dome from the crossroads of Camp Curry Road and South Side Road, Yosemite National Park (June 11, 1931).

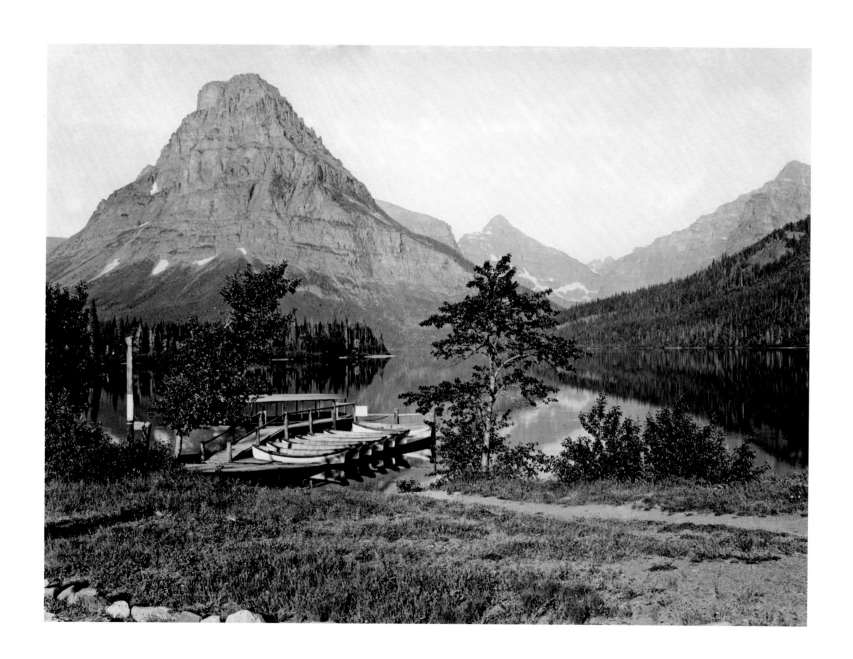

10 Boat docks at Two Medicine Lake, Glacier National Park (July 1932).

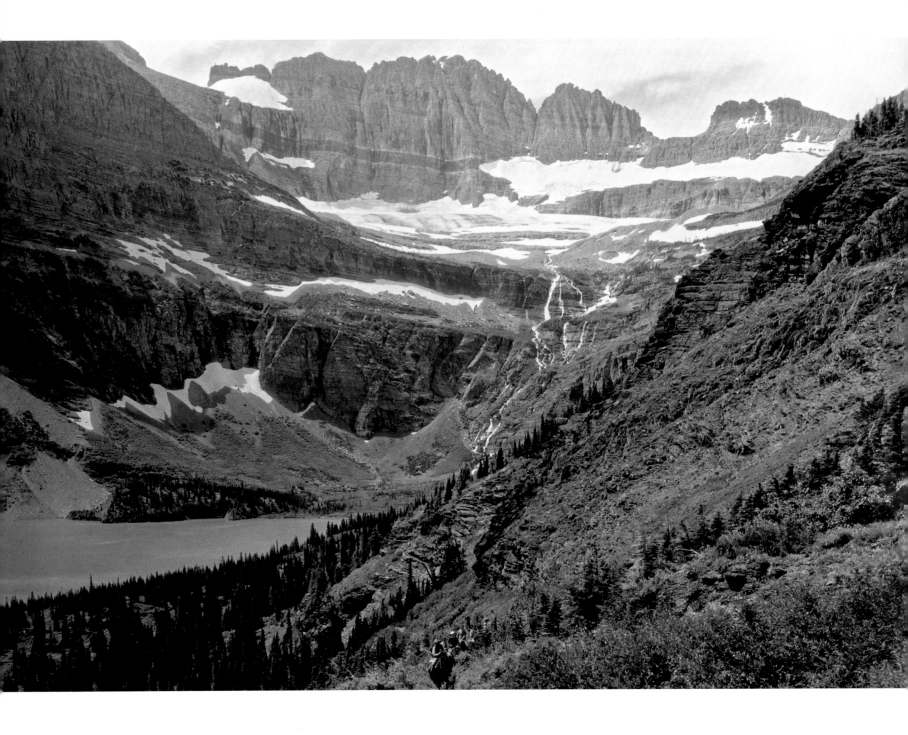

11 Grinnell Glacier and the lake from the trail, Glacier National Park (July 19, 1932).

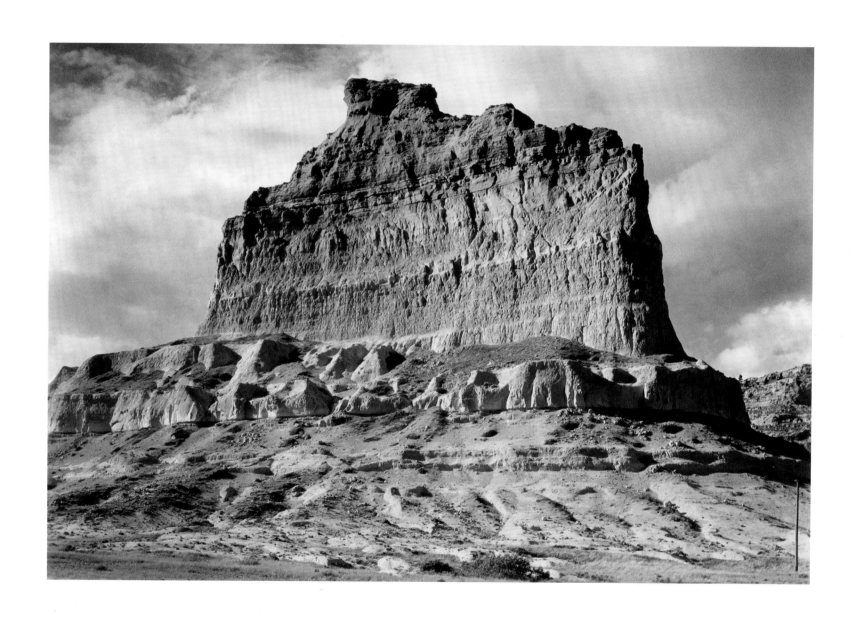

12 The bluff on a cliff on the north side of the Mitchell Pass summit—the southern extremity of the north plateau of Scotts Bluff. The Oregon Trail crossed the summit in the foreground. Scotts Bluff National Monument (1932).

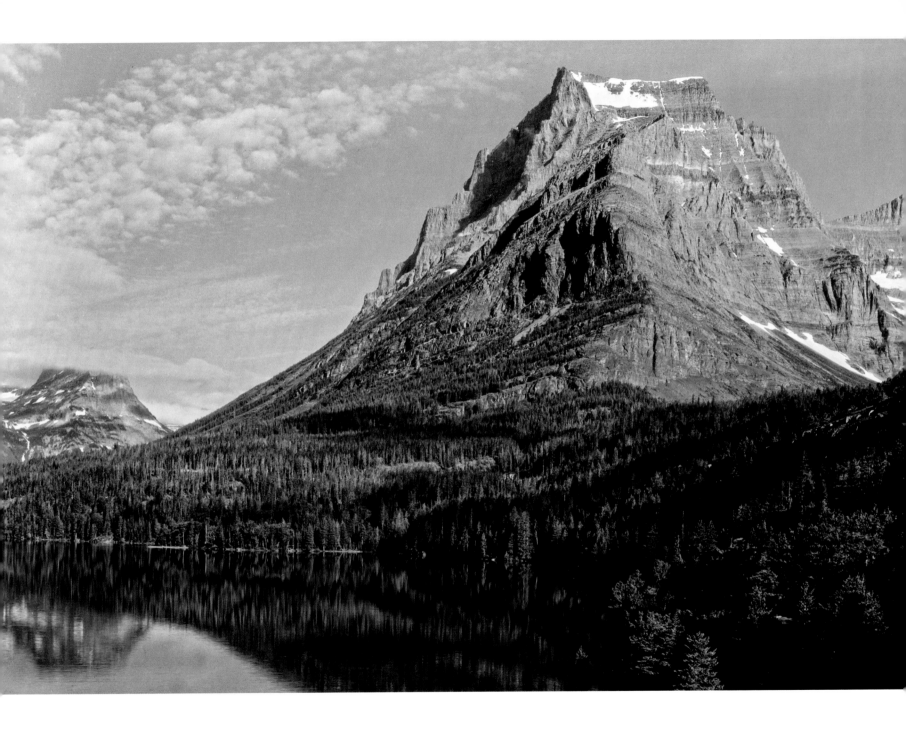

13 Going-to-the-Sun Mountain from the chalets on Upper Saint Mary Lake,
 Glacier National Park (July 1933).

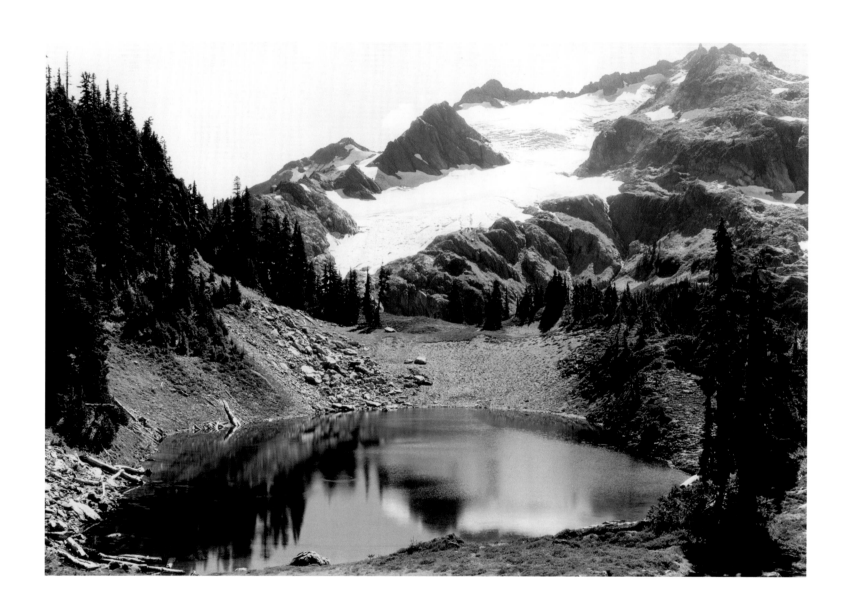

14 One of the beautiful lakes in Martin's Peak. Above is the De La Barre Glacier on the
east side of Mount Christie, proposed Olympic National Park (1934).

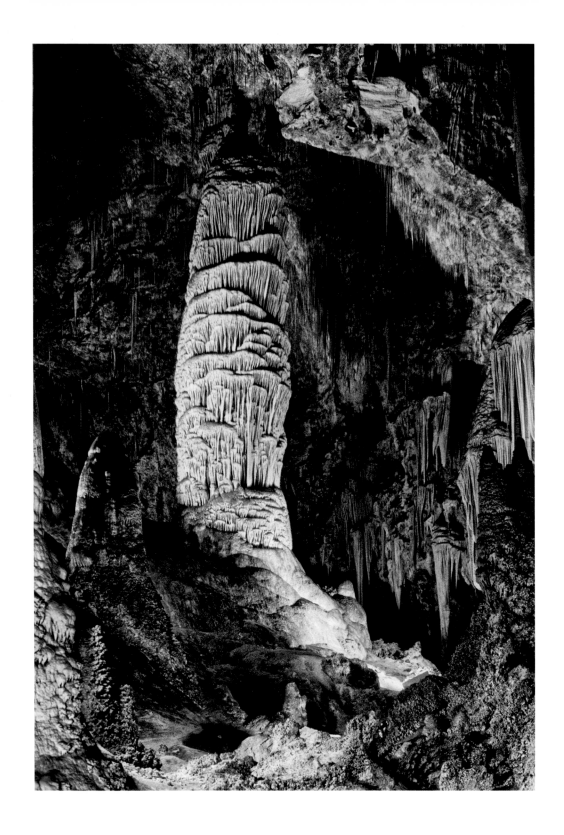

15 The Giant Dome is sixteen feet in diameter and estimated to be 60 million years old. Hall of Giants, Big Room, Carlsbad Caverns National Park (1934).

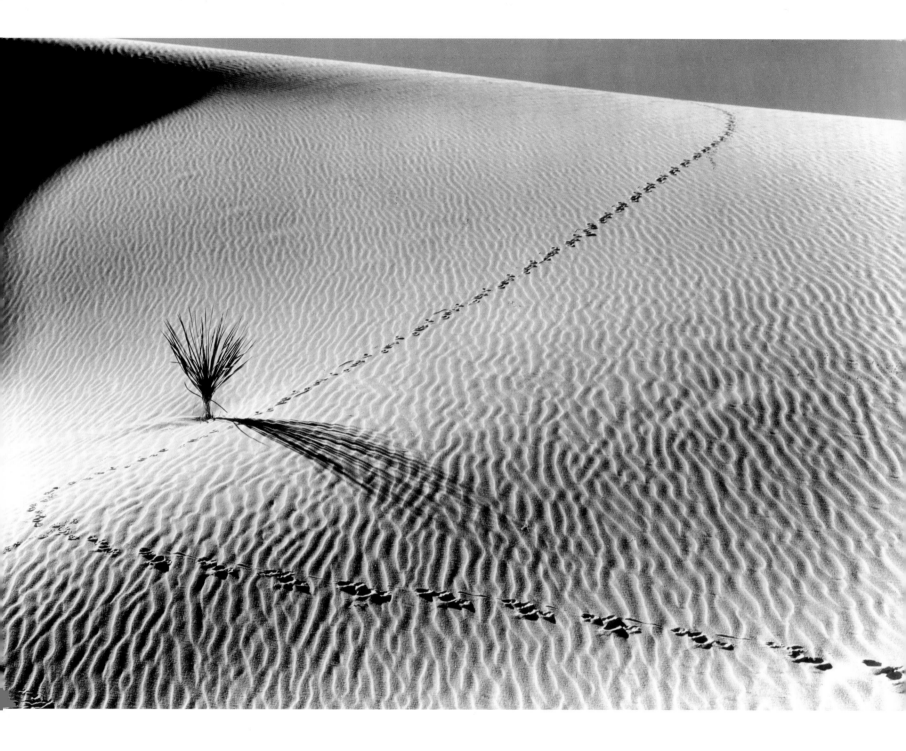

16 Tracks of small animals are commonly seen at White Sands, New Mexico (1934).

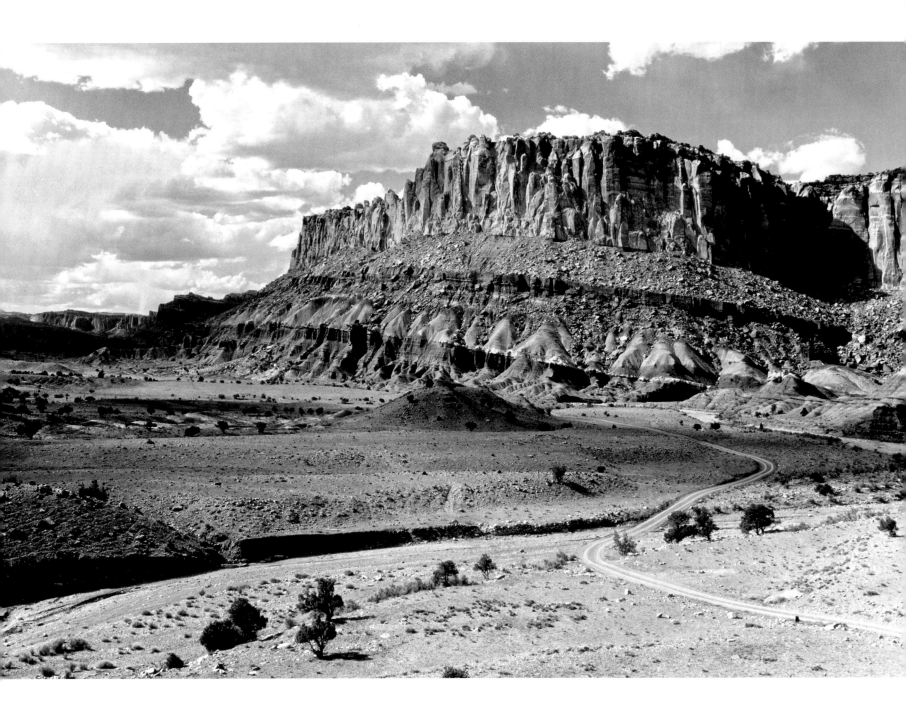

17 View west along Wayne Wonderland Cliffs, showing entrance to Capitol Wash at right, Capitol Reef National Park (July 24, 1935).

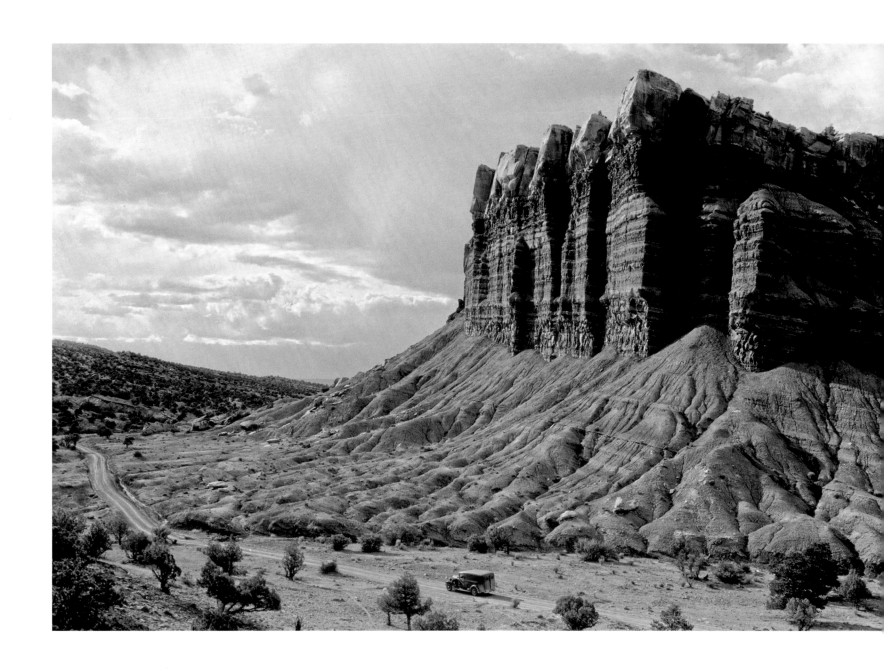

18 The Great Organ, Capitol Reef National Park (July 24, 1935).

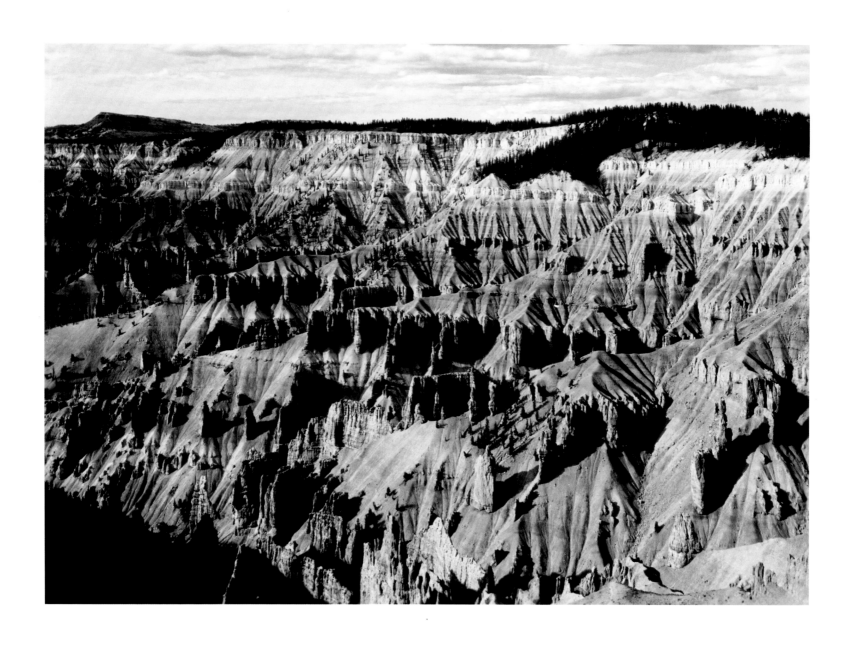

19 Cedar Breaks from the rim near Breaks Lodge with Bryan Head in the distance.
View from south, looking north, Cedar Breaks National Monument (1935).

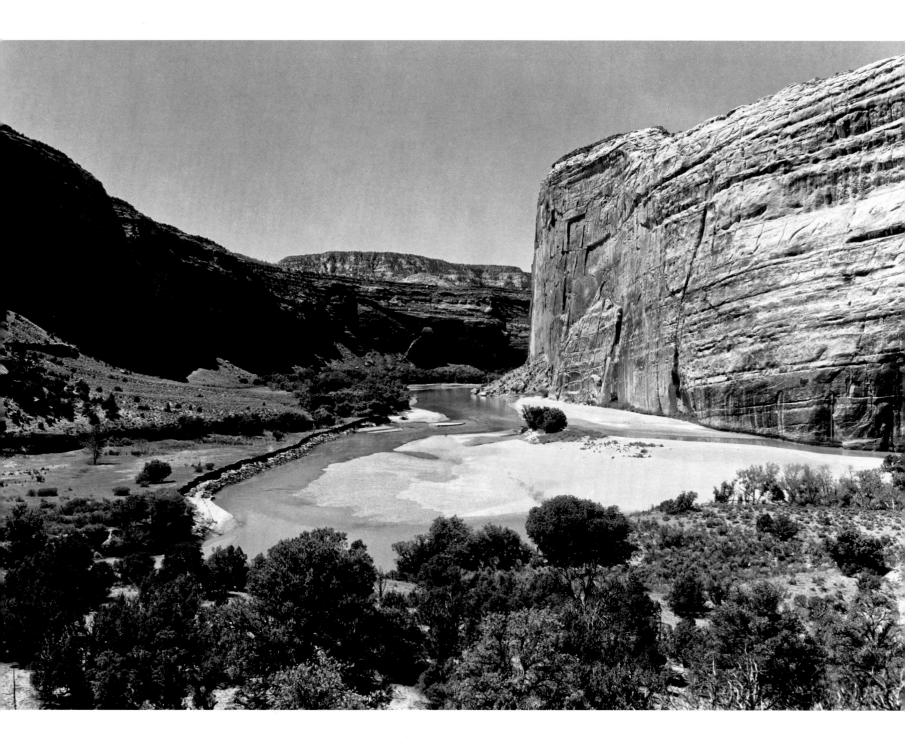

20 Part of Pat's Hole, junction of Yampa and Green Rivers and east side of Steamboat Rock,
Dinosaur National Monument (August 9, 1935).

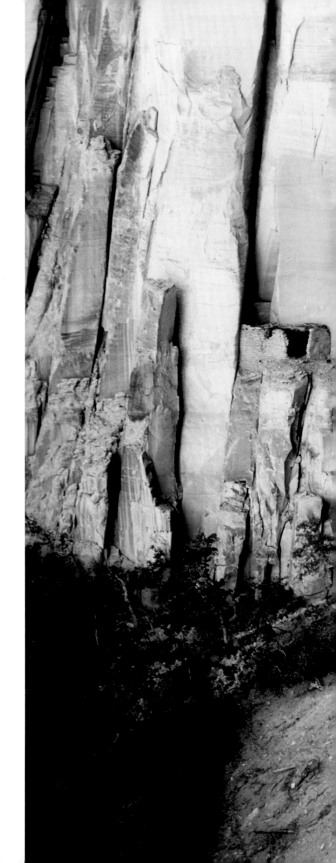

21 Western and main part of Betatakin Ruin, Navajo National Monument (September 17, 1935).

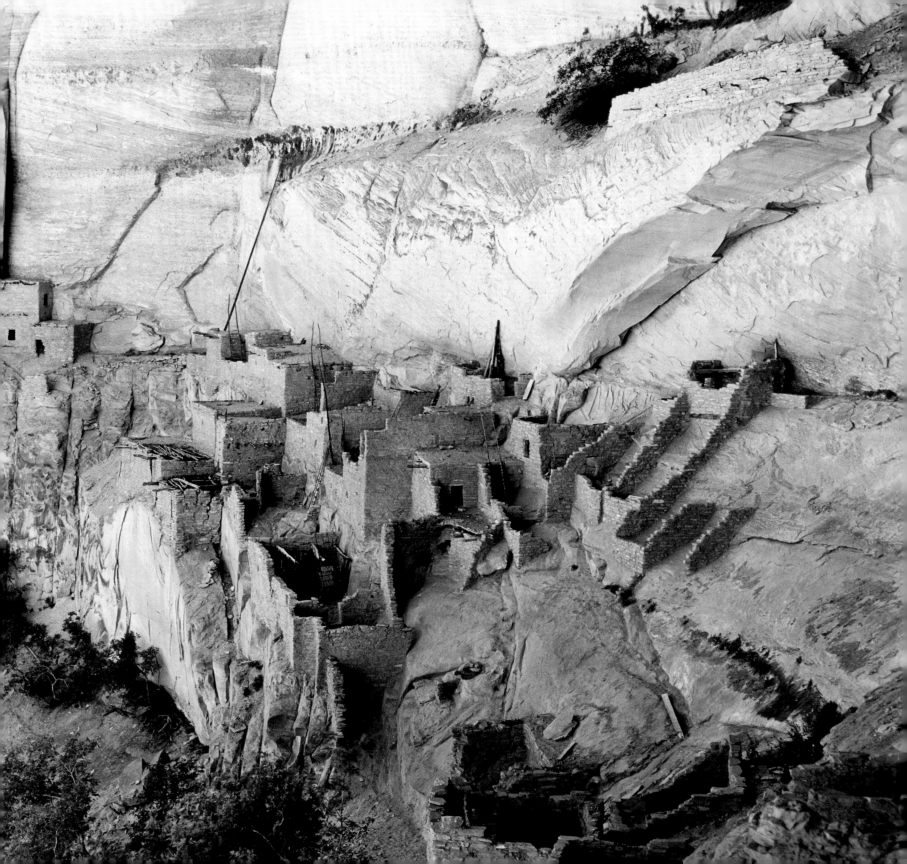

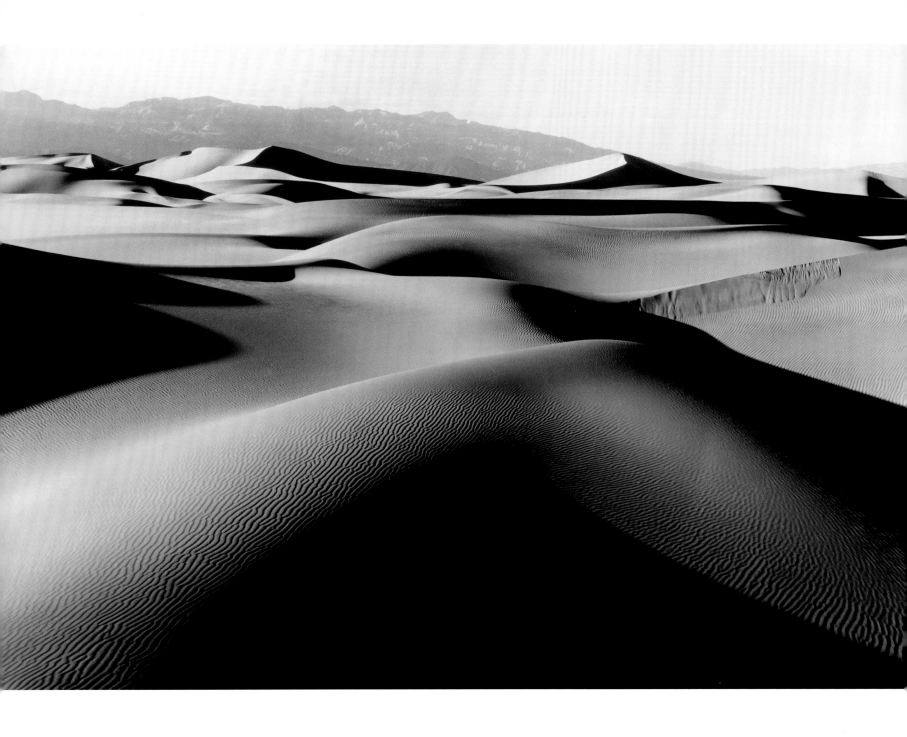

22 Sand dunes near Stovepipe Wells. The Cottonwood Mountains are in the background, Death Valley National Park (1935).
This image won first prize in the New York Explorers Club's photography competition in 1937.

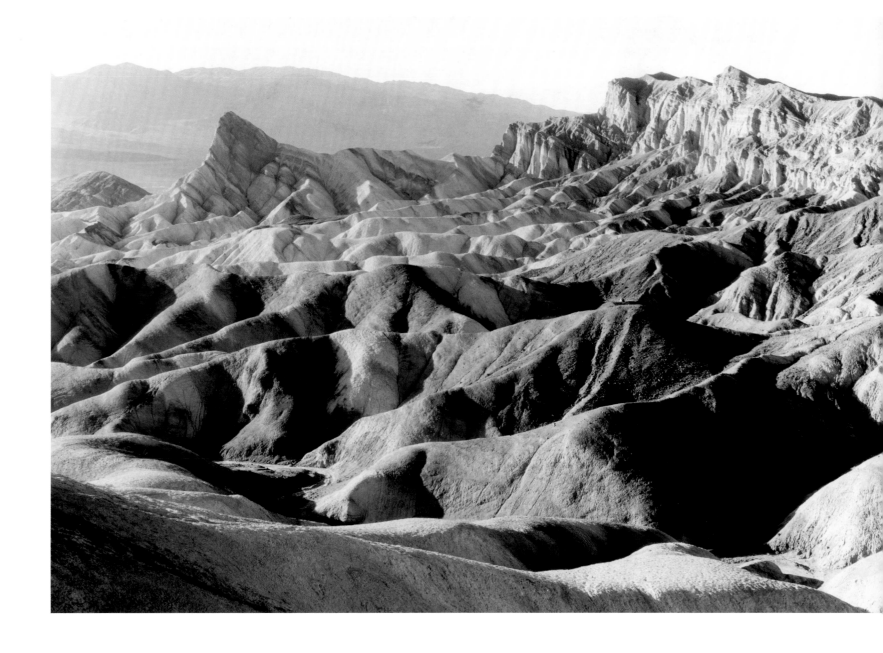

23 A view toward Death Valley from Zabriske Point, Death Valley National Park (November 29, 1935).

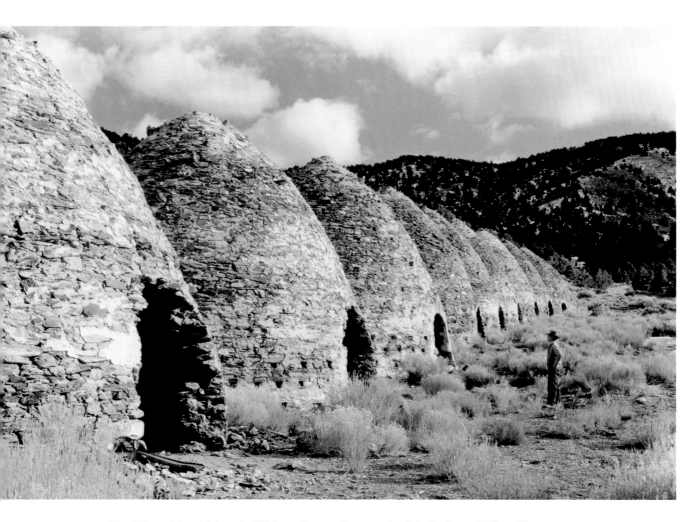

24 Near Thorndykes, high up in Wildrose Canyon, is a row of well-built charcoal kilns still in a good state of preservation, Death Valley National Park (December 2, 1935).

25 Casa Grande in Chisos Mountains, proposed Big Bend National Park (April 15, 1936).

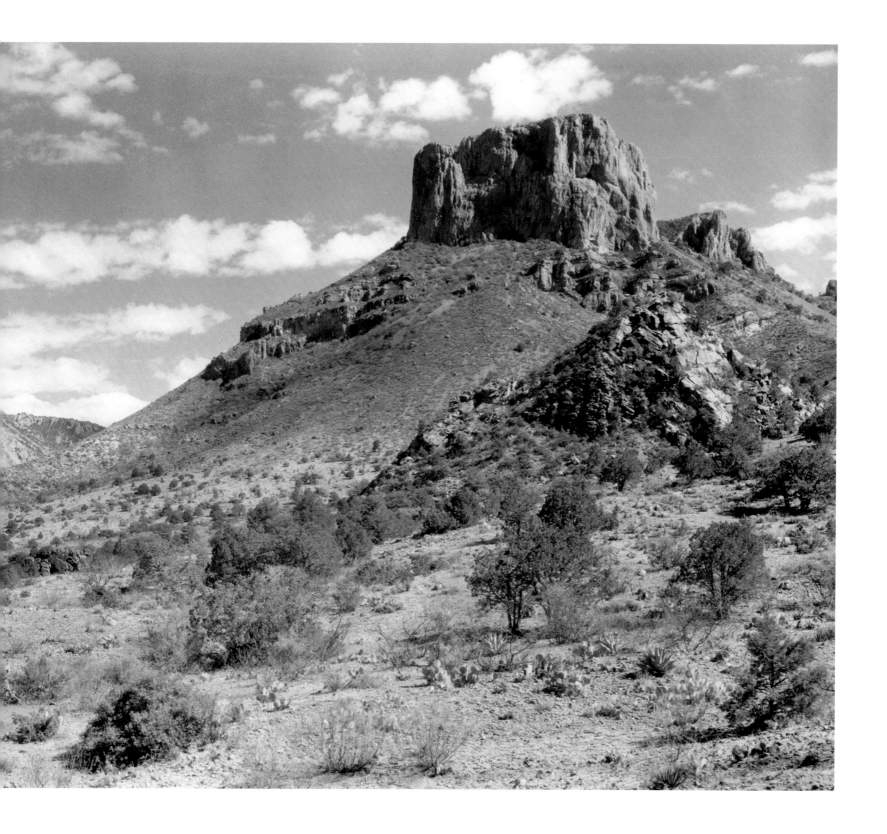

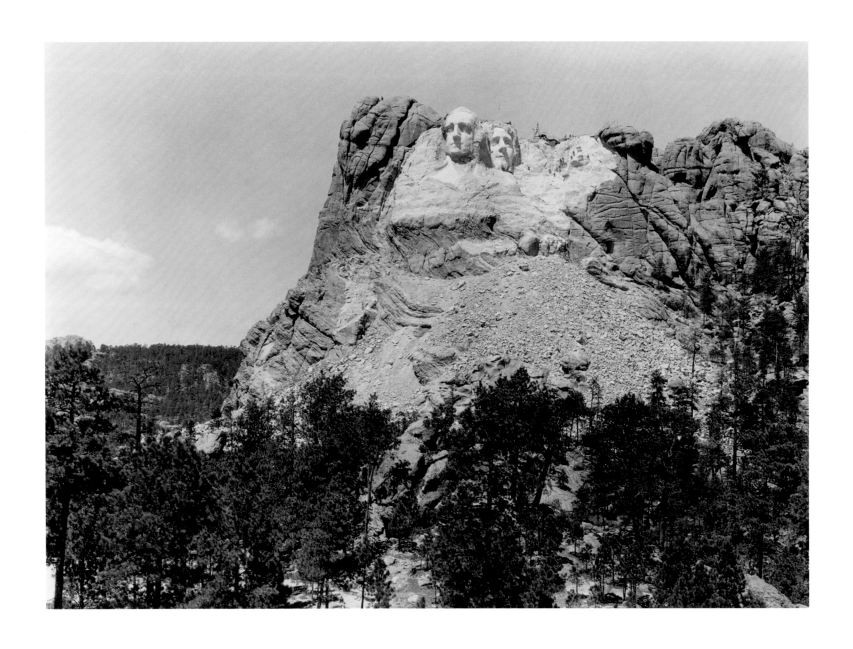

26 Heads of Washington and Jefferson. To the right men are working on Lincoln,
Mount Rushmore National Memorial (July 30, 1936).

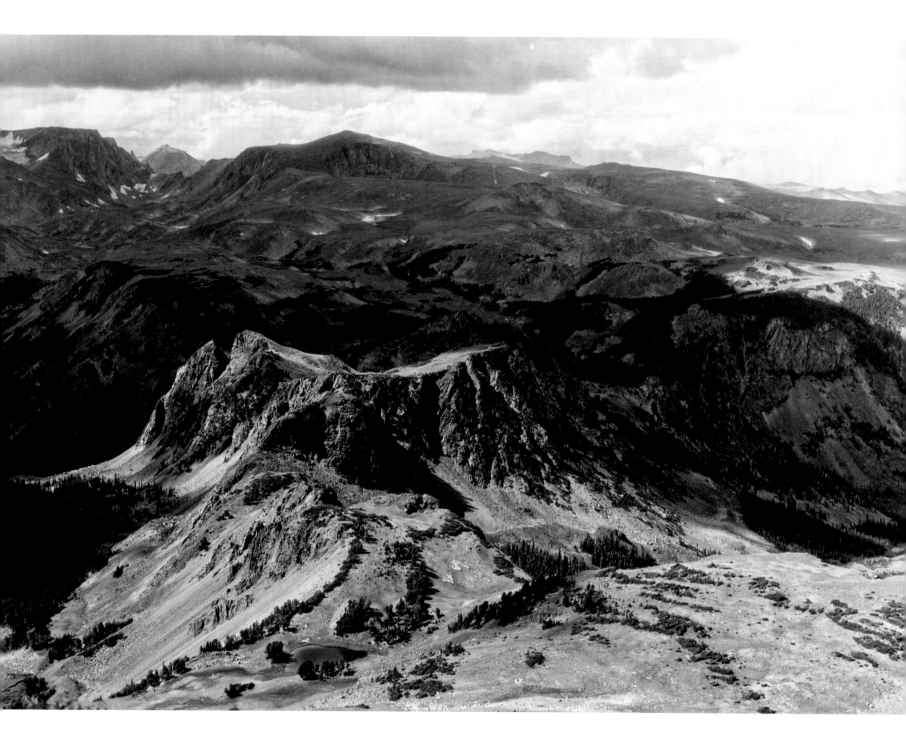

27 View into the head of Rock Creek from Red Lodge Highway, Beartooth Mountains, Montana,
outside the Yellowstone National Park boundary (August 13, 1936).

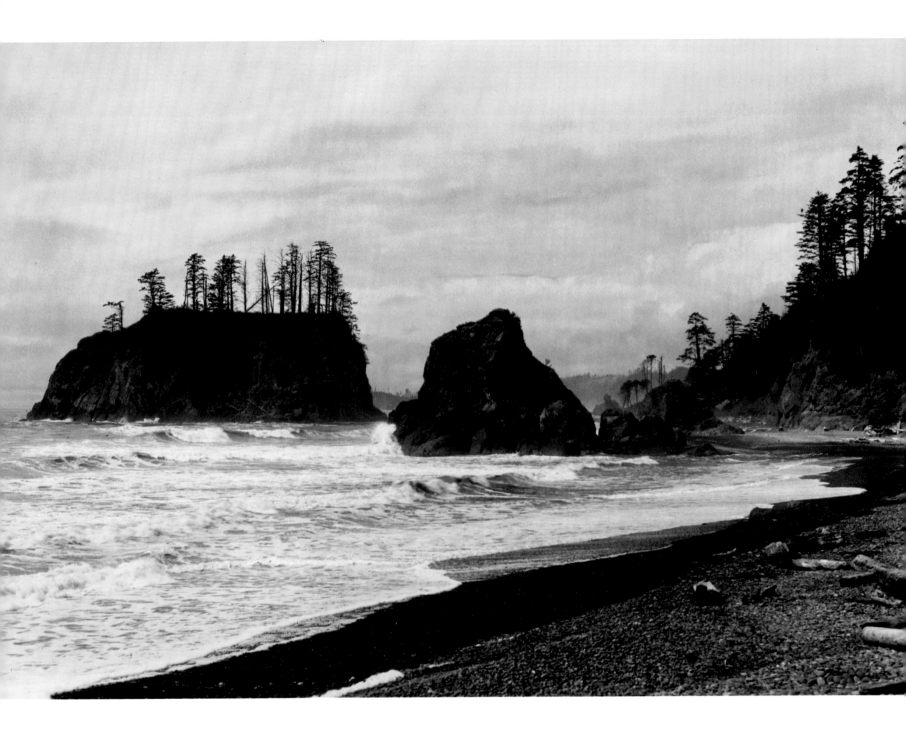

28 Rocks at Ruby Beach, near proposed Olympic National Park (September 1, 1936).

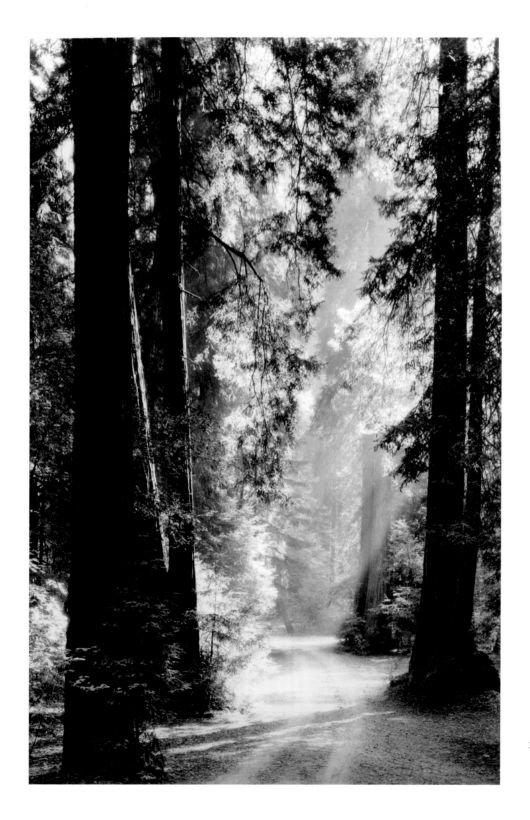

29 Sun streaks in Muir Woods,
Muir Woods National Monument
(October 13, 1936).

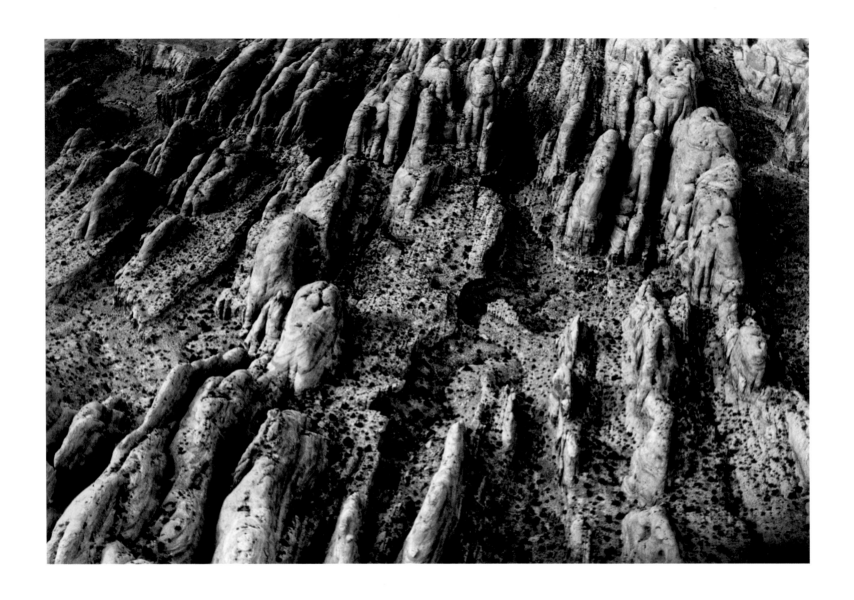

30 Aerial view of sandstone formations on top of a reef, Arches National Park (November 17, 1936).

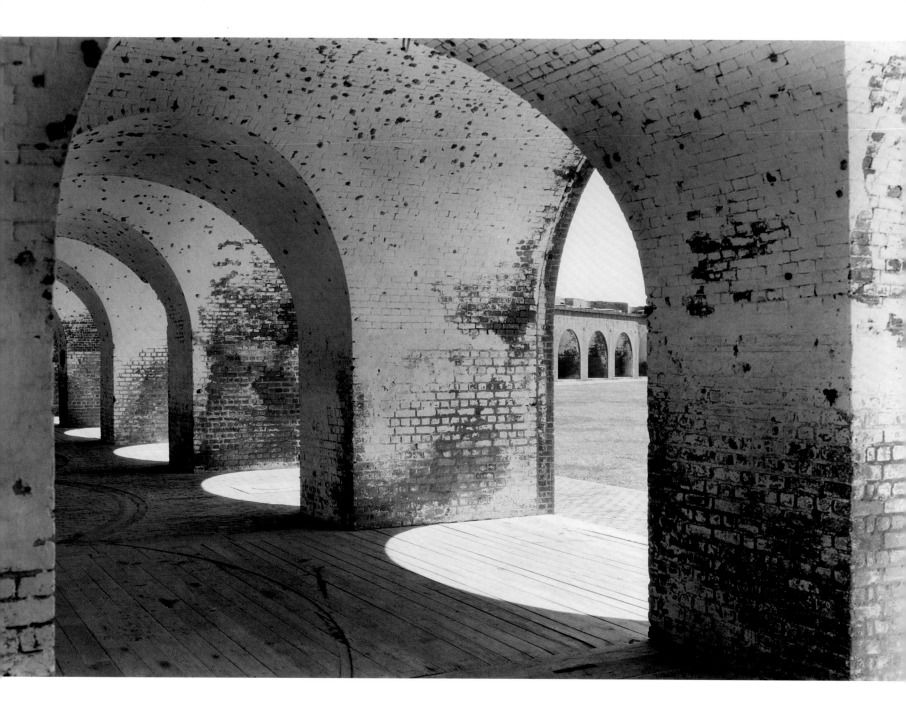

31 Brick archway within casements of the fort, Fort Pulaski National Monument (March 17, 1937).

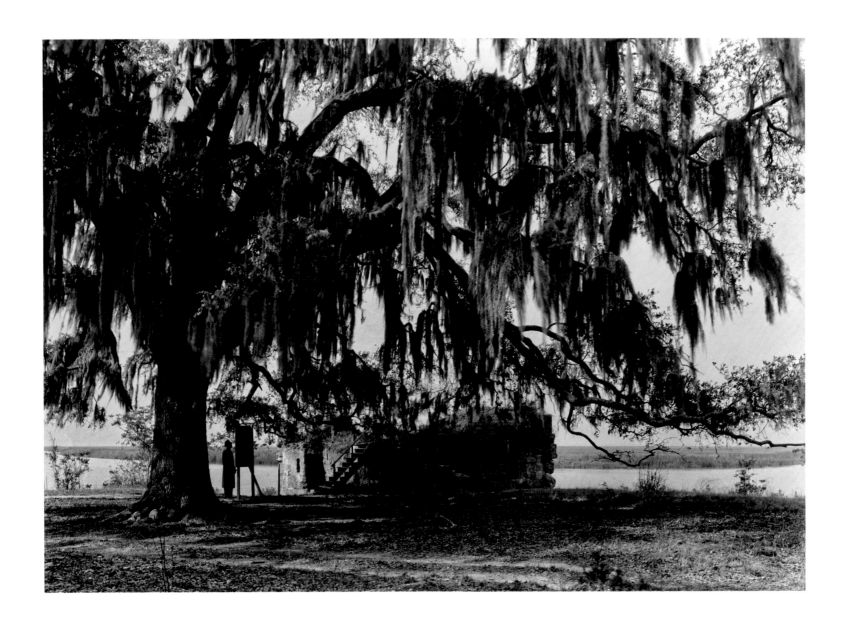

32 Portion of the original walls of the citadel facing Frederica River, Fort Frederica National Monument (March 18, 1937).

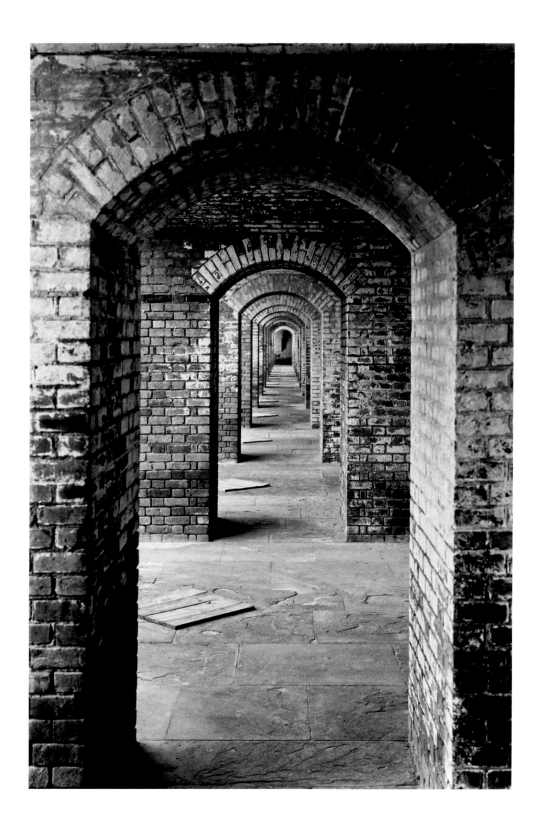

33 The narrow archways on the second gallery have rounded tops at Fort Jefferson, Dry Tortugas National Park (March 28, 1937).

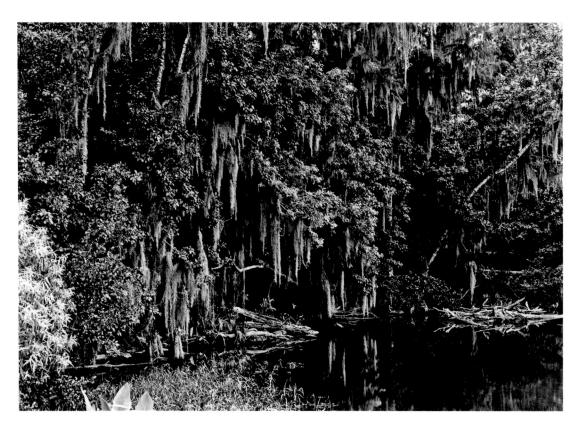

34 A lagoon with Spanish moss, Everglades National Park (May 4, 1937).

35 Mount Shuksan from Mount Baker Highway, proposed North Cascades National Park (August 19, 1937).

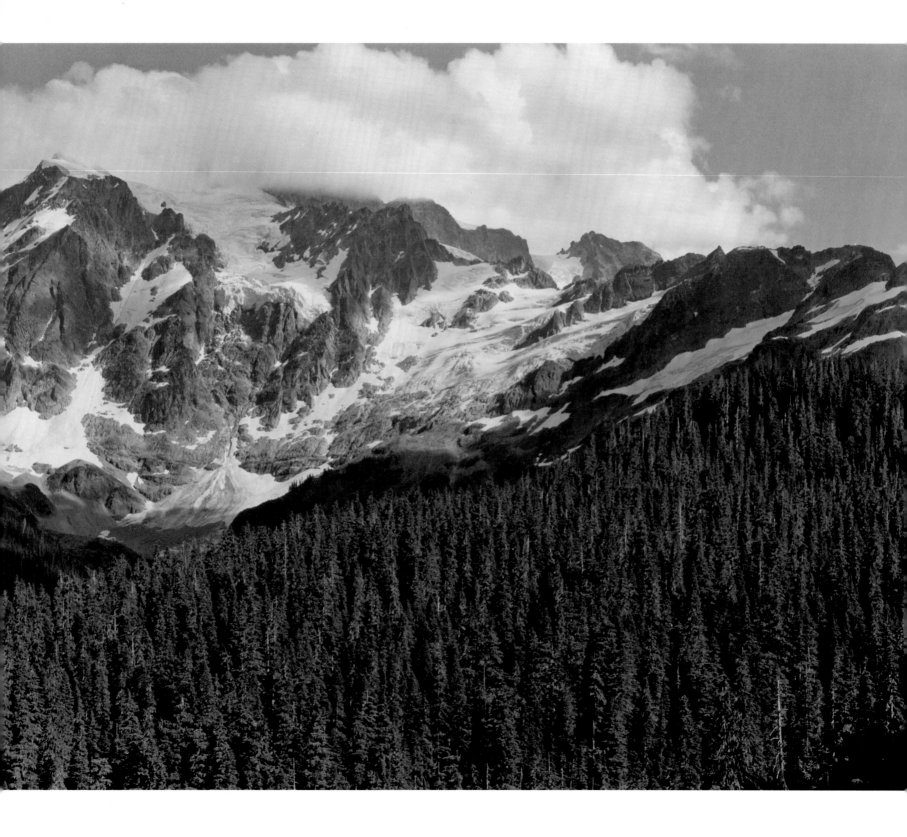

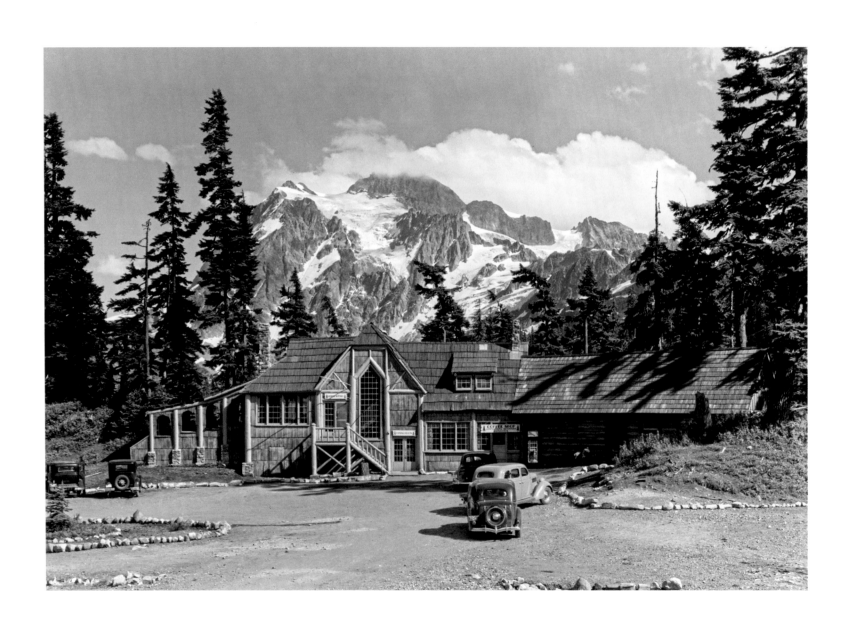

36 Restaurant at Mount Baker Lodge, proposed North Cascades National Park (August 19, 1937).

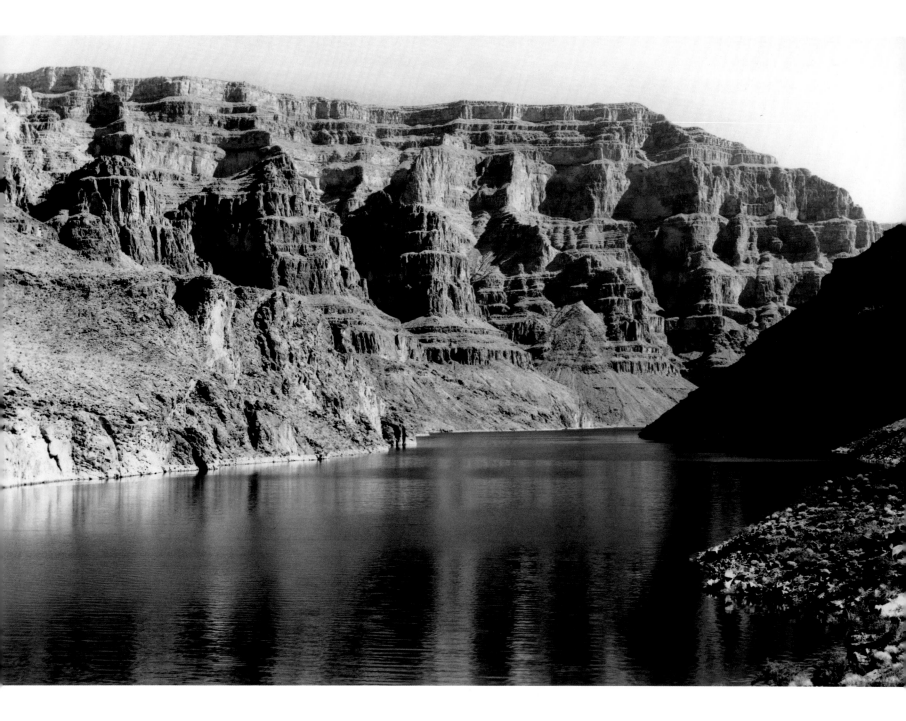

37 Geological cross section of the Grand Canyon, Lake Mead National Recreation Area (November 4, 1937).

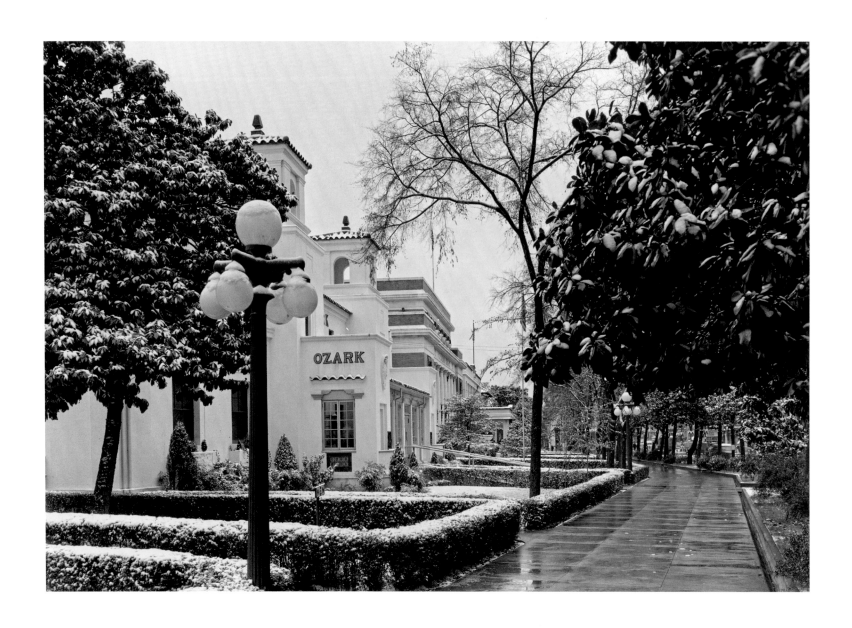

38 View along Bath House Row, showing the Ozark Bath House, Hot Springs National Park (November 22, 1937).

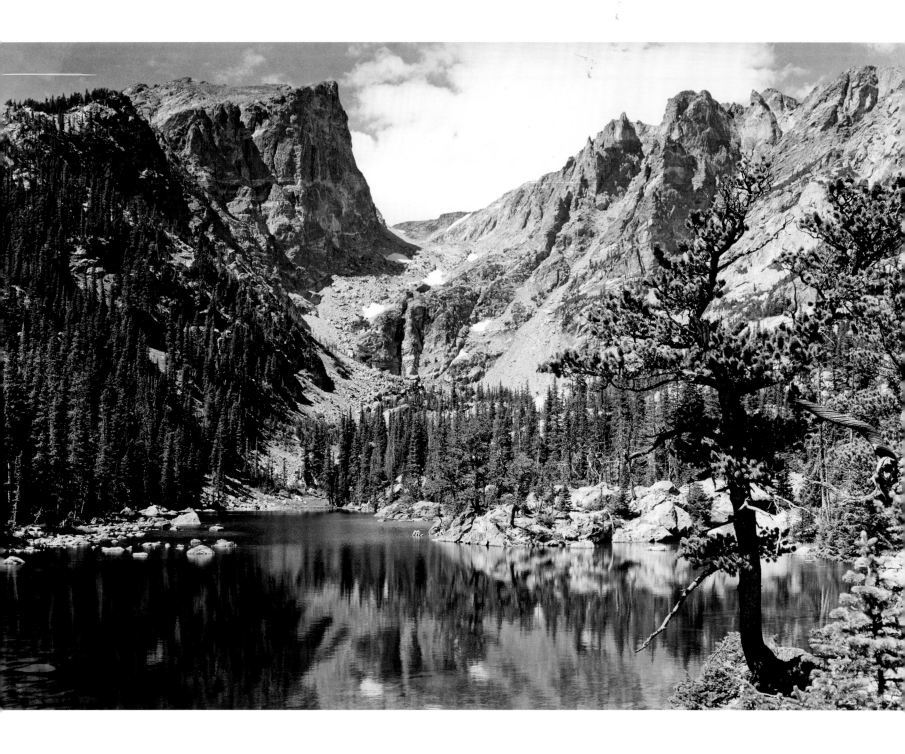

39 Dream Lake beneath Hallett Peak and Flattop, Rocky Mountain National Park (August 25, 1938).

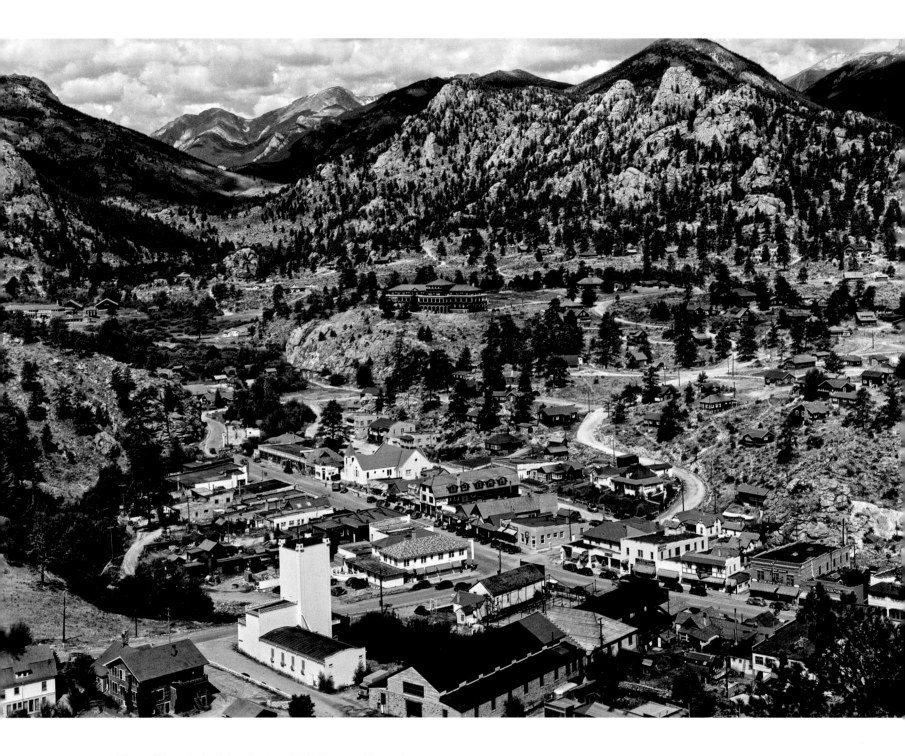

40 Village of Estes Park, Colorado, from Little Prospect Mountain,
 outside Rocky Mountain National Park (August 27, 1938).

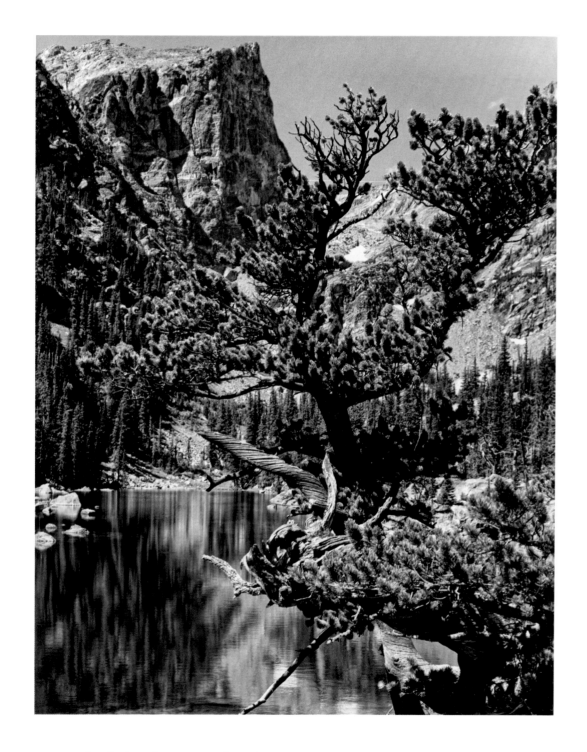

41 Lakeside view of mountains and trees beneath Hallett Peak,
Rocky Mountain National Park (September 2, 1938).

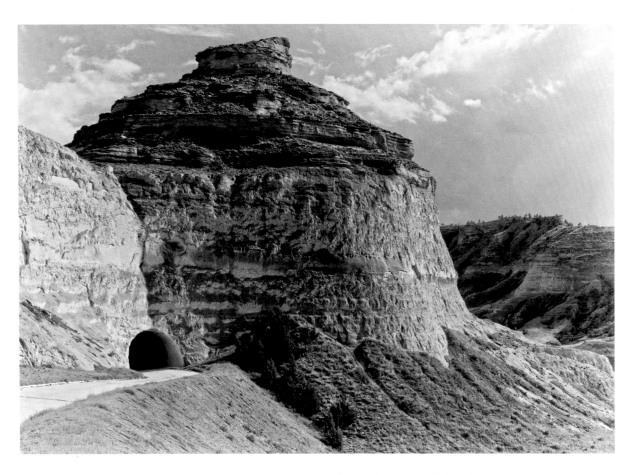

42 The spectacular bluff on the north side of Mitchell Pass. The road leads from the headquarters
 to the top of the bluff, Scotts Bluff National Monument (September 14, 1938).

43 The Olympic Mountains from Hurricane Ridge, Olympic National Park (October 14, 1938).

44 Sol Duc Falls with a rustic
bridge near the top of the falls,
Olympic National Park (1938).

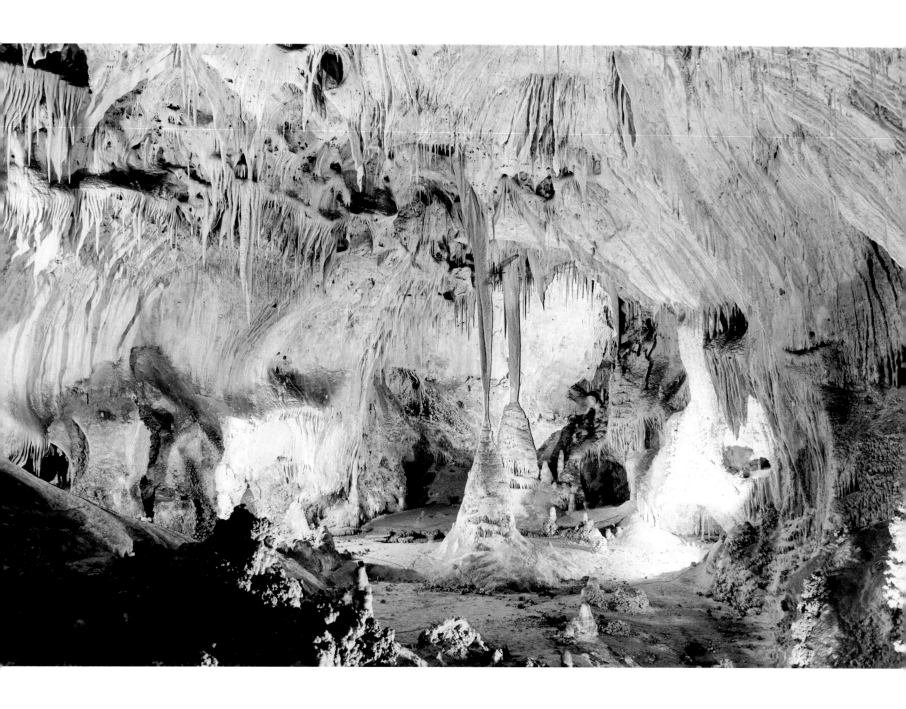

45 A large stalagmite formation with onyx drapes above it, in the King's Palace, Carlsbad Caverns National Park (1938).

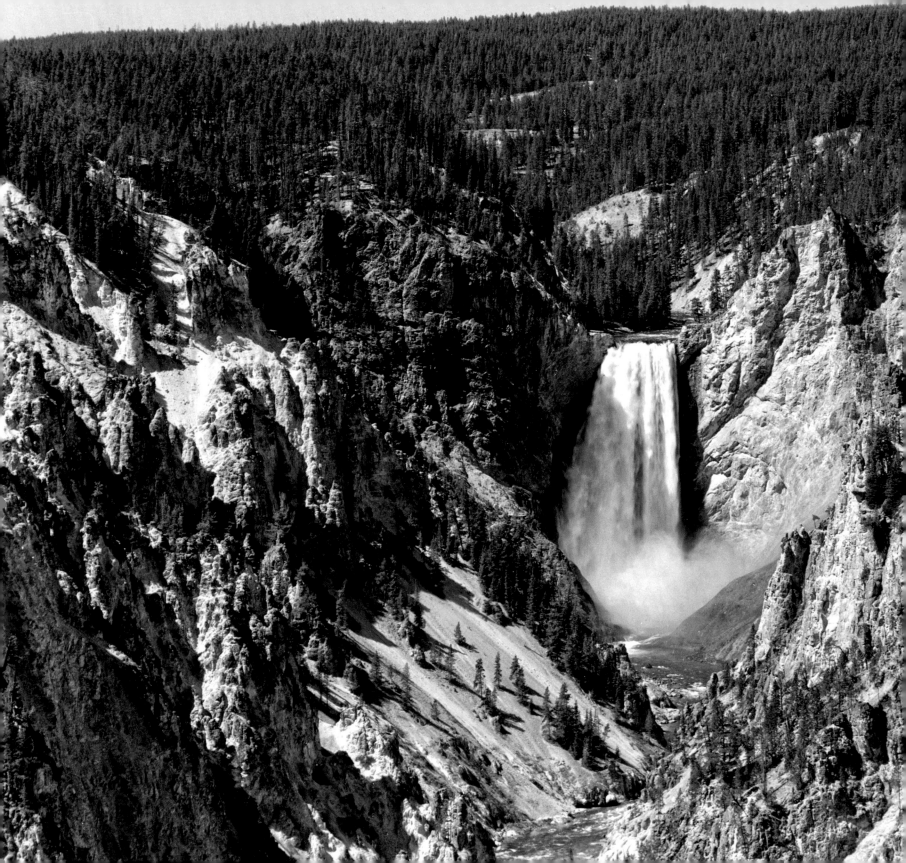

46 Yellowstone Canyon and the Lower Falls from Artist's Point,
Yellowstone National Park (August 20, 1939).

47 Potholes in granite along the
north wall at Separation Rapids,
Lake Mead National Recreation
Area (October 7, 1939).

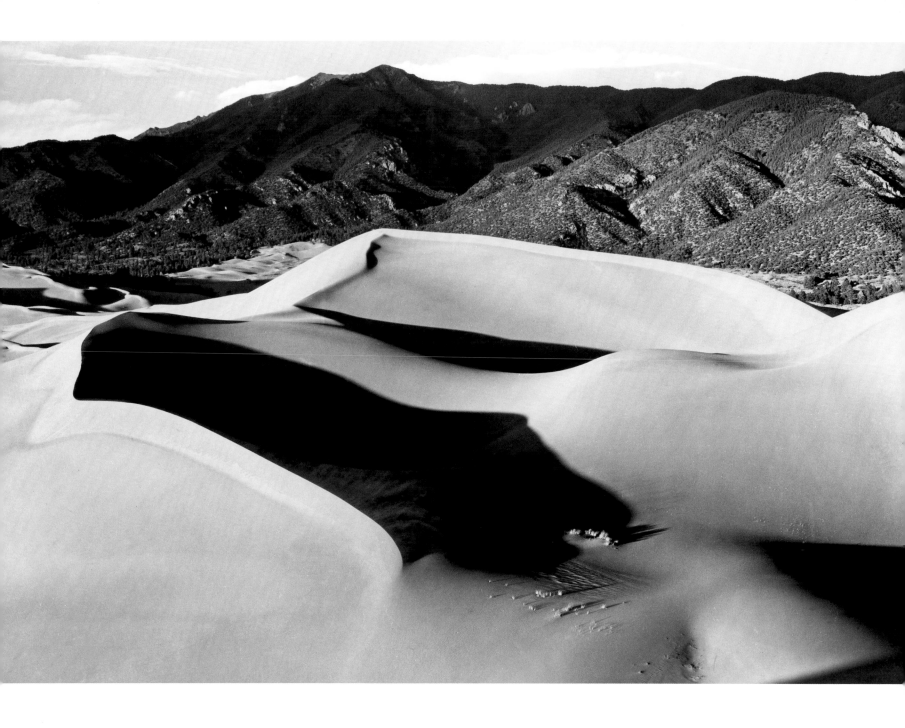

48 The Great Sand Dunes, Great Sand Dunes National Monument (1939).

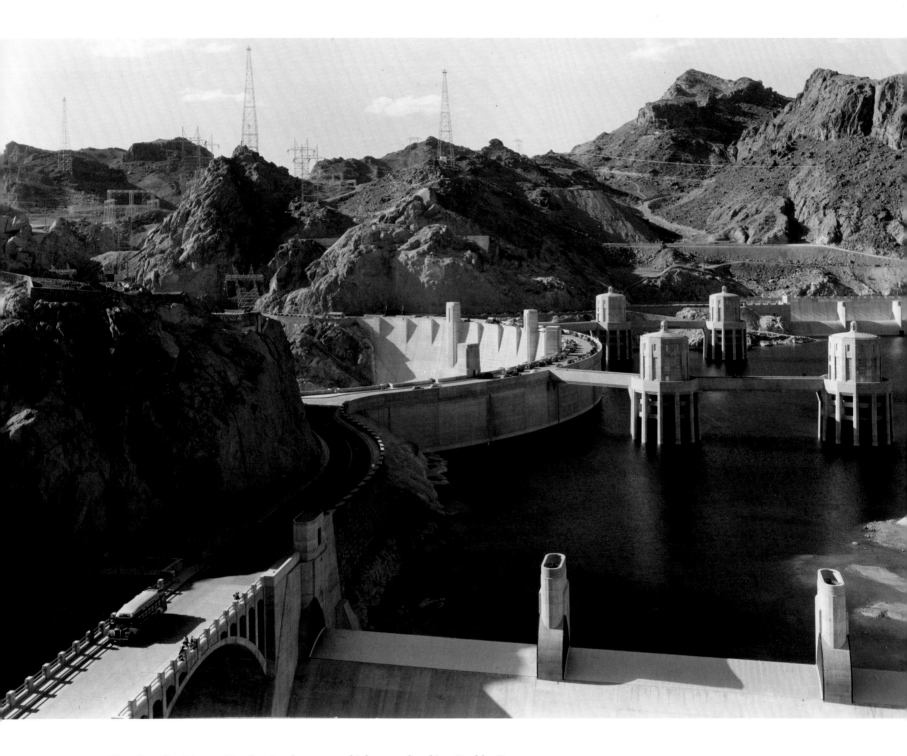

49 View from the Arizona side, showing the entrance highway and parking, Boulder Dam
and Lake Mead National Recreation Area (October 3, 1939).

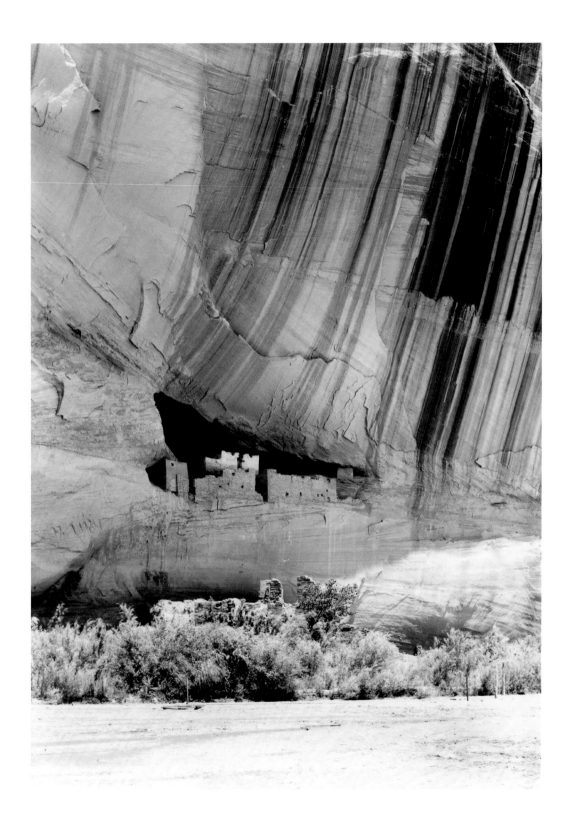

50 The White House (Casa Blanca),
Canyon de Chelly National
Monument (1940).

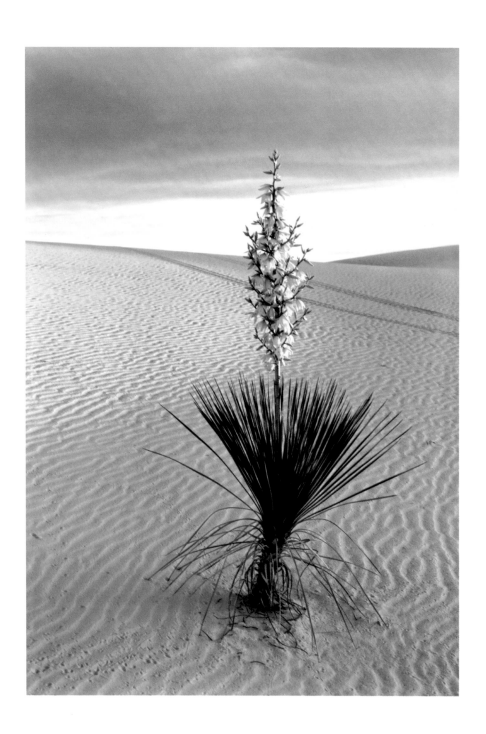

51 Yucca bloom in the sand, White Sands National Monument (1940).

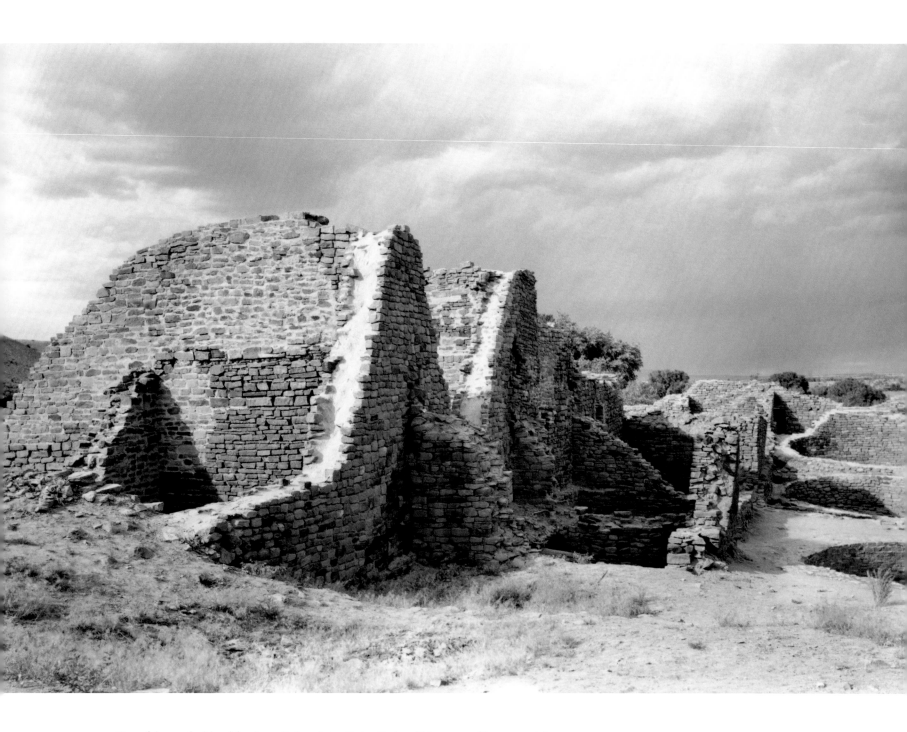

52 Part of the north side of the Aztec Ruins, Aztec Ruins National Monument (June 13, 1940).

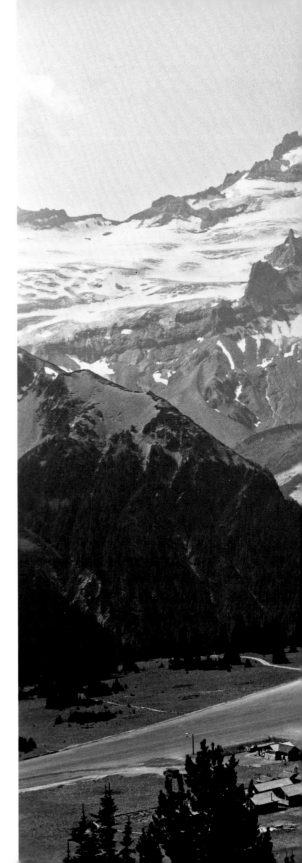

53 Visitors on horseback above Sunrise Lodge and cabins at Mount Rainier
 National Park (August 22, 1940).

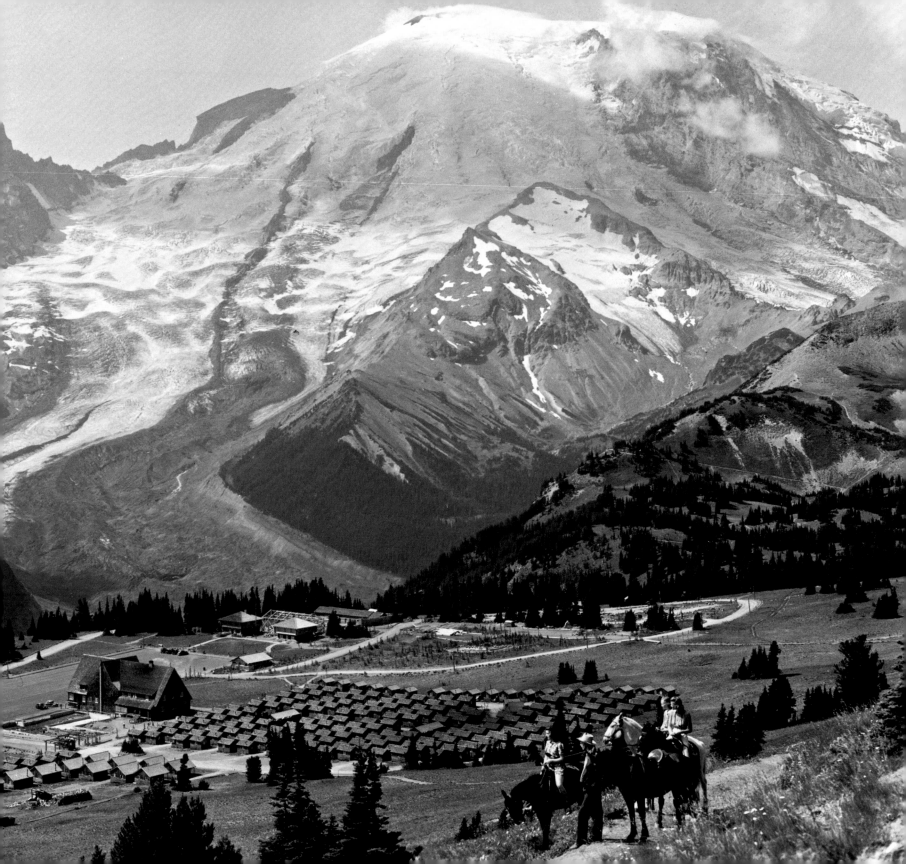

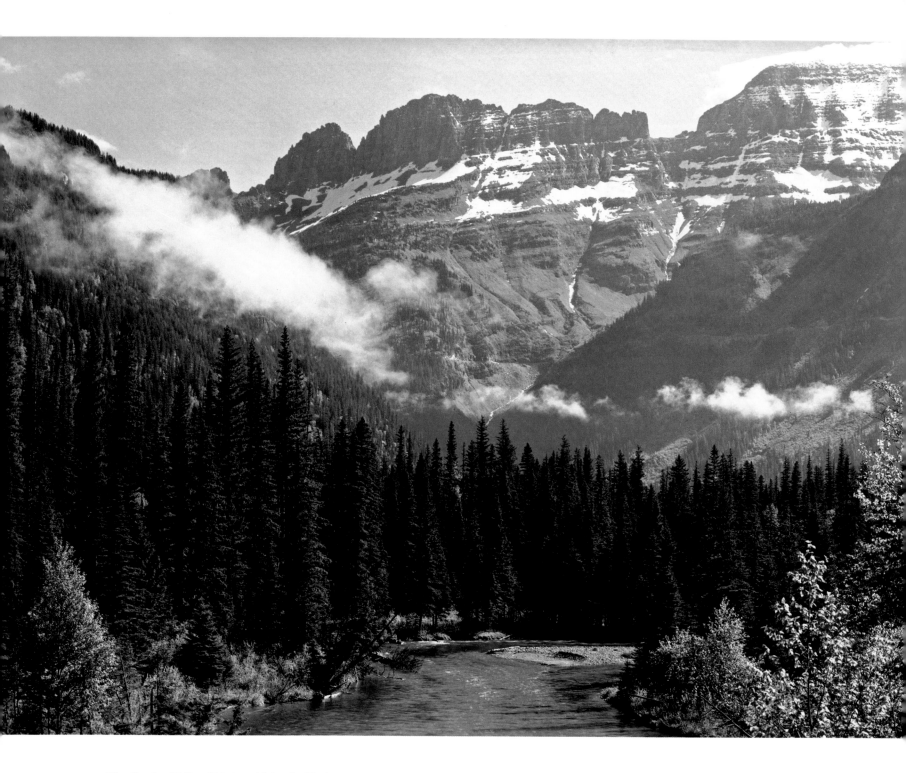

54 The Garden Wall and McDonald Creek, Glacier National Park (June 2, 1941).

55 Foliage of Port Orford Cedar, Oregon Caves National Monument (August 24, 1941).

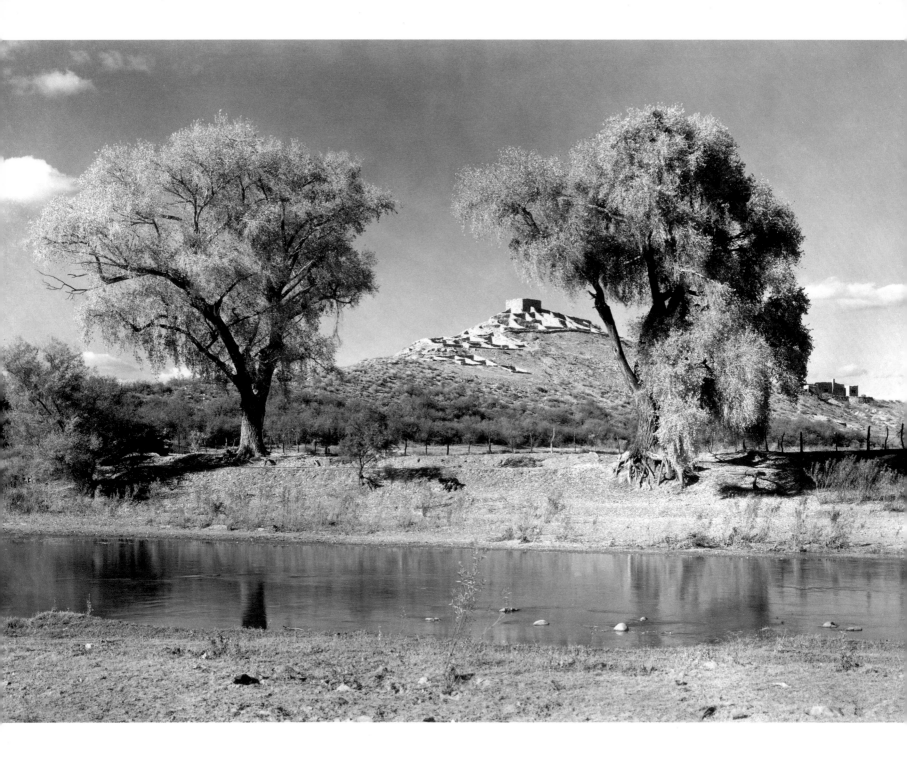

56 Tuzigoot ruin with the South Verde River in the foreground, Tuzigoot National Monument (November 30, 1945).

People and the Parks

57 Mary Crehore Bedell and her daughters with their automobile, Yellowstone National Park (1922).

58 Will it burn? Tenderfeet attempting to build a fire in the petrified forest, Petrified Forest National Park (1929).

59 From Yavapai Point,
 looking up Bright Angel
 Creek, Grand Canyon
 National Park (June 5, 1929).

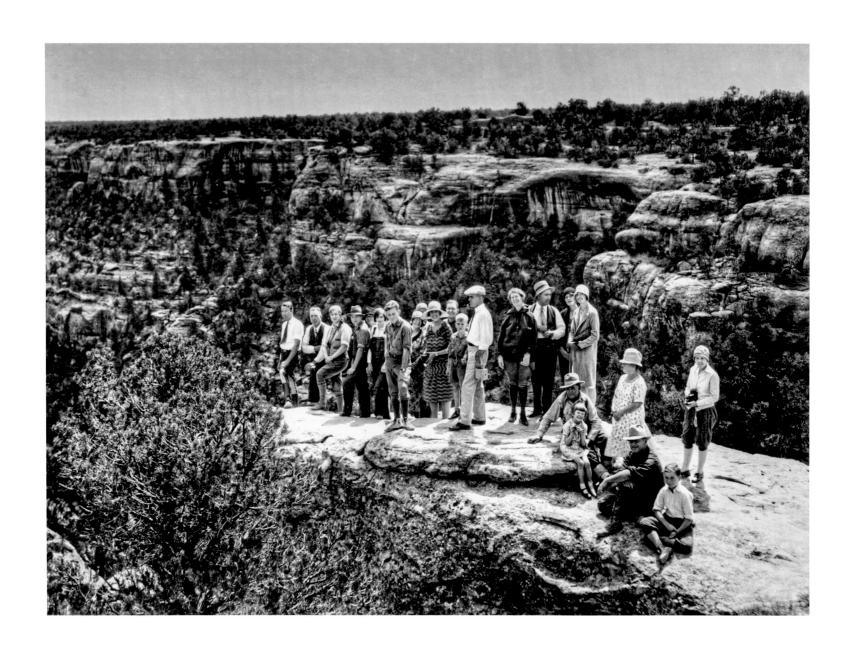

60 Tourist party on the cliff, preparing to descend into Cliff Palace, Mesa Verde National Park (August 18, 1929).

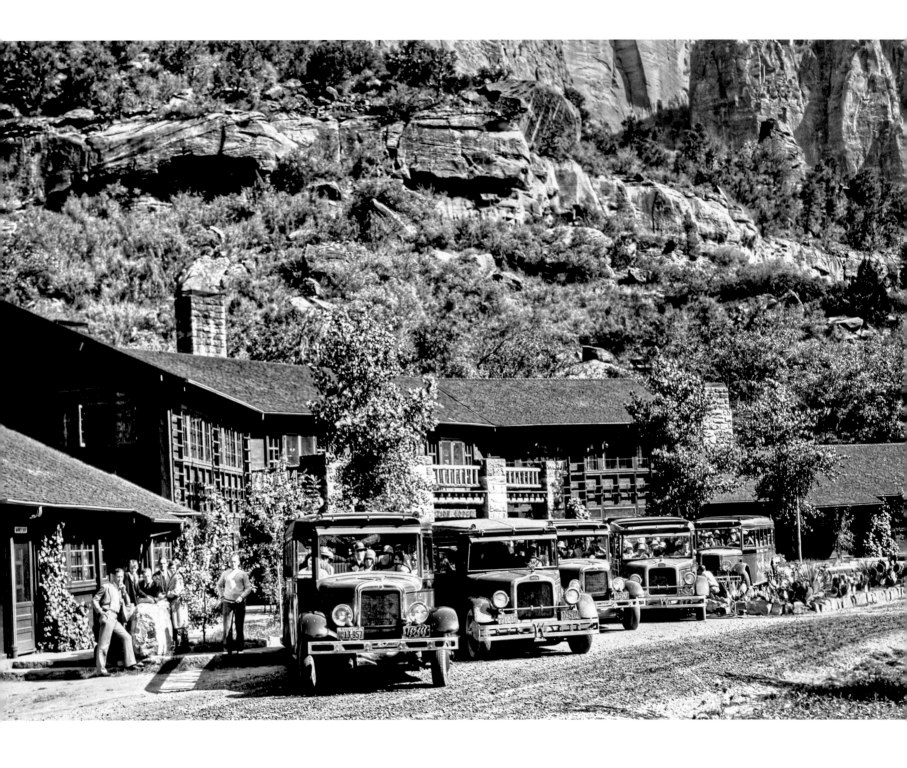

61 Tourists leaving Zion Lodge for the Temple of Sinawava and a trail trip to the Narrows, Zion National Park (September 8, 1929).

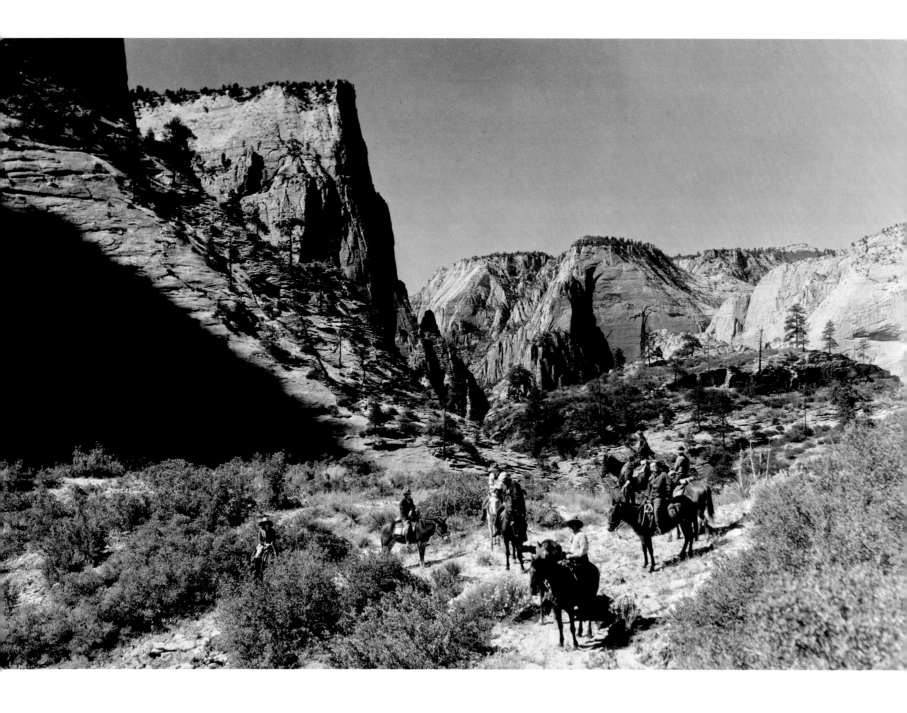

62 Horseback party on the East Rim Trail, Zion National Park (September 12, 1929).

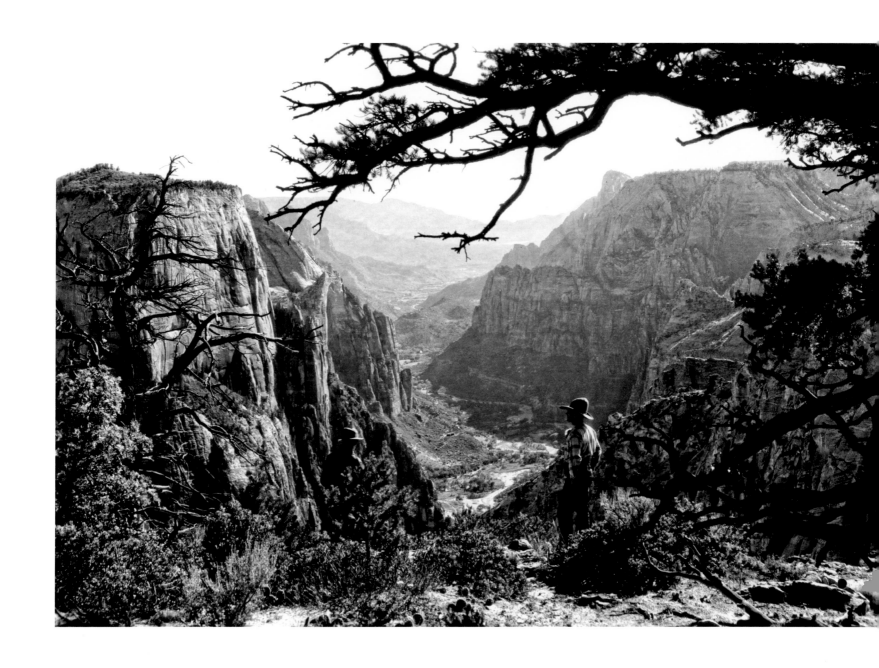

63 View of Zion Canyon from east of the Observation Point, Zion National Park (September 12, 1929).

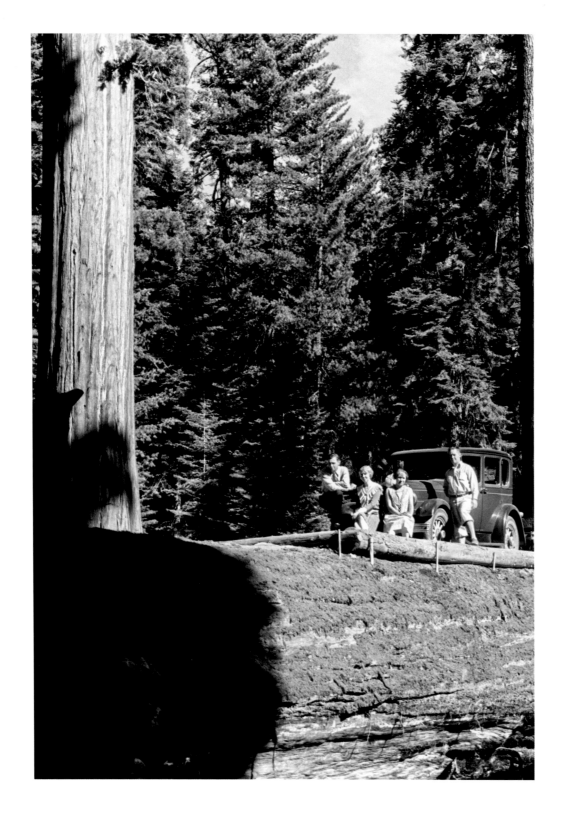

64 Automobile and passengers
on a downed tree trunk, Sequoia
National Park (1929).

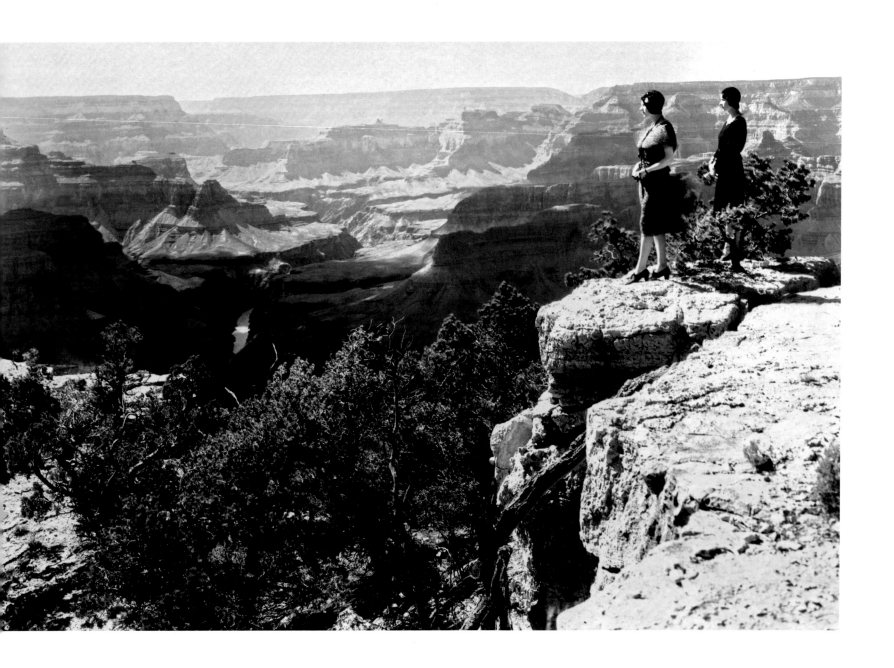

65 View of the canyon looking west, Grand Canyon National Park (June 19, 1930).

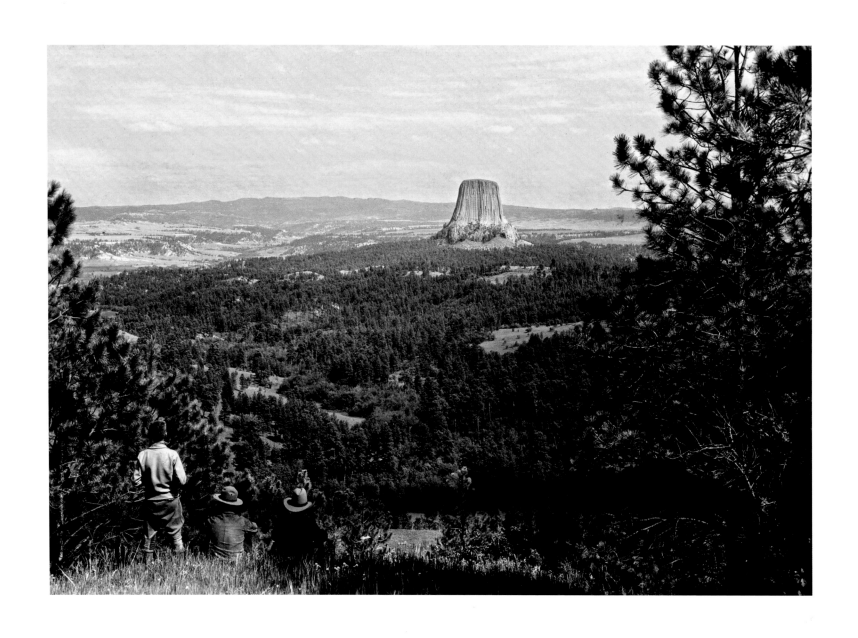

66 Devils Tower from the edge of the mesa, west of George Weaver's ranch, showing
 surrounding wooded area, Devils Tower National Monument (1930).

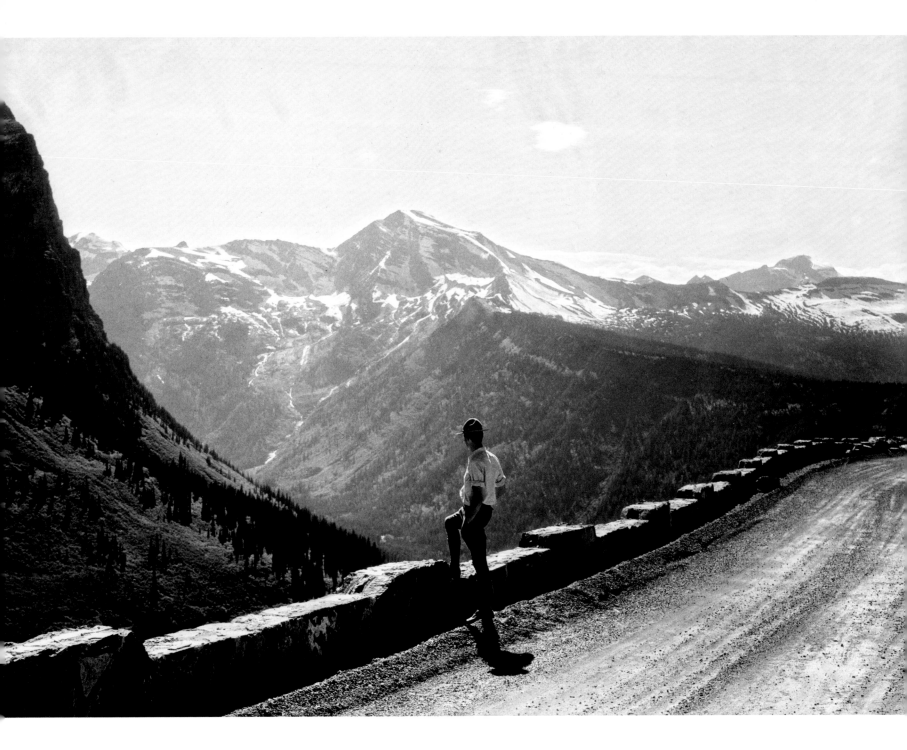

67 Stone parapet along the new Transmountain Highway, Lake McDonald side. The ranger
in the photo shows the height of the parapet, Glacier National Park (July 19, 1932).

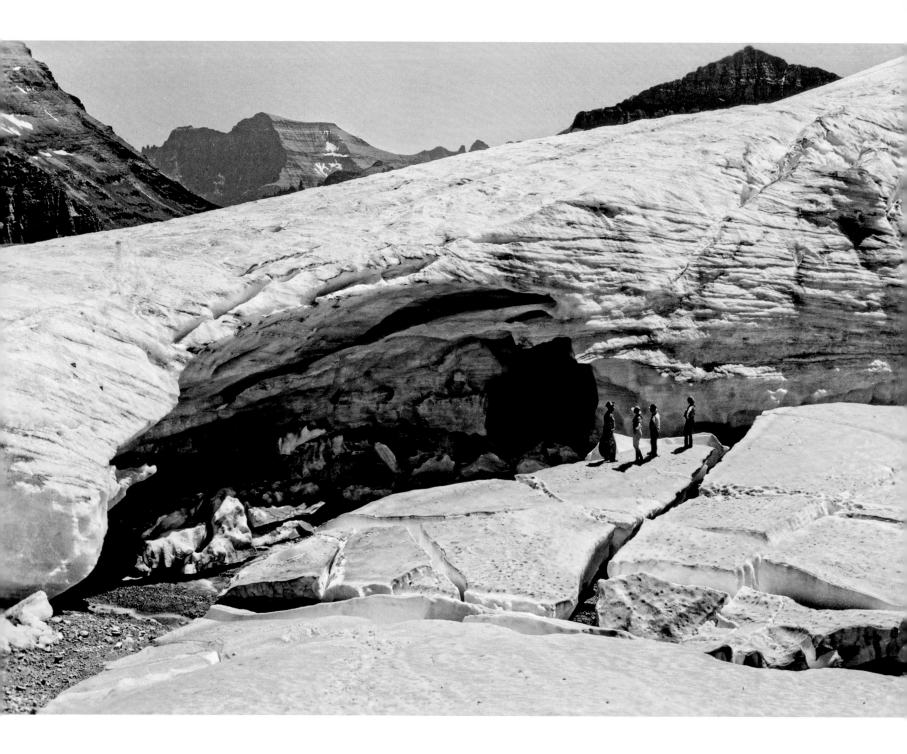

68 Ice cave on the Boulder Glacier, Glacier National Park (July 27, 1932).

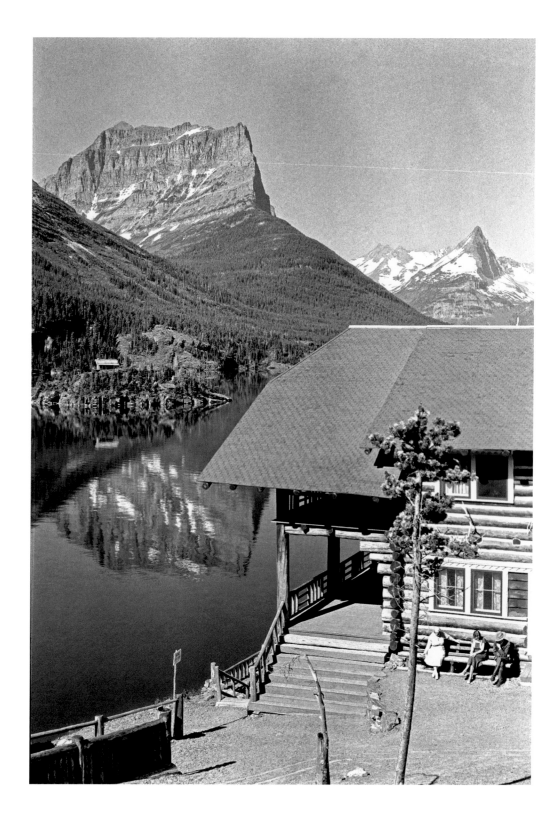

69 Mount Rockwell and Two Medicine
Lake from the Two Medicine Chalet,
Glacier National Park (1932).

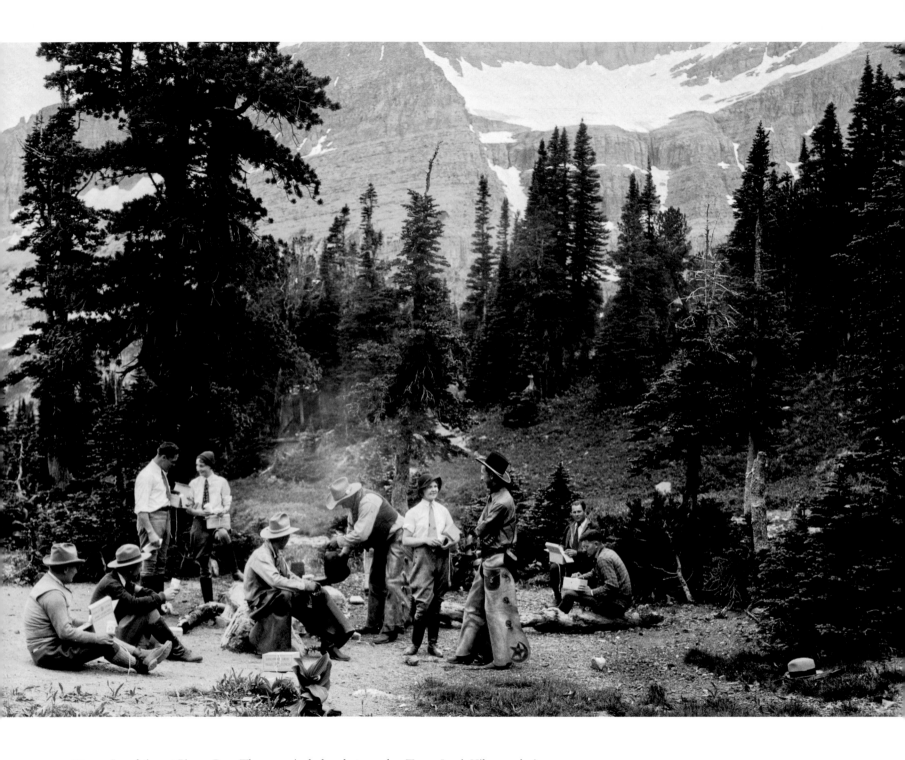

Lunchtime at Piegan Pass. The group includes photographer Tomar Jacob Hileman, during a filming expedition for the Great Northern Railroad, Glacier National Park (1932).

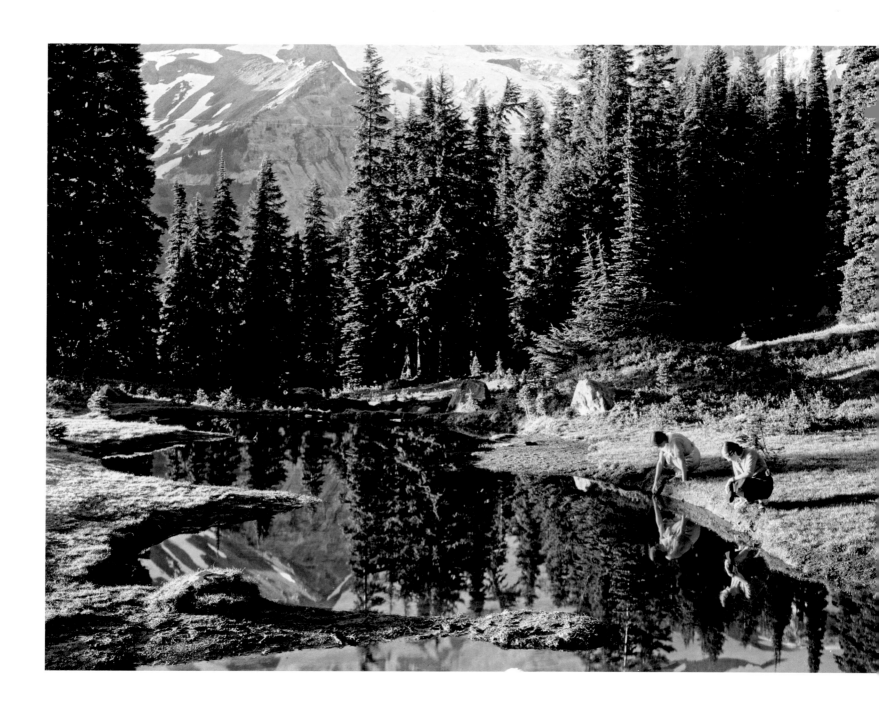

71 Fairy Pool at Paradise Valley, Mount Rainier National Park (1932).

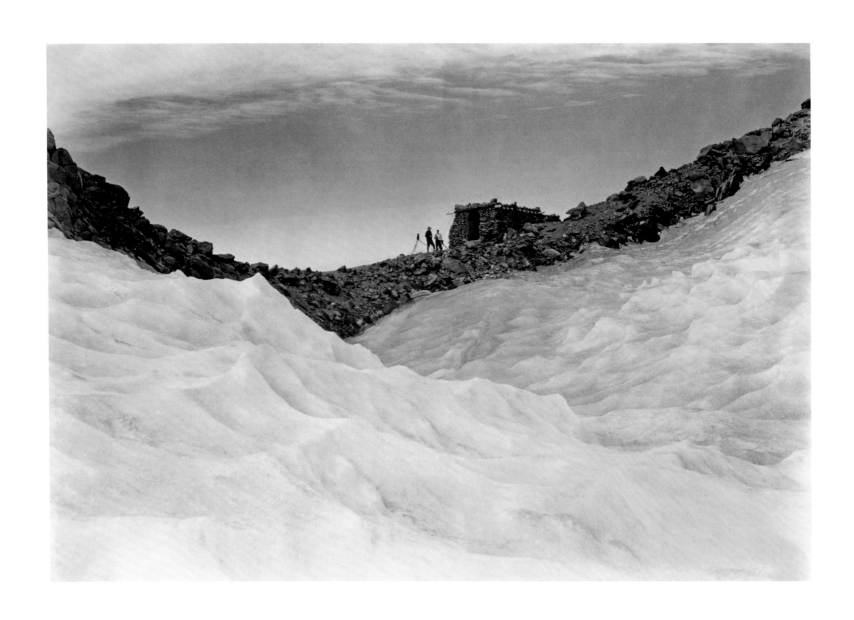

72 National Park Service shelter cabin at Camp Muir, Mount Rainier National Park (1932).

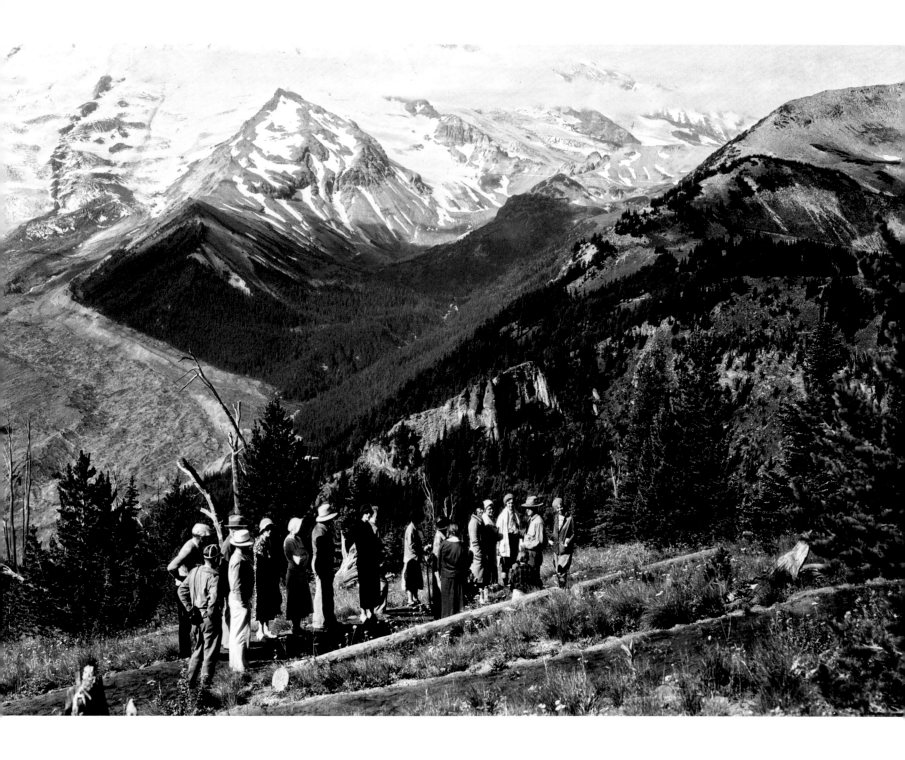

73 Nature guide party on the trail with Ranger Hormuth at Sunrise, Mount Rainier National Park (1932).

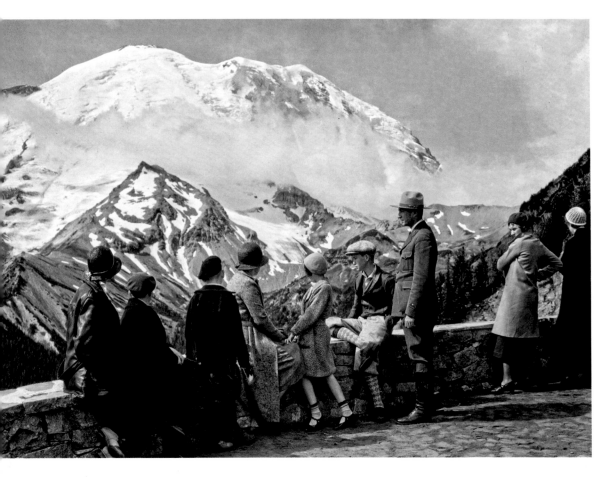

74 Grace Albright, wife of Horace Albright, with children Marian and Bob
and Superintendent Owen Tomlinson and his family at the lookout point on
the loop trail north of Sunrise Lodge, Mount Rainier National Park (1932).

75 Tourists enjoy a view of Mount Rainier from Ricksecker Point,
Mount Rainier National Park (1932).

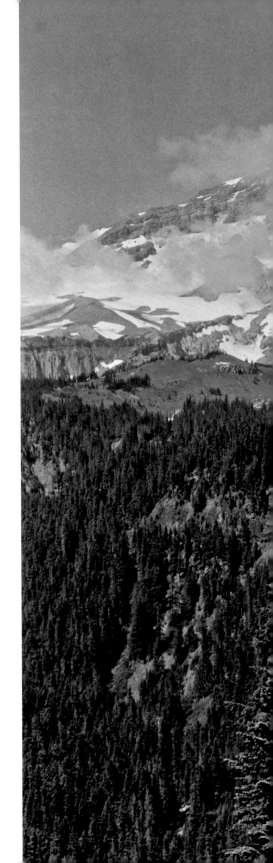

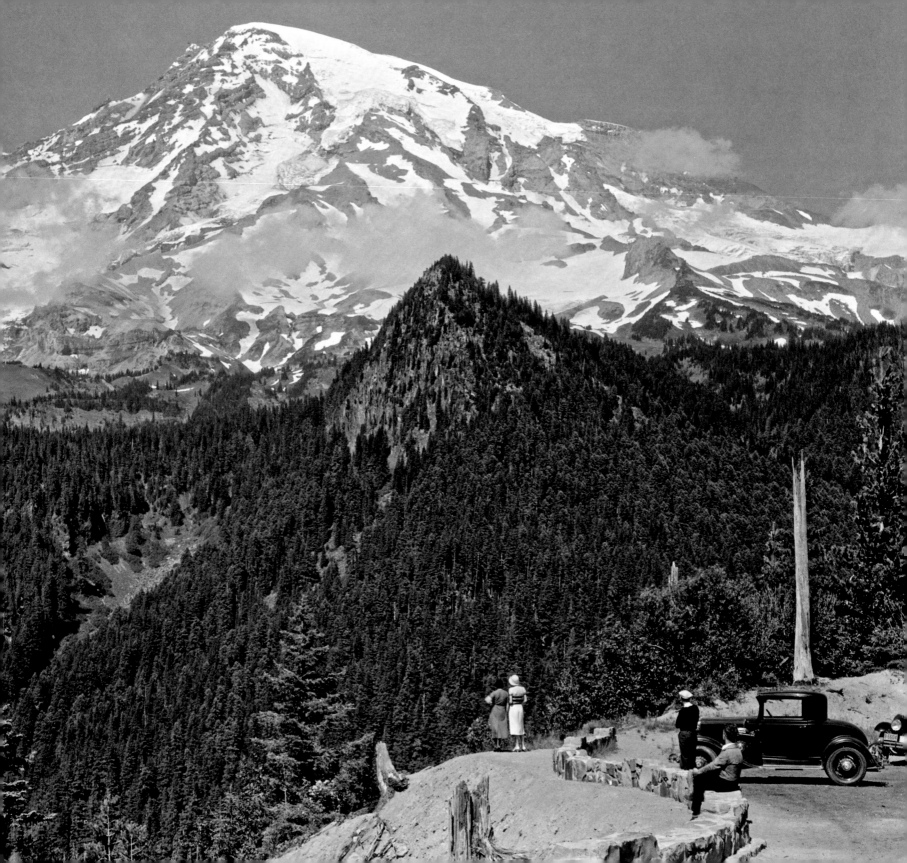

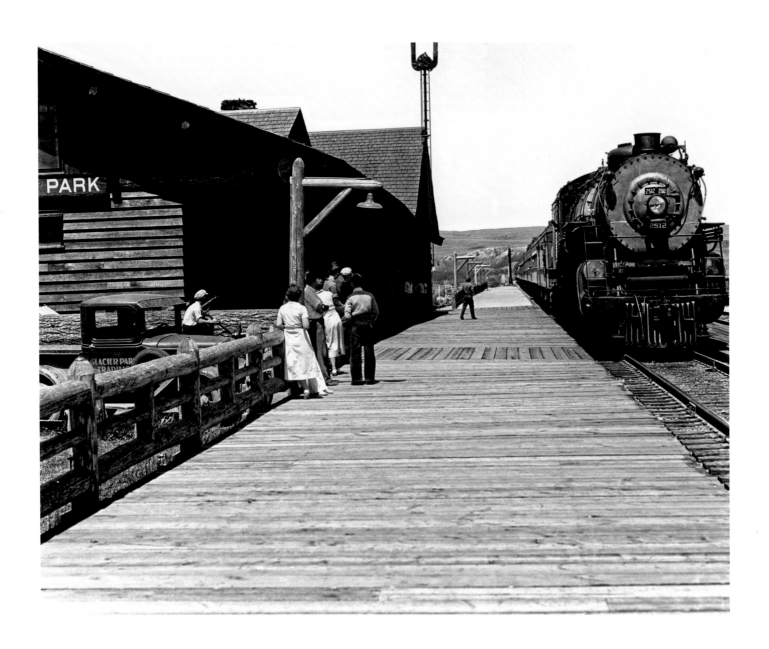

76 The *Empire Builder* arriving at Glacier Park Station outside Glacier National Park (1933).

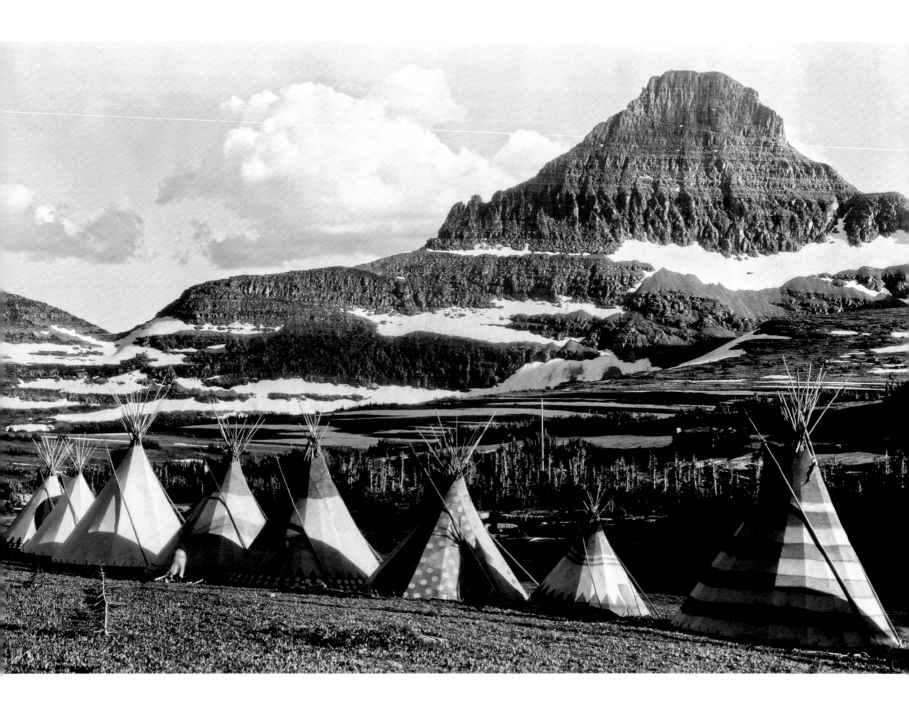

77 Blackfoot tepees near the summit of Logan Pass and beneath Mount Reynolds, in preparation for the
dedication ceremony of the Going-to-the-Sun Road, Glacier National Park (July 14, 1933).

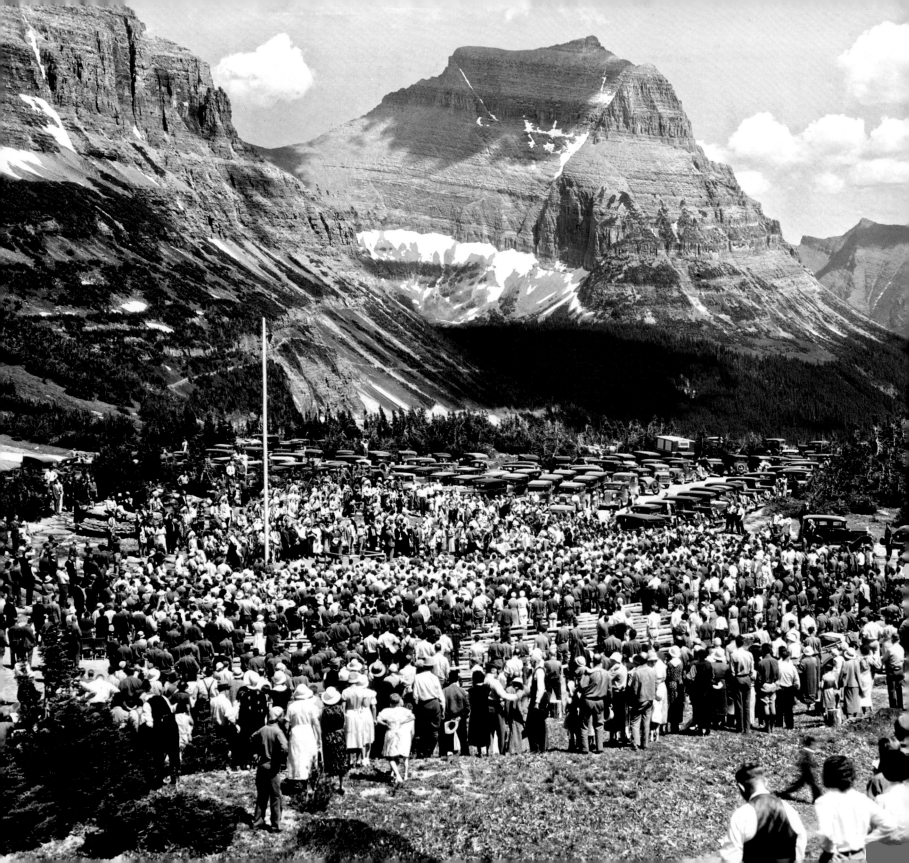

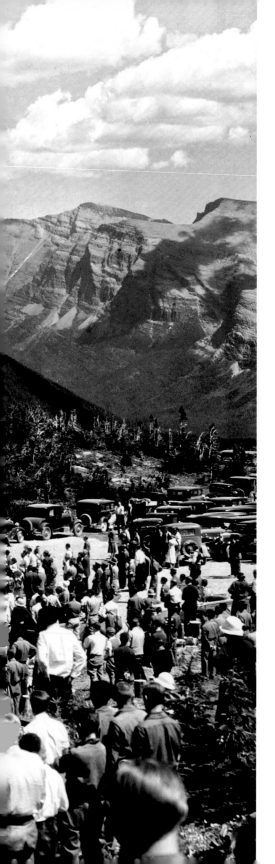

78 Gathering at the summit of Logan Pass during the dedication of the Going-to-the-Sun Road.
The crowd is singing "America the Beautiful," Glacier National Park (July 15, 1933).

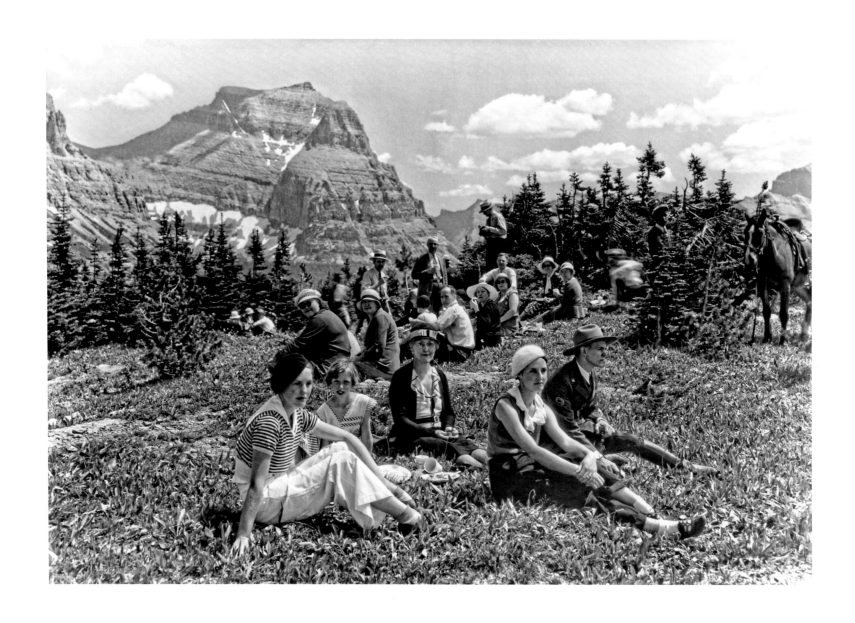

79 Visitors enjoying the dedication ceremony for the Going-to-the-Sun Road, Glacier National Park (July 15, 1933).

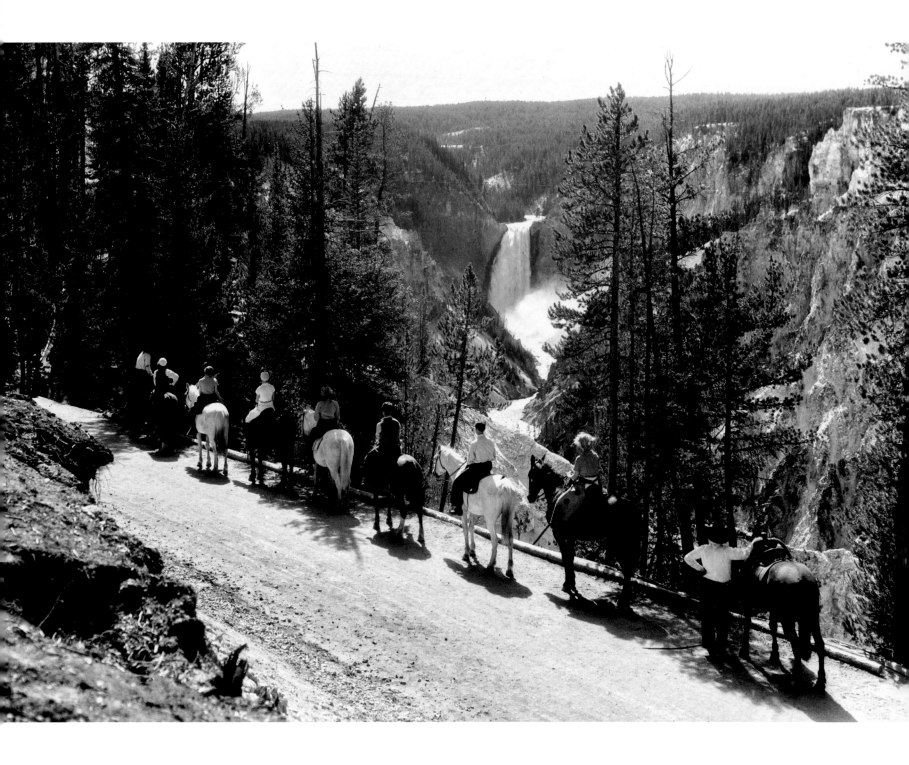

80 Horseback party along the rim of the canyon near Artist's Point, Yellowstone National Park (July 30, 1933).

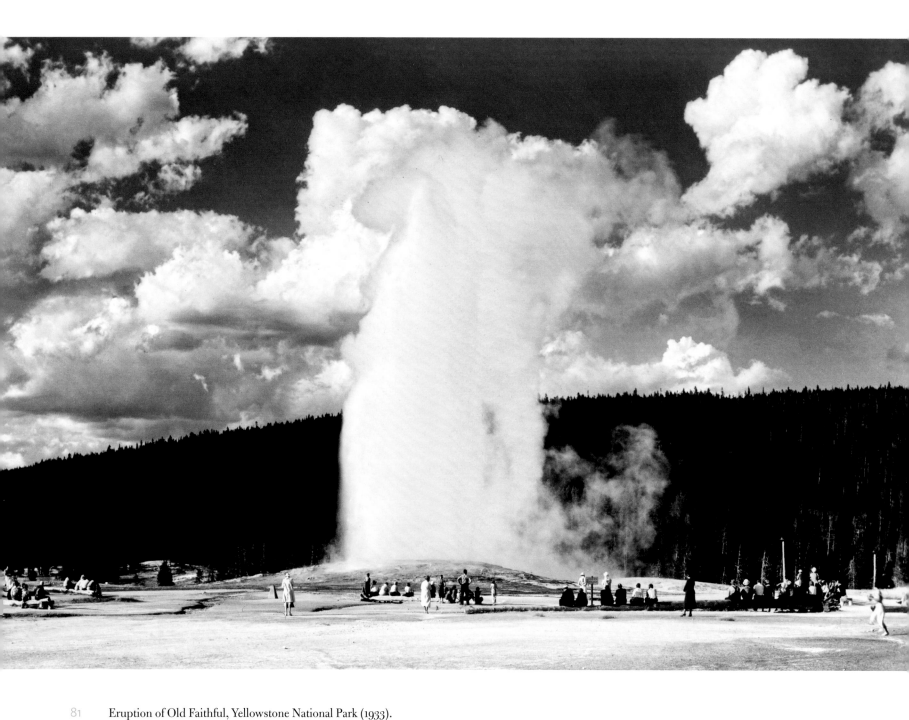

81 Eruption of Old Faithful, Yellowstone National Park (1933).

Trail leading to the base of the limestone wall at the head of Taggard Canyon. Rangers Montgomery and Ballew, with pack mule and horse, are in the foreground, Grand Teton National Park (1933).

83 Jackson Lake and the Tetons from the small island out from CCC Camp no. 2. Enrollees Ray Ickes
and Ned Munn are on the rocks in the foreground, Grand Teton National Park (1933).

84 View south from summit of Mount Tamalpais, showing Mill Valley, Richardson Bay, Sausilito,
and San Francisco, Muir Woods National Monument (September 7, 1933).

85 Camping at the Jenny Lake campground, Grand Teton National Park (July 21, 1934).

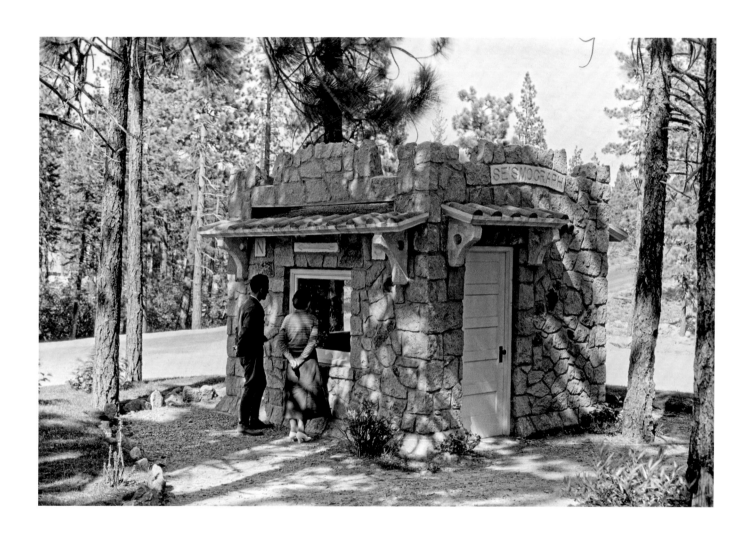

Seismograph in a small building near the museum at Manzanita Lake, Lassen Volcanic National Park (August 5, 1934).

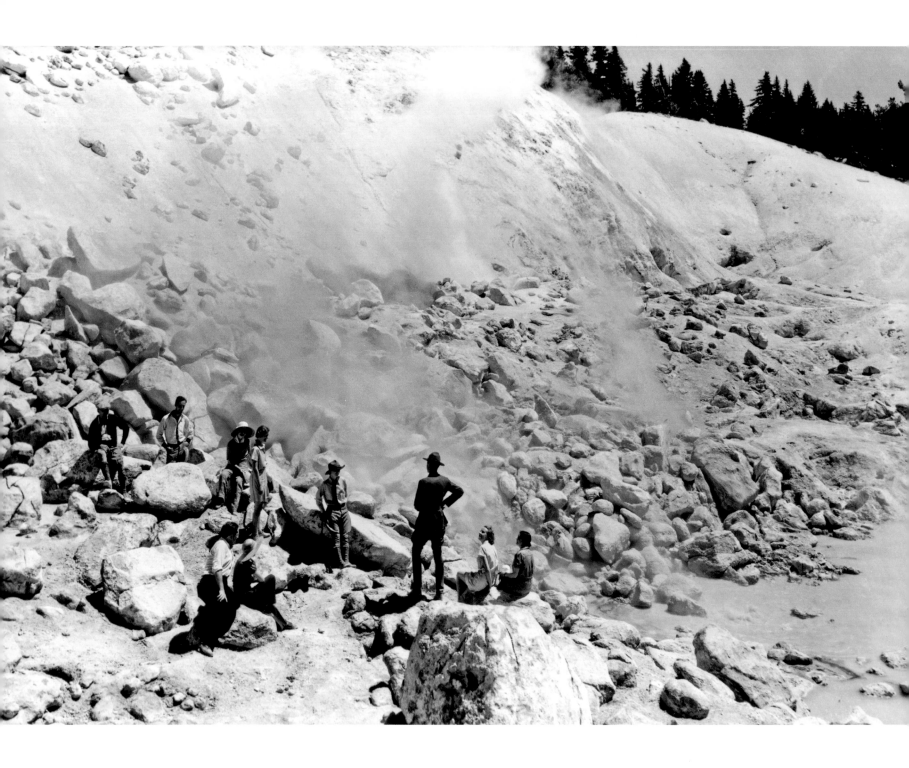

87 Visitors with a ranger at Bumpass Hell, Lassen Volcanic National Park (1934).

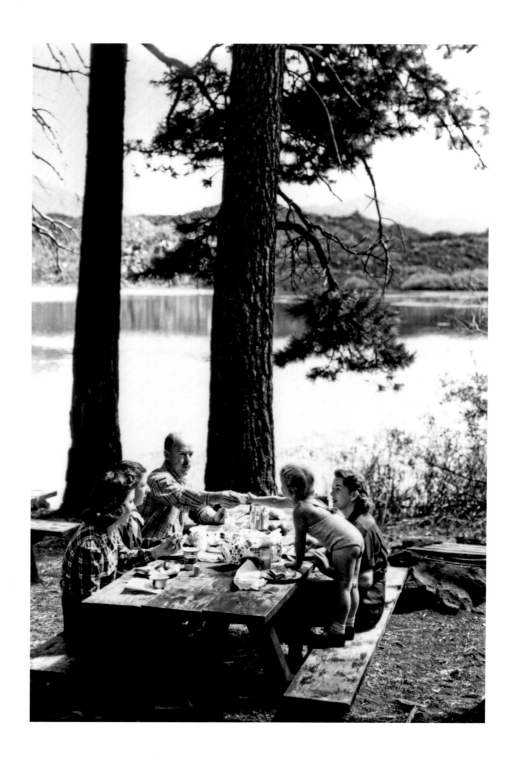

88 Picnicking at Manzanita Lake, Lassen Volcanic National Park (1934).

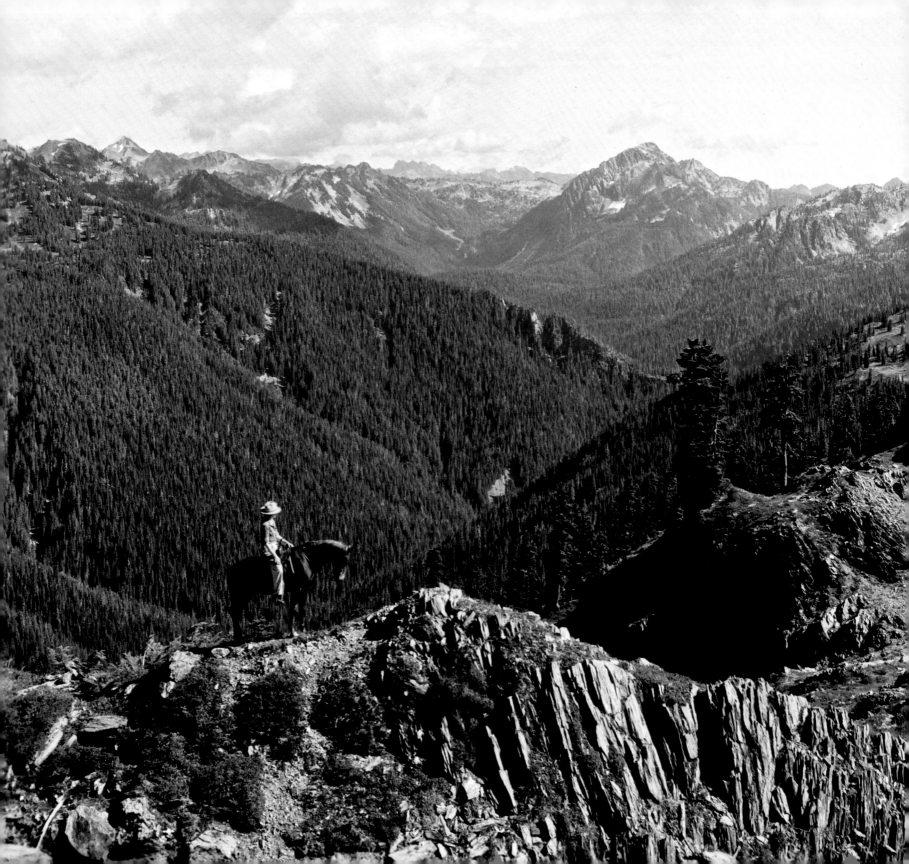

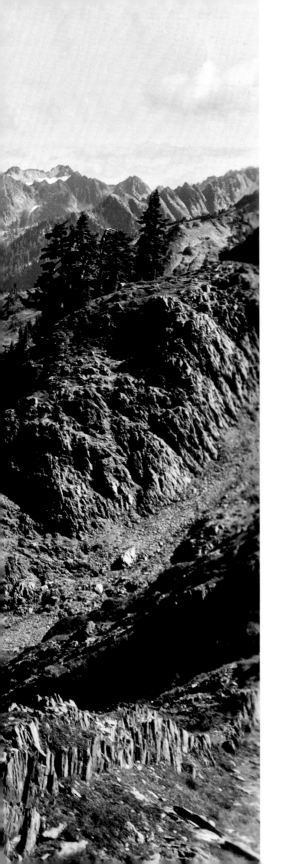

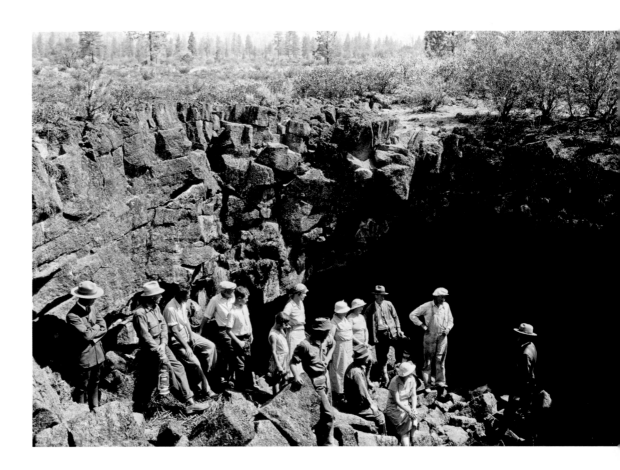

89 Ranger naturalist and visitors at the mouth of a lava tube, Lassen Volcanic
National Park (August 6, 1934).

90 View of Seattle Creek toward Mount Muncaster from the High Divide,
proposed Olympic National Park (1934).

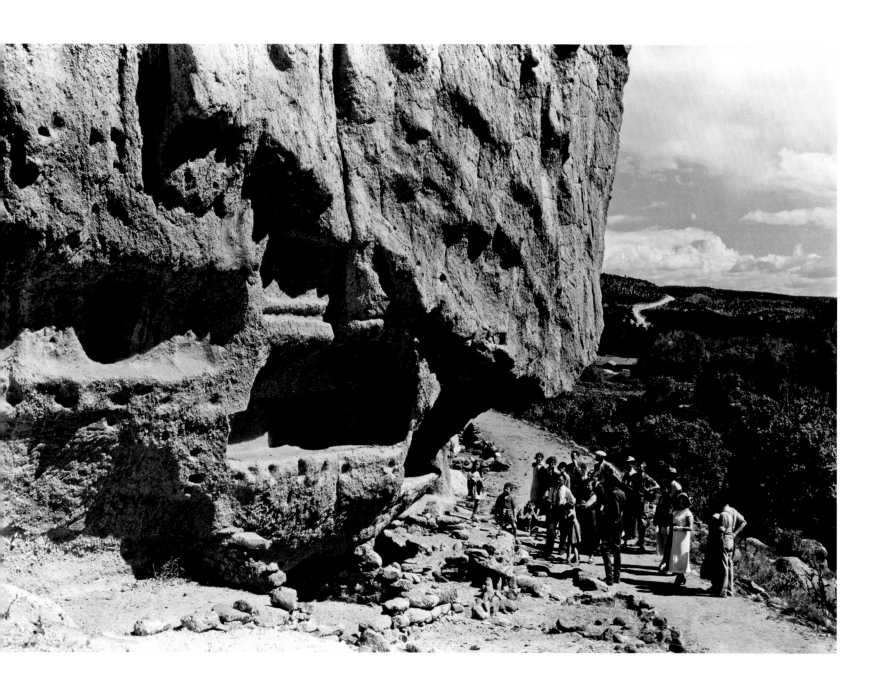

91 Visitors being led by a ranger on the trail through the Frijoles Canyon ruins, Bandelier National Monument (August 30, 1934).

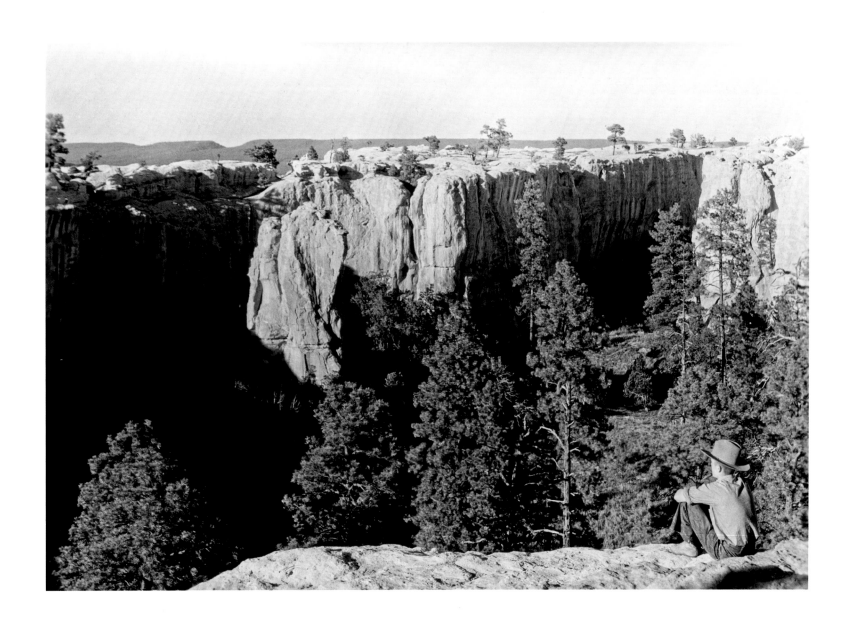

View into the *rincón* that enters El Morro from the southwest and separates the two large surface ruins on top. The north surface ruin is on the opposite rock, El Morro National Monument (September 24, 1934).

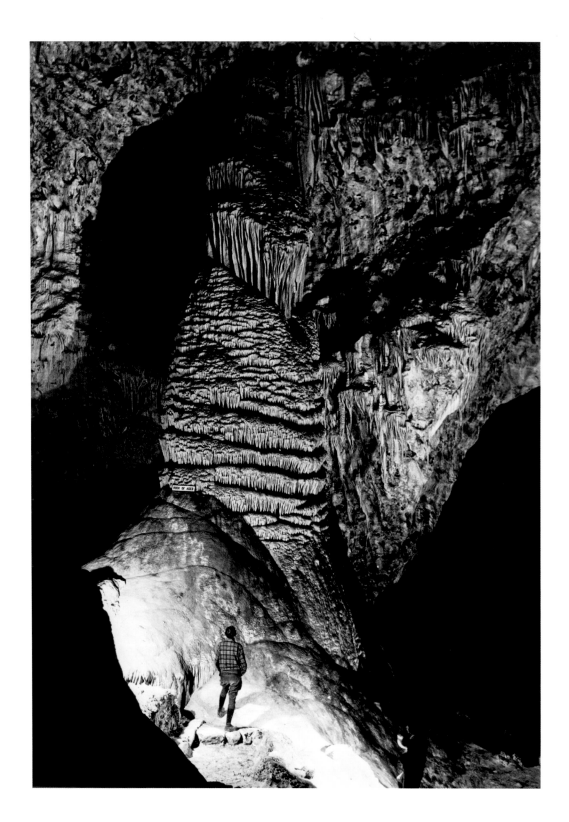

93 Onyx draperies called
the Elephant's Ear, in the
Queen's Chamber, Carlsbad
Caverns National Park
(October 26, 1934).

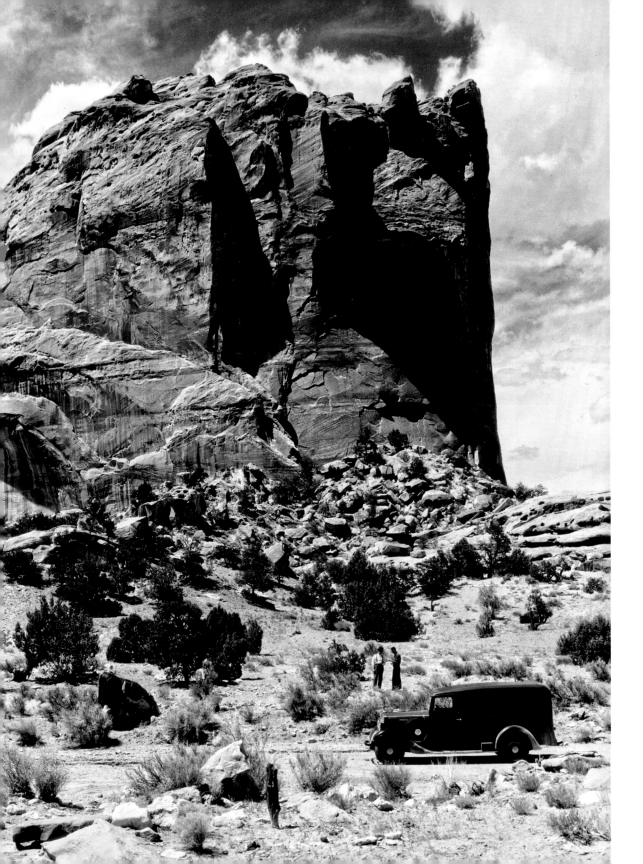

94 One of the many high cliffs in Grand Gorge, Capitol Reef National Park. Note Grant's Hearse in the foreground (1935).

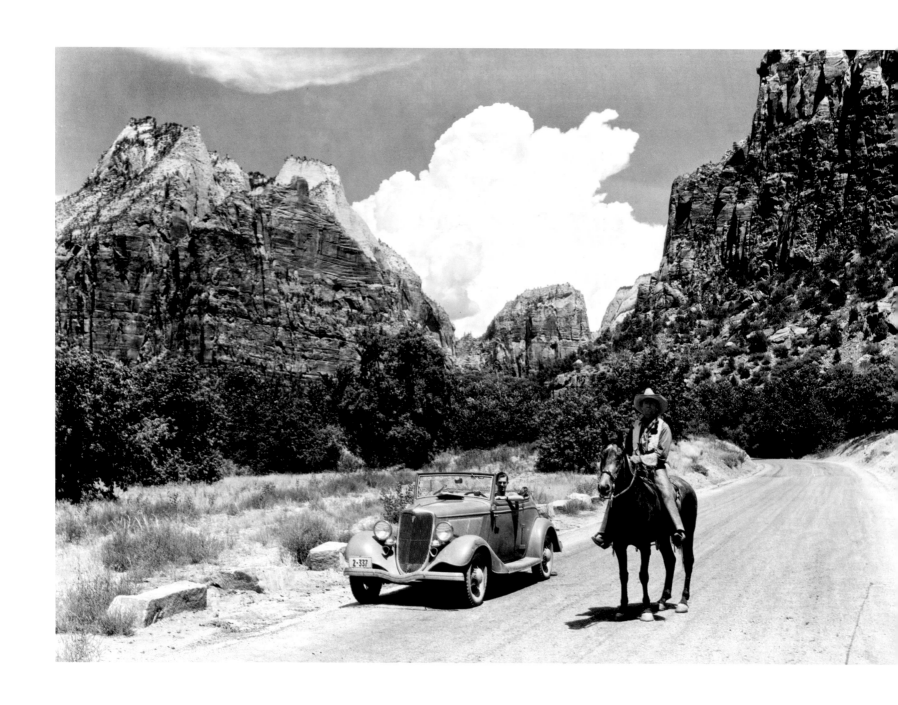

95 Henry Wallace in the car and Walt Beatty on the horse, Zion National Park (1935).

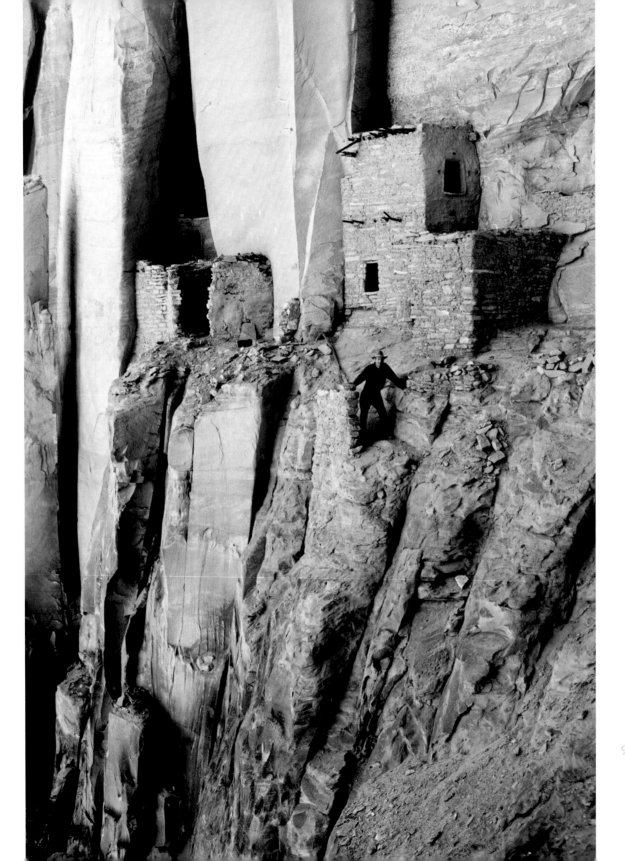

96 Interior of Keet Steel Rim,
 Navajo National Monument
 (September 17, 1935).

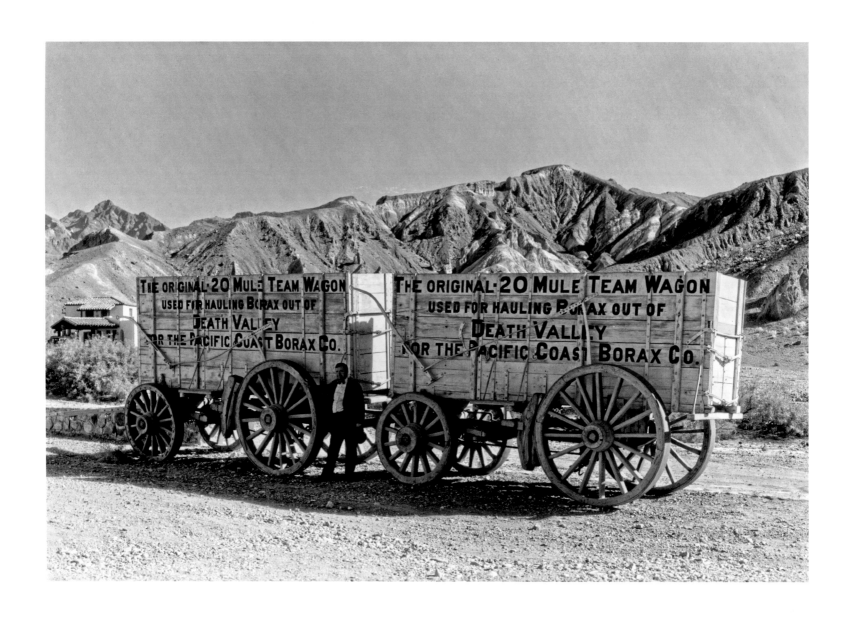

97 Two of the original Twenty-Mule–Team Borax wagons on display at Furnace Creek Inn,
Death Valley National Park (November 28, 1935).

98 Rim of a bluff near Artist's Point in Yellowstone Canyon. It is not as dangerous as it looks, Yellowstone National Park (August 15, 1936).

99 Park ranger on horseback beneath large spruce and cedar trees near the old Olympus
Ranger Station, proposed Olympic National Park (August 28, 1936).

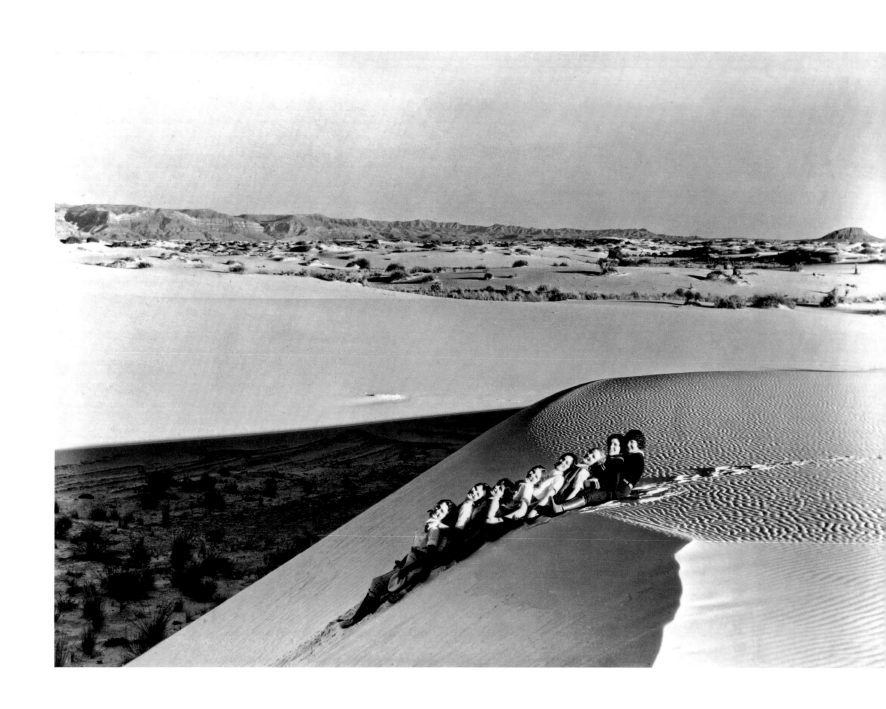

Sands of pure gypsum are perfect for sliding, White Sands National Monument (1936).

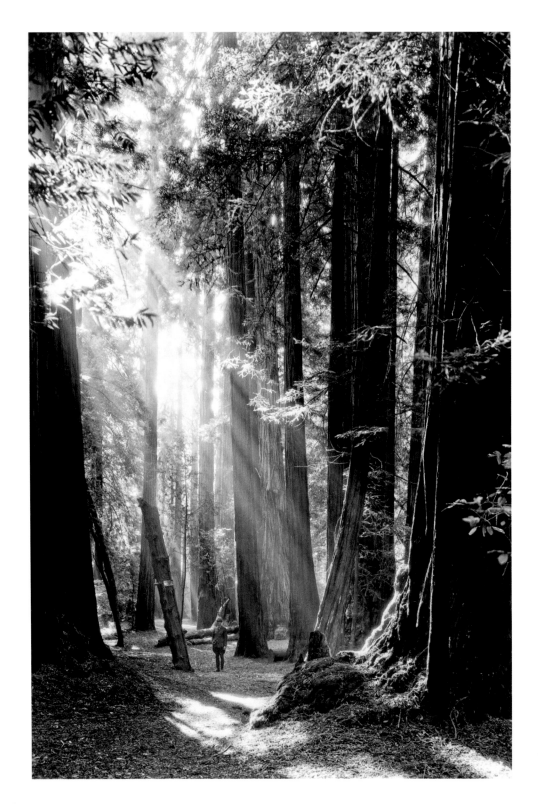

101 Hiker enjoying the sun streaks, Muir Woods
National Monument (October 14, 1936).

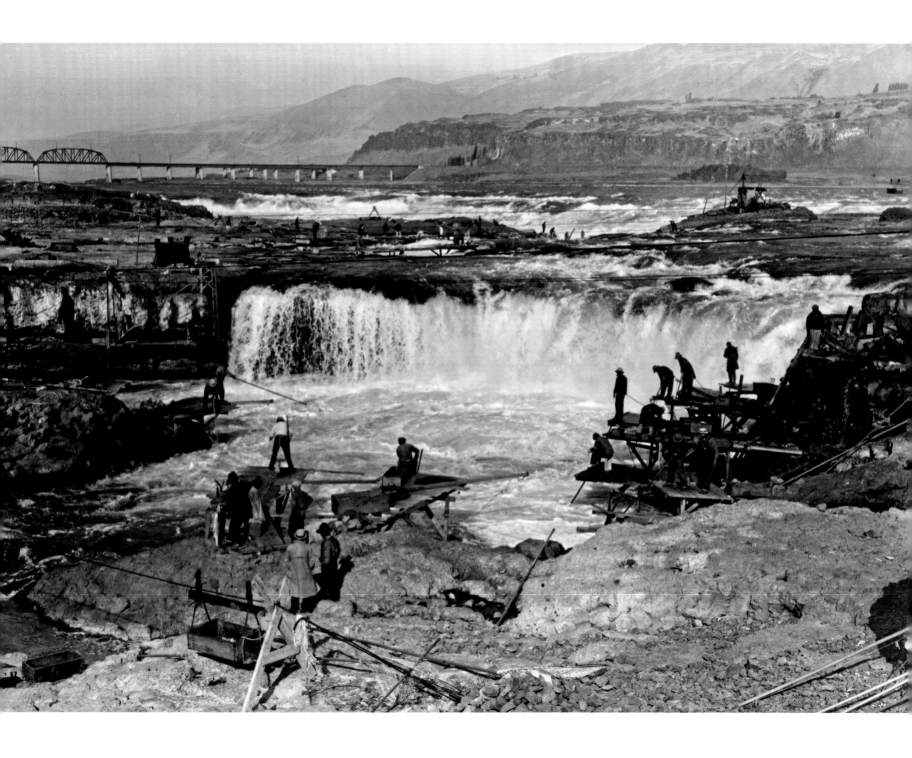

102 Indian fishermen at work on a salmon run at Celilo Falls, Columbia River above
the Dalles, future North Cascades National Park (September 20, 1937).

103 Visitors touring newly opened Boulder (Hoover) Dam, near the octagonal platform surmounted
by signs of the Zodiac, Lake Mead National Recreation Area (October 3, 1939).

Fishing for bass, Lake Mead National Recreation Area (October 8, 1939).

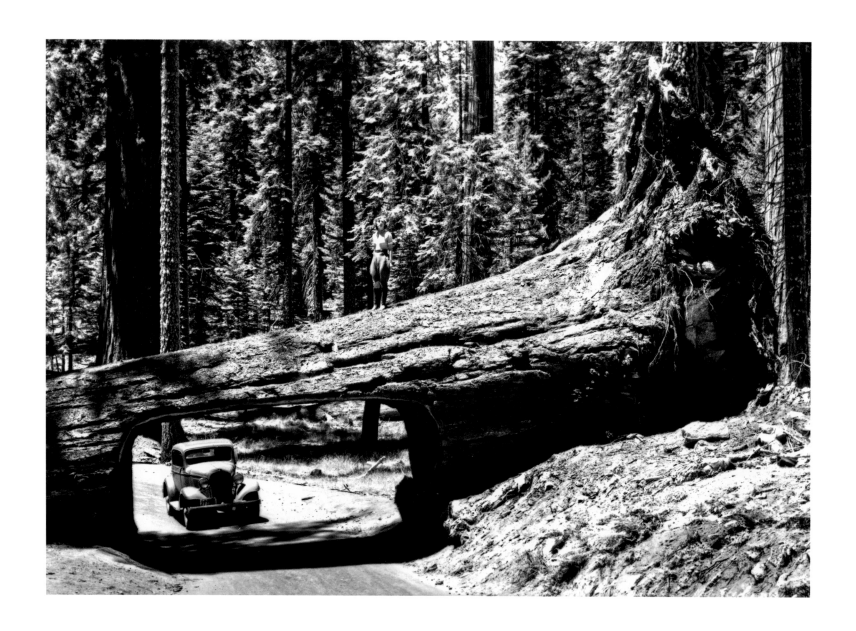

105 Automobile approaching Tunnel Tree on Crescent Meadow Road, Sequoia and Kings Canyon National Parks (July 17, 1940).

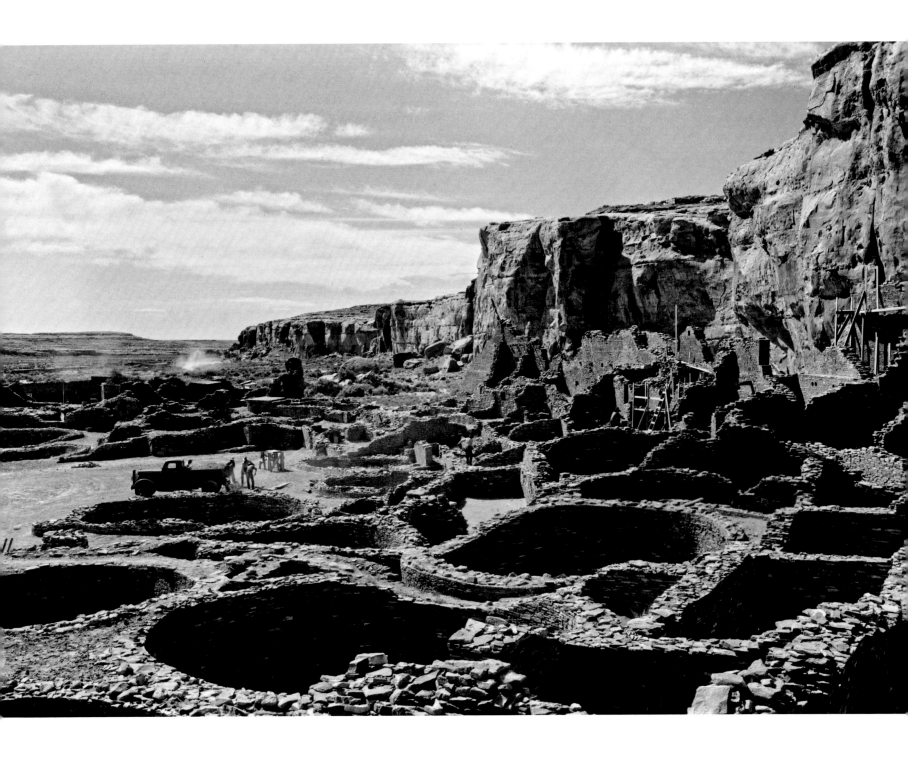

106 Navajo Indians employed by the CCC at work refinishing the edge of the walls at Pueblo Bonito, Chaco Culture National Historical Park (1940).

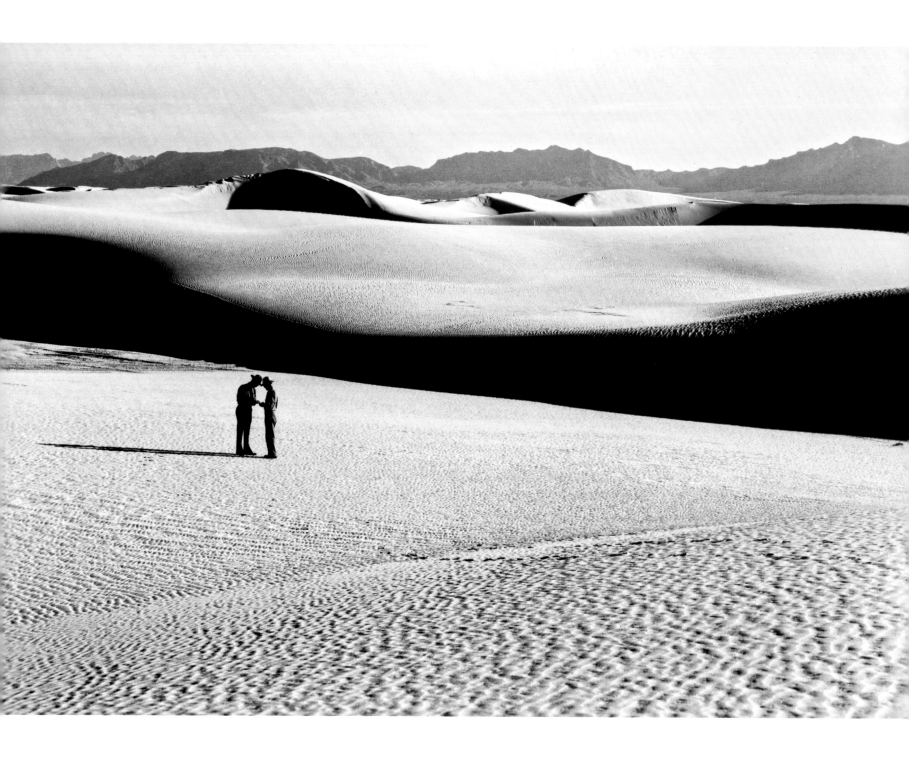

107 The White Sands and the San Andreas Mountains, White Sands National Monument (1940).

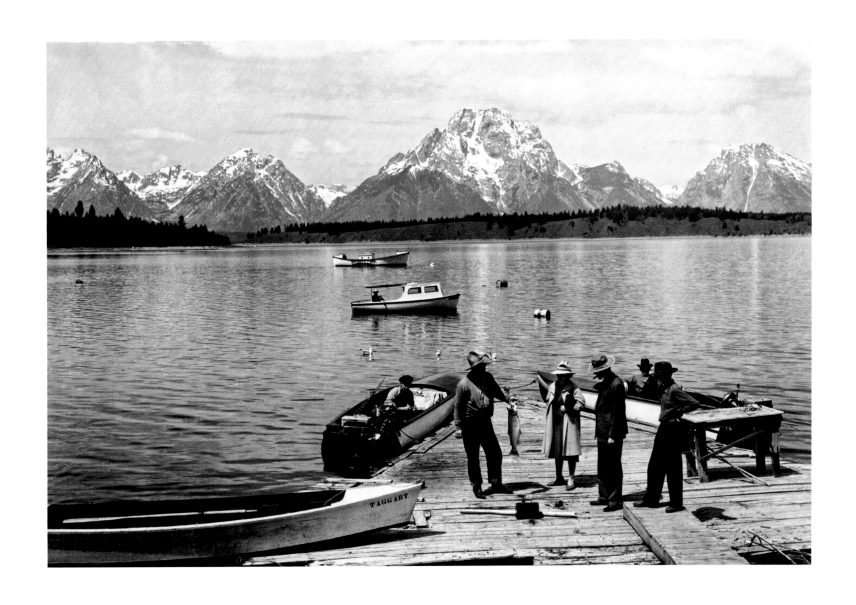

Skipper displaying seven-and-a-half-pound cutthroat trout, native, caught from the dock, Grand Teton National Park (June 15, 1941).

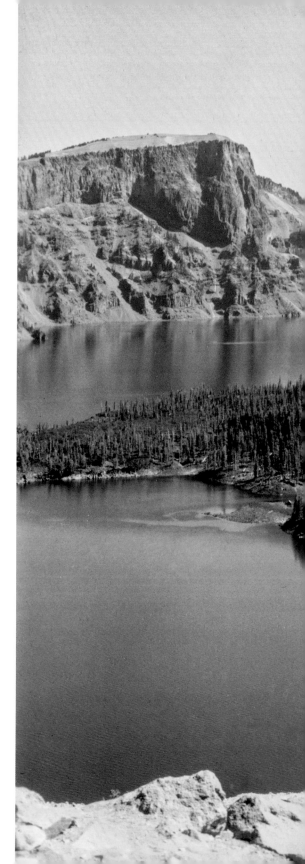

109 Ranger naturalist with visitors on the rim of the lake, Crater Lake National Park (July 24, 1941).

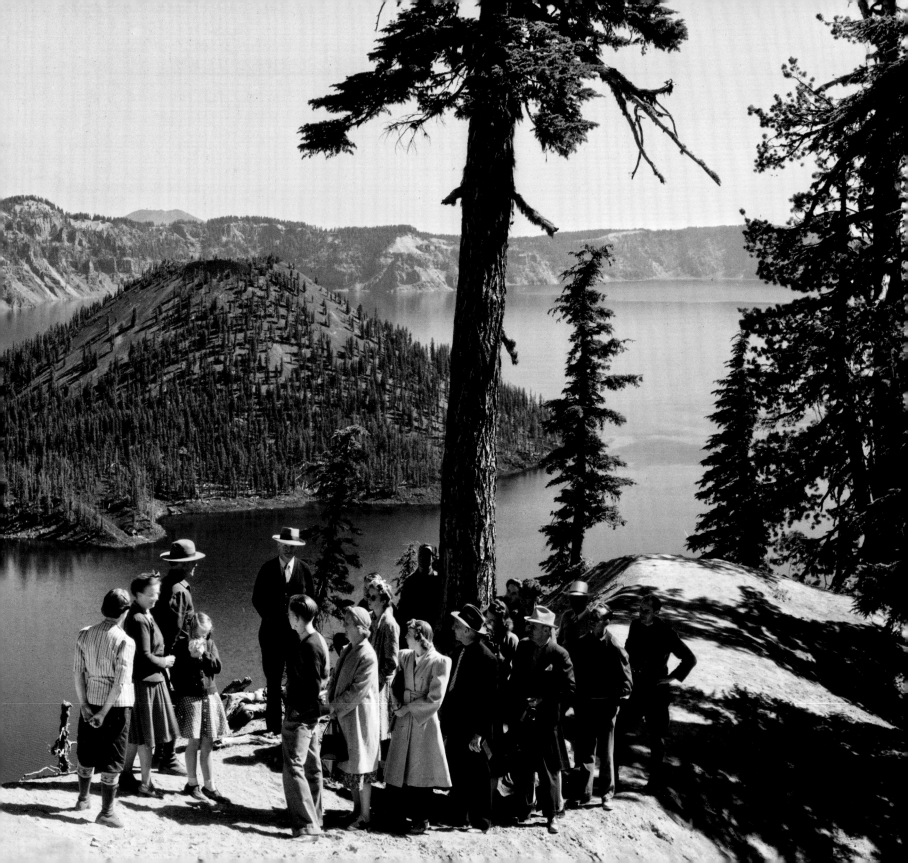

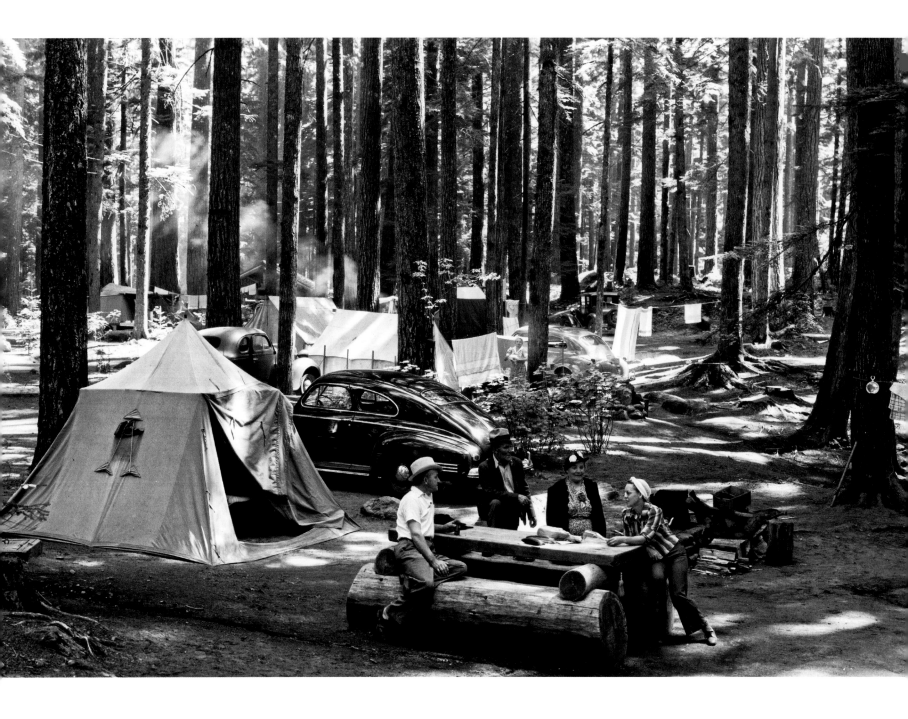

110 Campground at Ohanapecosh Springs, Mount Rainier National Park (August 7, 1941).

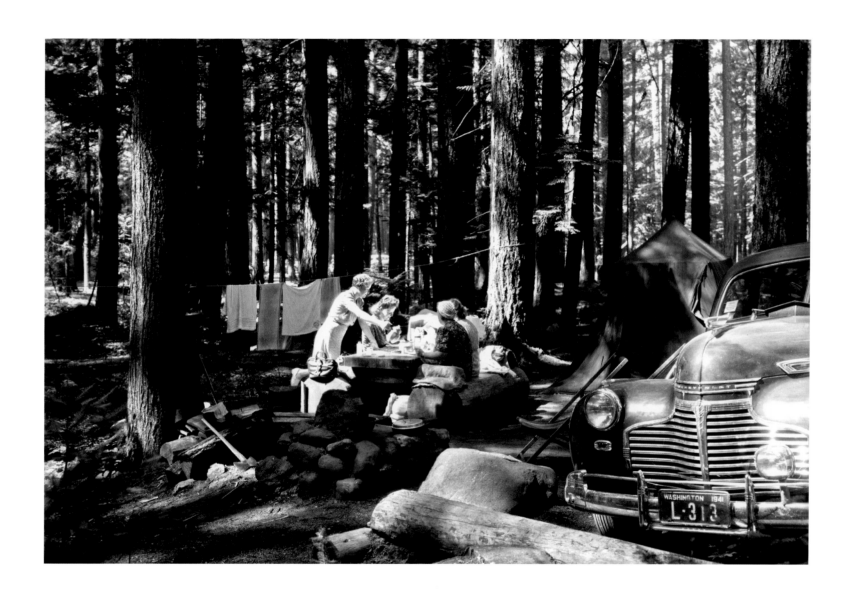

111 Breakfast at Ohanapecosh Springs Campground, Mount Rainier National Park (August 11, 1941).

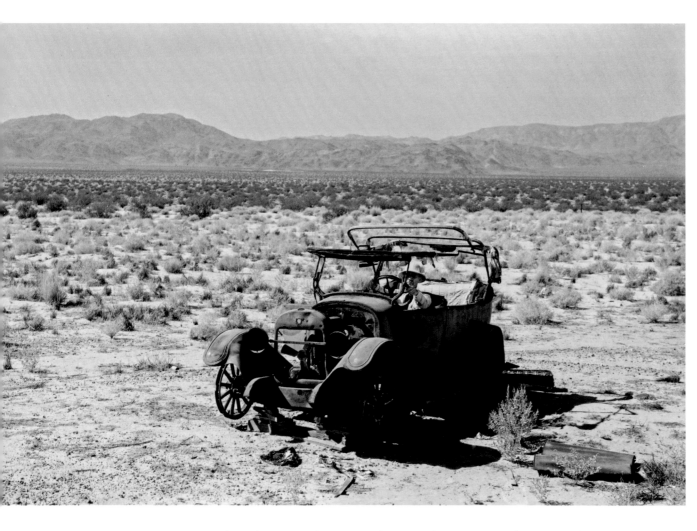

112 Dr. J. Velmey Lewis needs good transportation to cover the area, Joshua Tree National Monument (1941).

113 Visitors inspecting an obsidian rock from the talus on Glass Mountain, Lava Beds National Monument (1941).

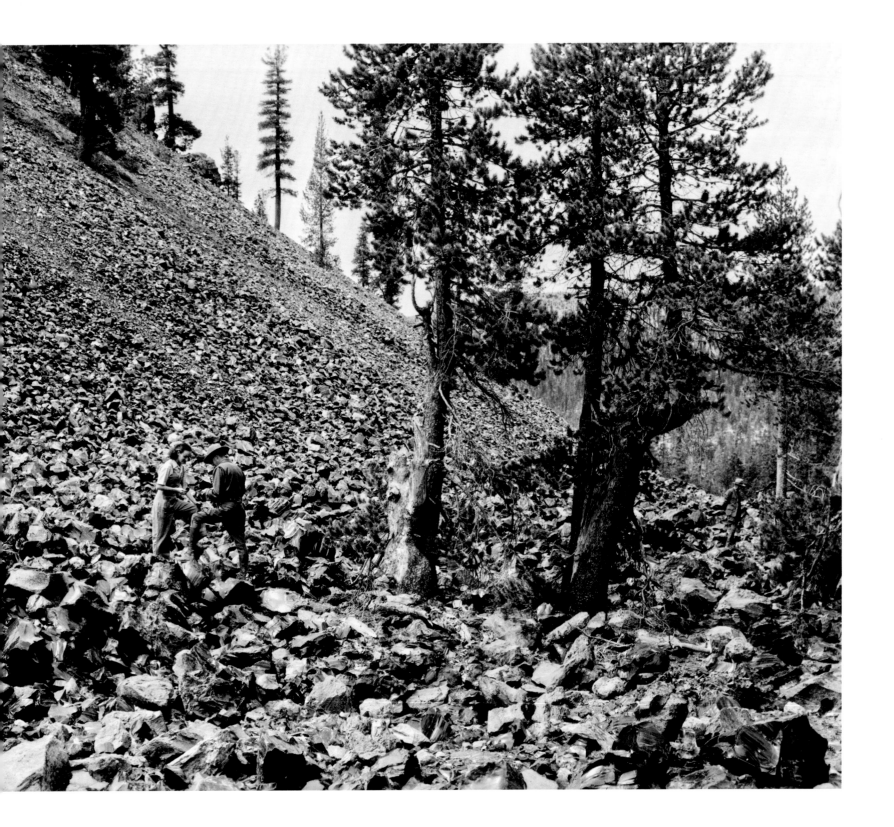

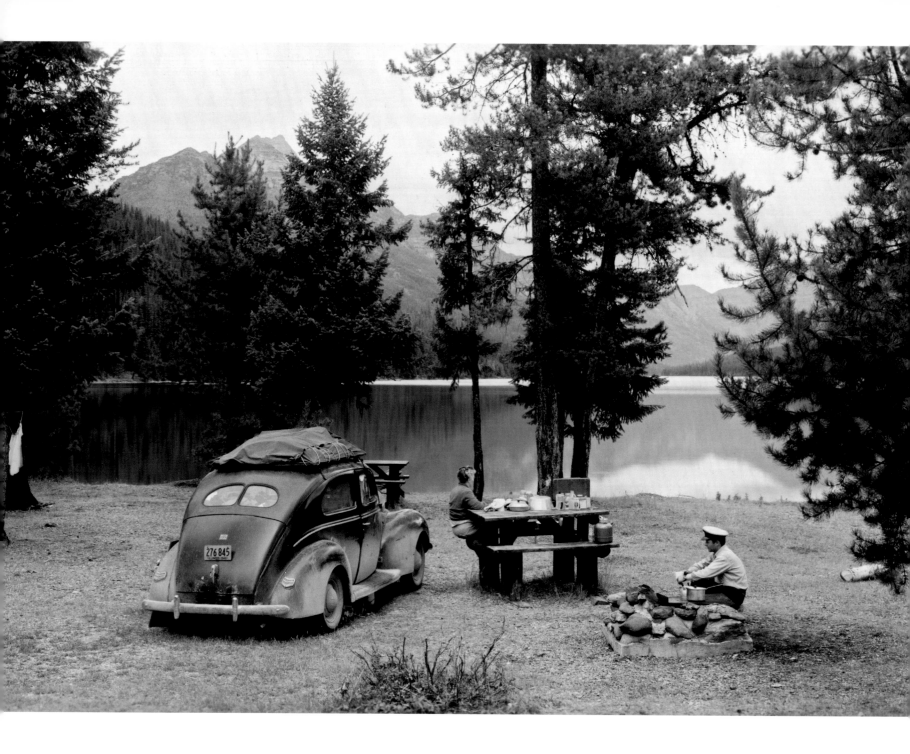

114 Car camping, Glacier National Park (1948).

Portraits, Special Assignments, and Technical Images

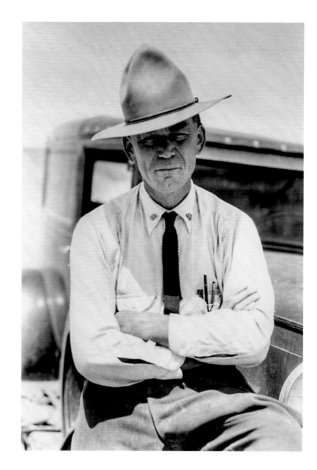

115 Frank Pinkley, superintendent of
Southwestern Monuments, Casa Grande Ruins
National Monument (July 16, 1929).

116 T-shaped doorway at Balcony House.
Emmett Harryson, a Navajo, is in the
doorway, Mesa Verde National Park
(August 21, 1929).

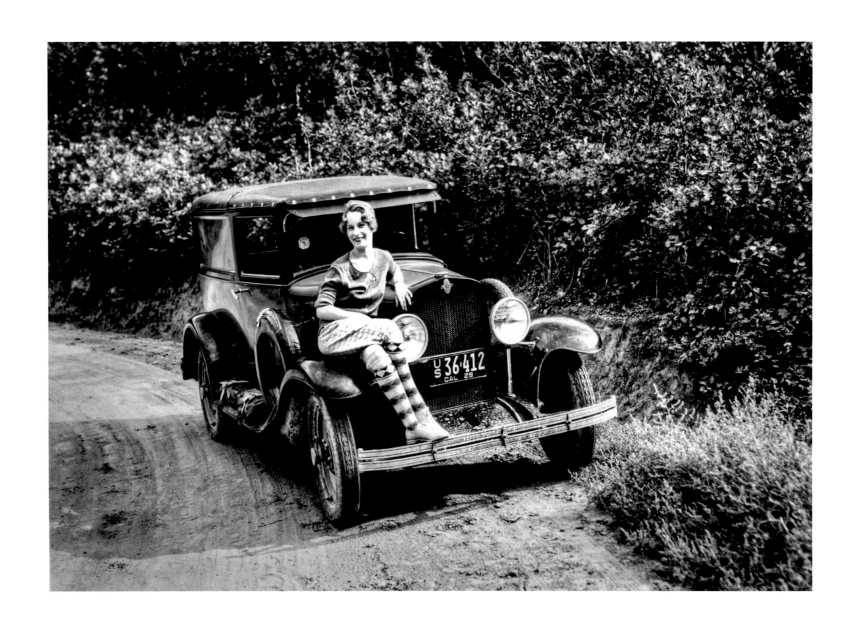

117 Model with Photographic Department car, Mesa Verde National Park (August 21, 1929).

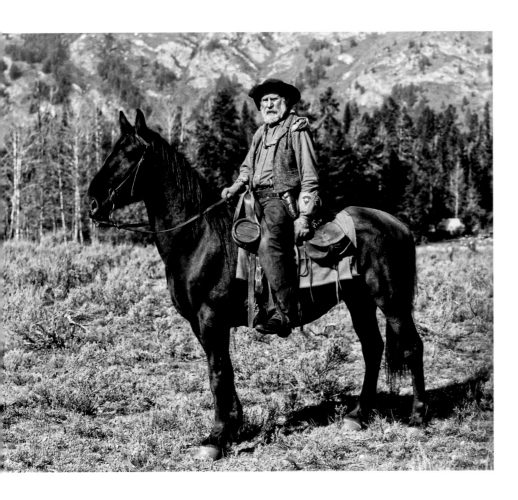

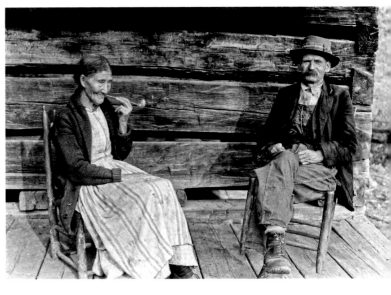

118 "Dad" Adam N. Keith, an old-timer who ran a string of horses during the summers and wintered three hundred miles away each October in Powder River, Wyoming. Keith witnessed many incidents in the Johnson County War and served as an outfitter and backcountry ranger at Grand Teton National Park (September 28, 1930).

119 Aunt Sophie and Uncle Tom Campbell are seated on the front porch of their rustic log cabin near Gatlinburg, Tennessee, Great Smoky Mountains National Park (November 10, 1931).

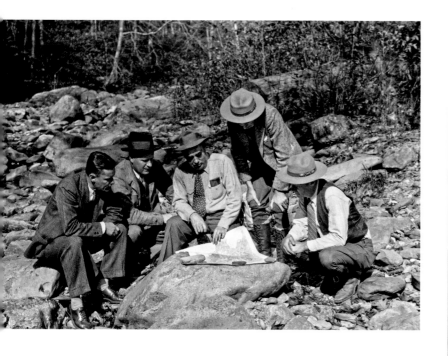

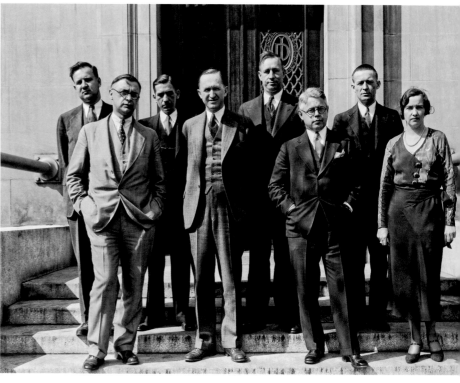

120 Conducting a preliminary survey of Great Smoky Mountains National Park's boundaries are (*left to right*) Arthur P. Miller, John Needham, J. Ross Eakin, Oliver G. Taylor, and Charles E. Peterson. The survey party is shown looking at a map while stopped along Bradley Fork in North Carolina (1931).

121 National Park Service headquarters staff (*left to right*): Conrad Wirth, Arno Cammerer, R. M. Holmes, Horace Albright, Harold Bryant, Arthur Demaray, George A. Moskey, and Isabelle Story (1932).

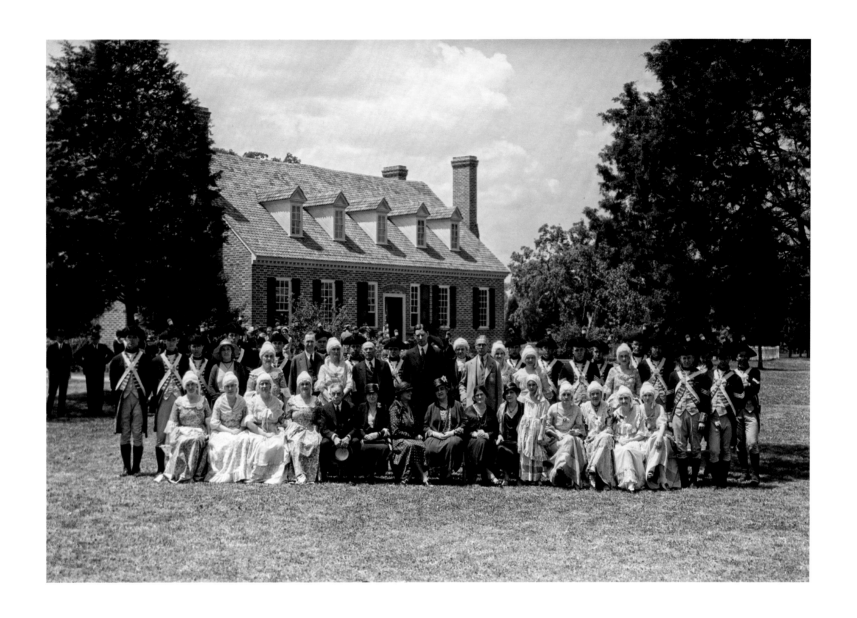

Interior Secretary Ray Wilbur (*center, standing*) and a group of Colonial Dames, Monticello Guards, and members of the official party (including Horace Albright) at the dedication ceremony, George Washington Birthplace National Monument (1932).

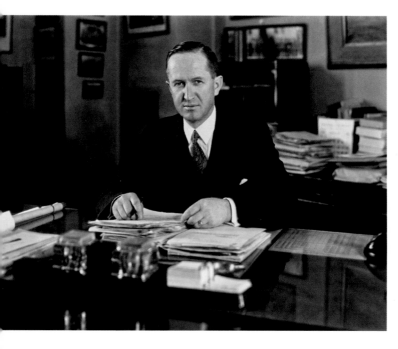

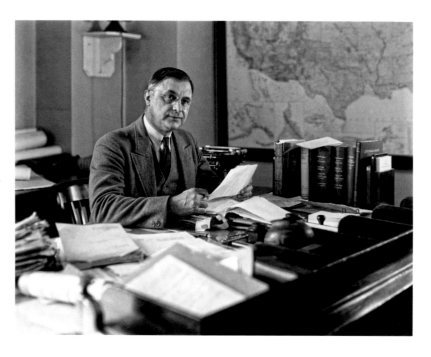

123 Horace Albright, director of the National Park Service, 1929–33 (1933).

124 Arno Cammerer, director of the National Park Service, 1933–40 (1933).

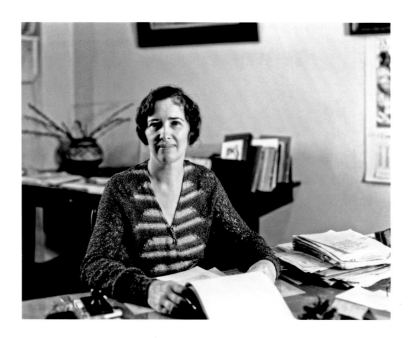

125 Isabelle Story in her office at the old Interior building. She began at the NPS in 1916 and retired as editor in chief of the bureau in 1954 (1933).

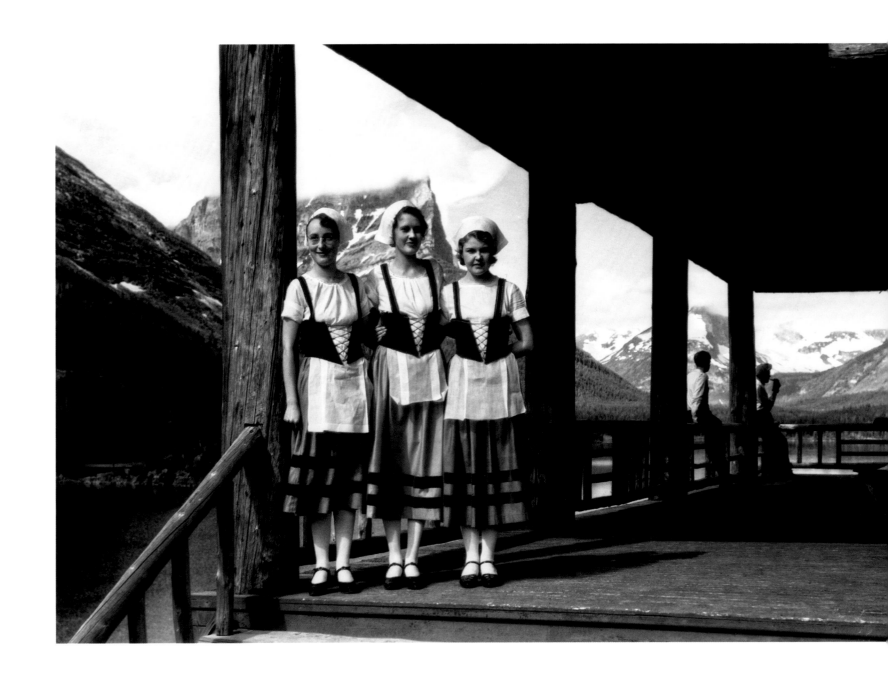

126 Servers in Swiss costumes on the verandah of the
Going-to-the-Sun Chalets, Upper Saint Mary Lake,
Glacier National Park (July 5, 1933).

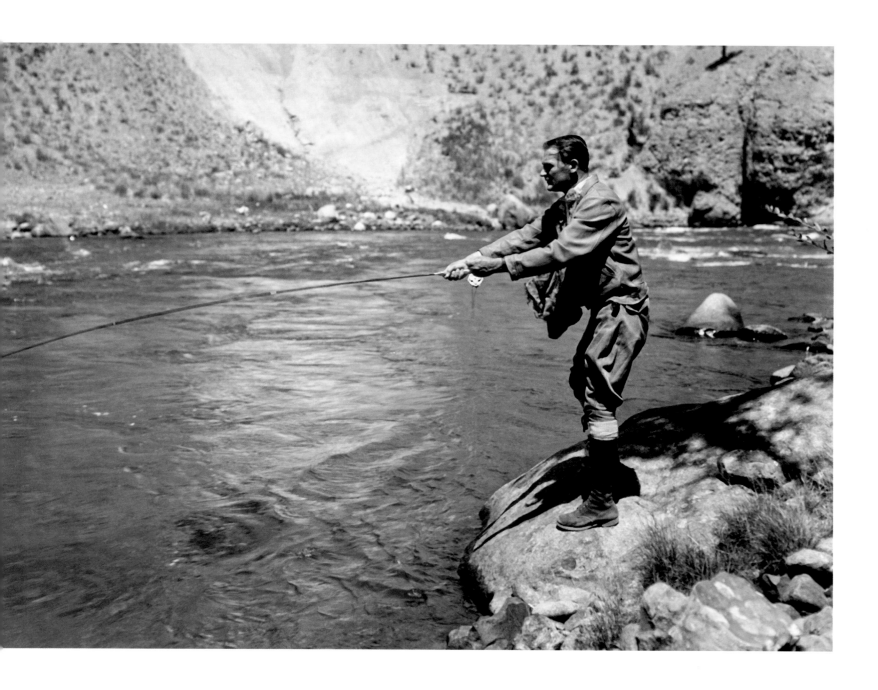

127 Senator Gerald P. Nye of North Dakota fishing in the Yellowstone River
near Camp Roosevelt, Yellowstone National Park (1933).

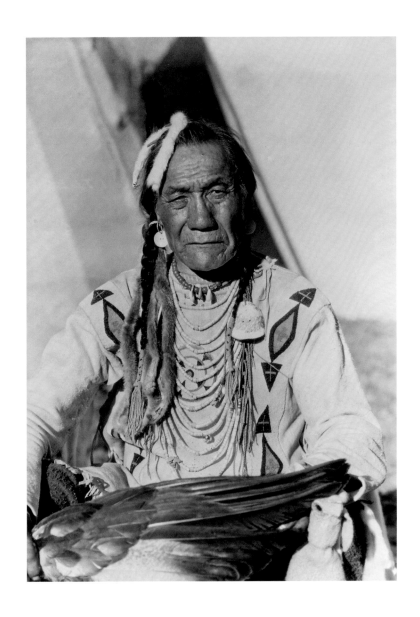

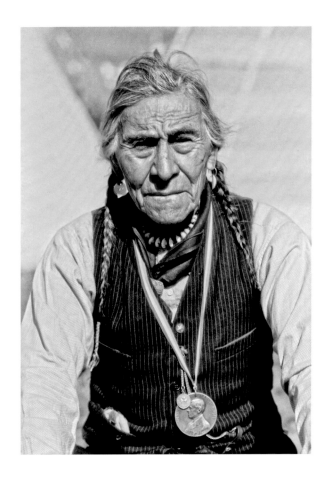

128 Bird Rattler of the Blackfoot Nation, in full native dress, at the dedication ceremony of the Going-to-the-Sun Road, Glacier National Park (July 15, 1933).

129 Blackfoot Nation chief Wolf Plume at the dedication ceremony of the Going-to-the-Sun Road, Glacier National Park (July 15, 1933).

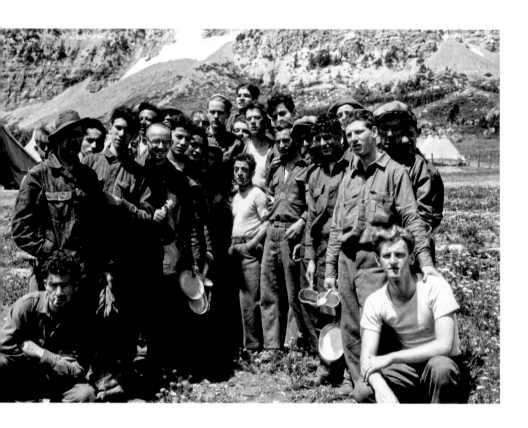

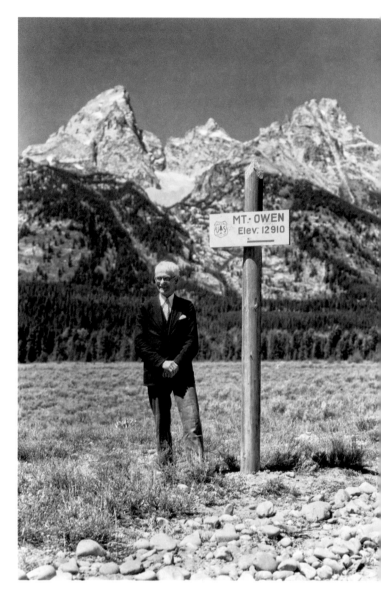

130 Group of CCC enrollees from Camp no. 4, Company 1240, at Many Glacier, made up mostly of men from New York City. In the center is Dominick Laulette, said to be the shortest man in the CCC, Glacier National Park (1933).

131 Standing in front of Mount Owen is Mr. William Owen, for whom the mountain was named. He was a well-known Wyoming pioneer and early engineer and surveyor in the territory. In 1898 he and three others were the first to climb the Grand Teton, or American Matterhorn, Grand Teton National Park (1933).

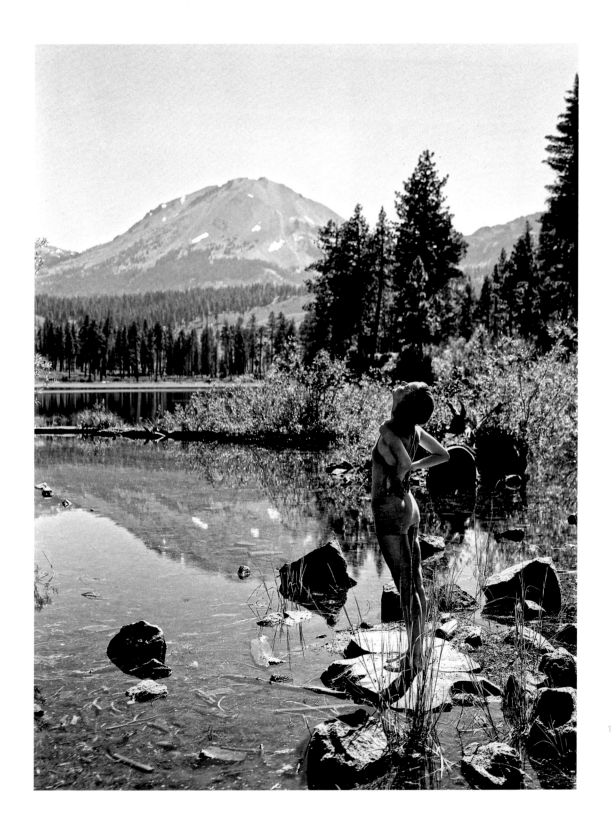

132 "'September Morn, 1934'—
American Style." Mount Lassen
and Manzanita Lake, Lassen
Volcanic National Park (1934).

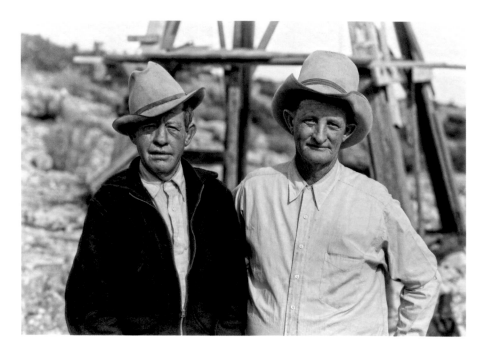

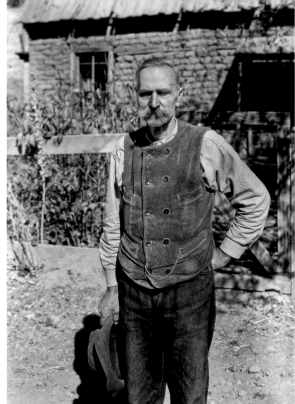

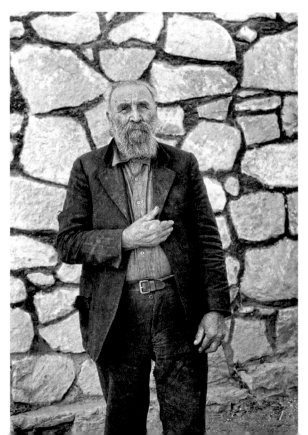

133 Jim White, reputed discoverer of Carlsbad Caverns, with an unidentified companion (possibly the Mexican nicknamed "Muchacho" who helped him explore the cave in 1901), Carlsbad Caverns National Park (1934).

134 Judge Almer N. Blazer, son of Dr. Blazer of Blazer's Mill. At the age of fourteen he witnessed the Blazer's Mill fight of 1878, which involved William H. Bonney (aka Billy the Kid), White Sands National Monument (1934).

135 George Coe of Glencoe, New Mexico, with his missing finger. He lost his finger in the Blazer's Mill fight in 1878, in which Dick Brewer and Andrew L. "Buck Shot" Roberts were killed. George Coe was a regulator who fought alongside Billy the Kid in the gunfight that was part of the Lincoln County War, White Sands National Monument (1934).

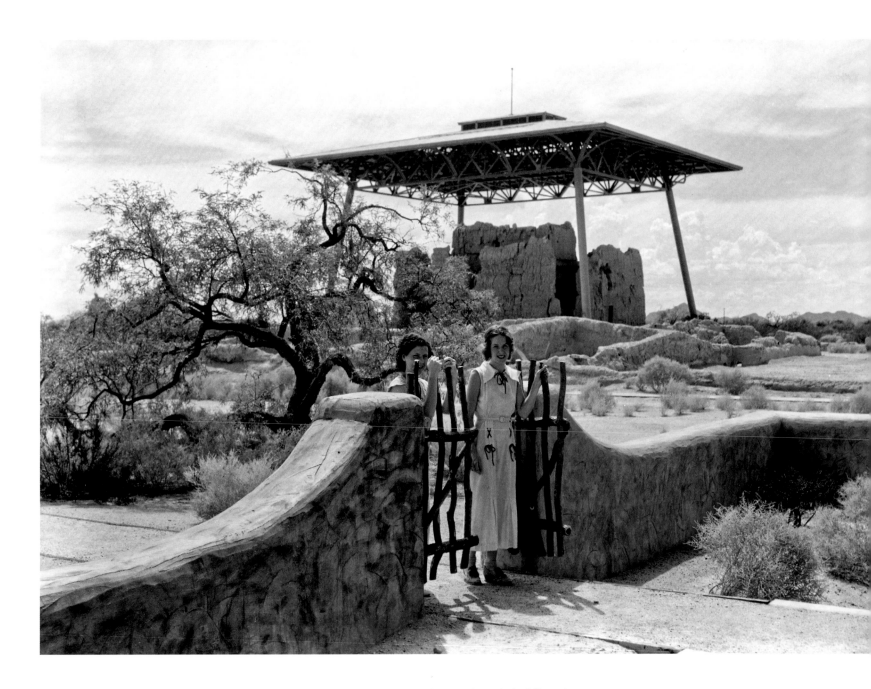

136 The wall and gate at the south side of the administration building patio, showing the main building of Casa Grande Ruins in the background. Nancy Pinkley (Boss Pinkley's daughter) is in gateway, followed by custodian Hilding Palmer's wife, Casa Grande Ruins National Monument (1934).

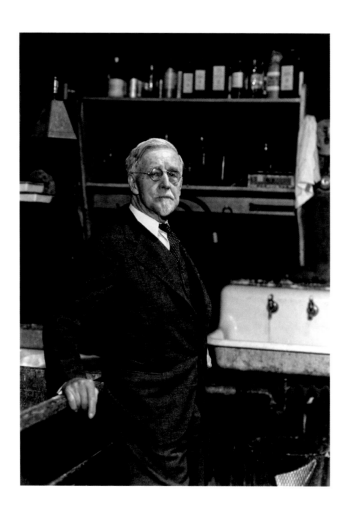

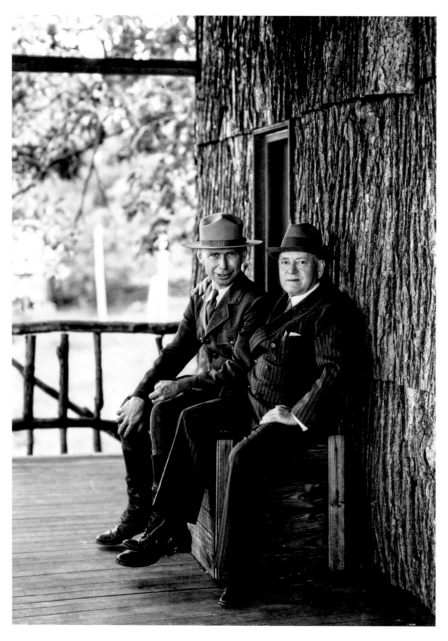

137 William Henry Jackson, pioneer landscape
photographer and member of the Hayden Expedition
to Yellowstone in 1870, photographed in the darkroom
of the National Park Service headquarters (1934).

138 Mr. James Lassiter (*left*), superintendent of Shenandoah
National Park, and Mr. George F. Pollock (*right*),
owner of Skyland Resort in the park (1936).

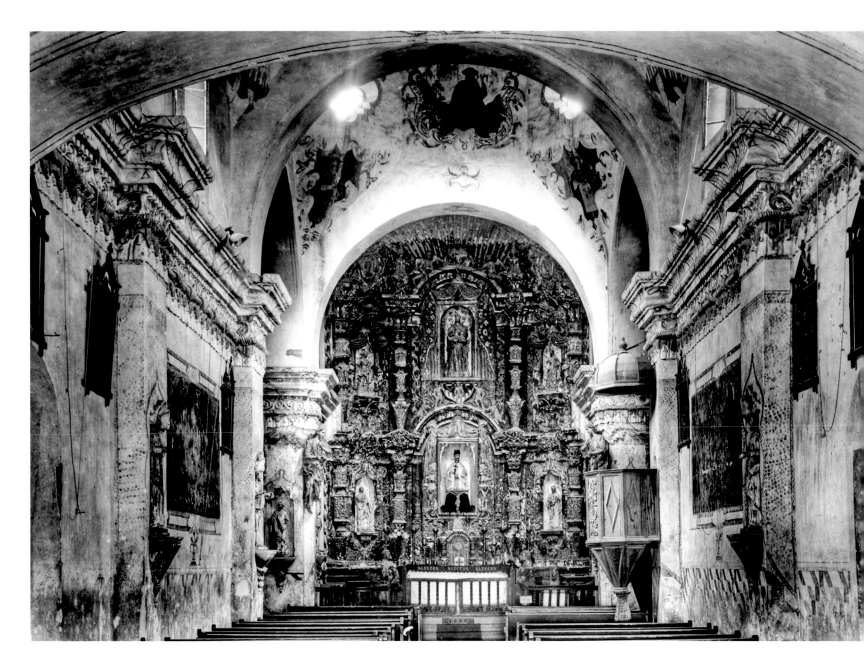

139 Interior and altar of Mission San Xavier del Bac, in Tucson, Arizona,
near Tumacácori National Historical Park (July 8, 1929).

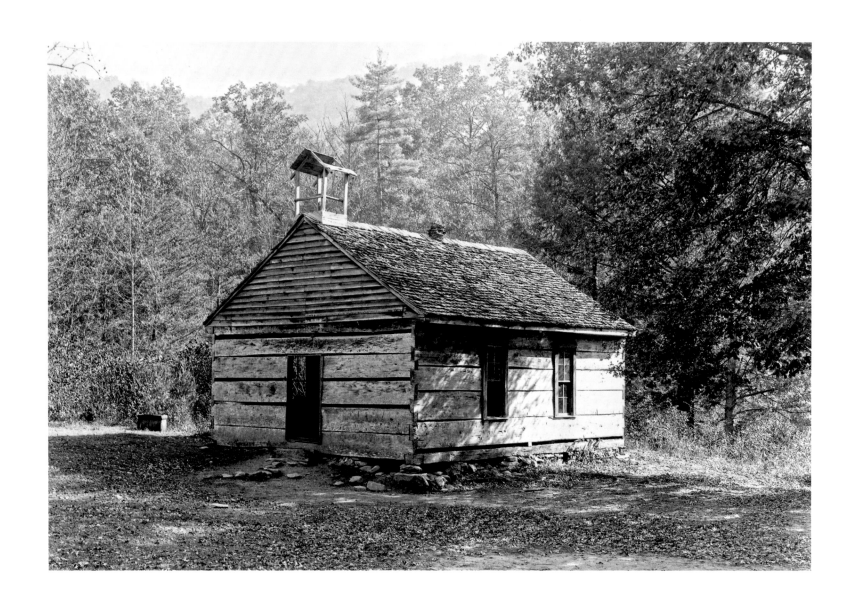

140 Little Greenbrier Schoolhouse, Great Smoky Mountains
National Park (November 12, 1931).

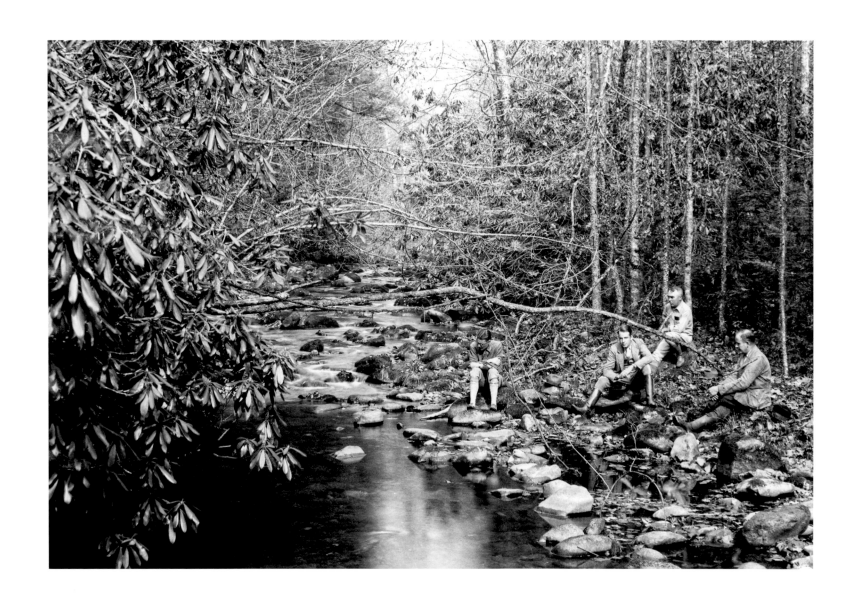

141 Conducting a preliminary survey of Great Smoky Mountains National Park's boundaries in 1931 are
(*left to right*) Arthur P. Miller, Charles E. Peterson, J. Ross Eakin, and Oliver G. Taylor. The photograph shows
a view up Deep Creek in North Carolina, where the team has taken time to stop and rest (November 20, 1931).

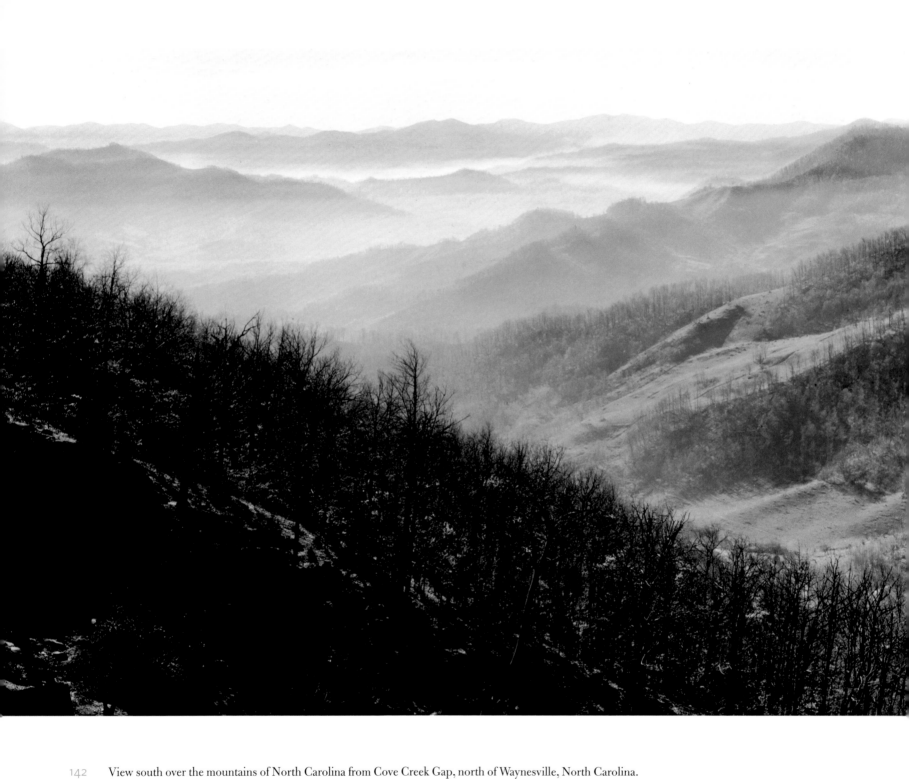

142 View south over the mountains of North Carolina from Cove Creek Gap, north of Waynesville, North Carolina.
Taken from Great Smoky Mountains National Park boundary (November 25, 1931).

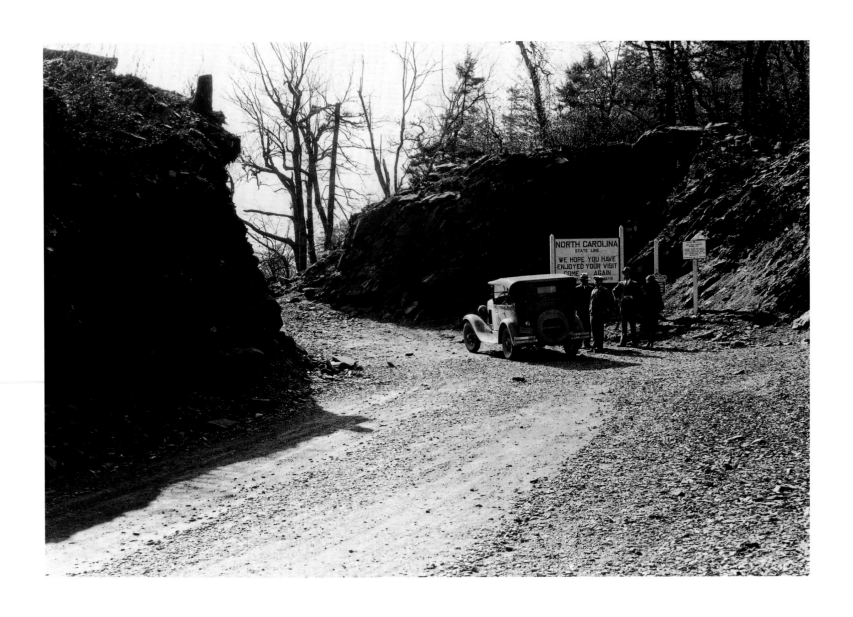

143 The summit of Newfound Gap Highway at the Tennessee–North Carolina line,
Great Smoky Mountains National Park (November 1931).

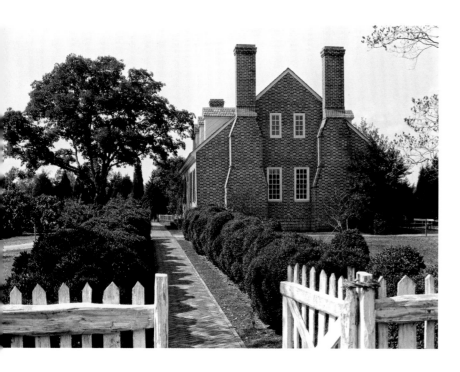

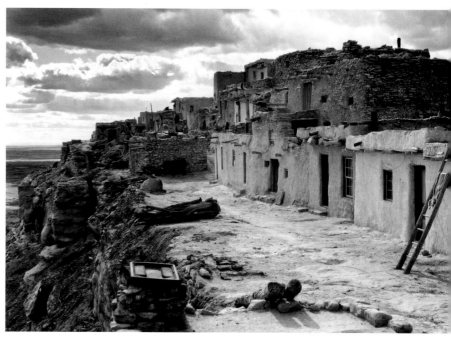

144 Mansion from the garden, showing English boxwood along the walk, George Washington Birthplace National Monument (May 15, 1932).

145 Hopi village of Walpi on First Mesa, Arizona (October 8, 1932).

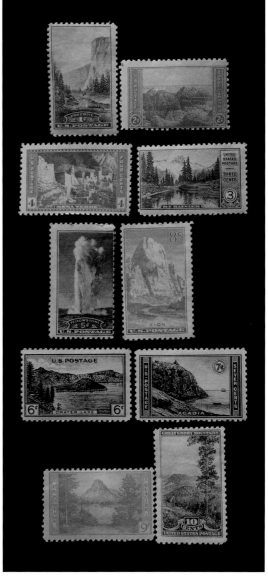

146 Tourist buses loaded with CCC workers ready to depart from camp to the various work sites, Rocky Mountain National Park (May 26, 1933).

147 Set of ten national park stamps commissioned for the National Parks Year (1934).

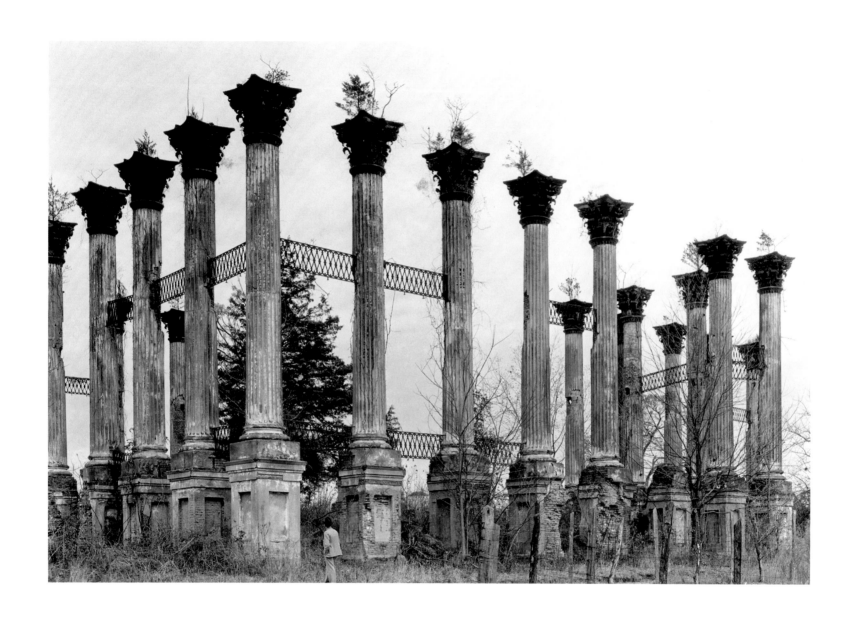

148 Ruins of Windsor Castle plantation near Bruinsburg, Mississippi,
 along the proposed Natchez Trace Parkway (December 6, 1934).

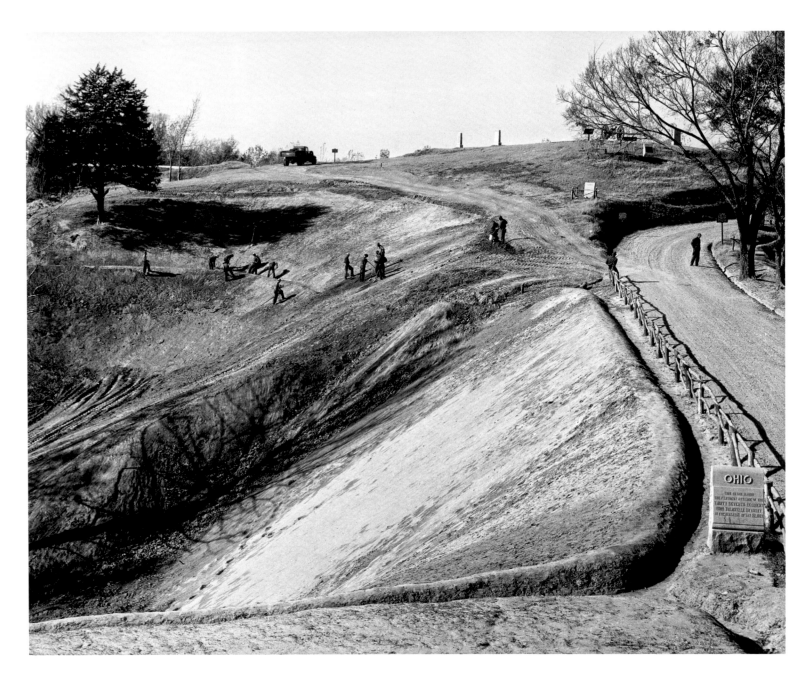

149 CCC enrollees carrying on an erosion-control operation along the Graveyard Road in front of Stockade Redan. Here huge gullies, which were eating their way toward the redan, have been filled in and sloped, Vicksburg National Military Park (1934).

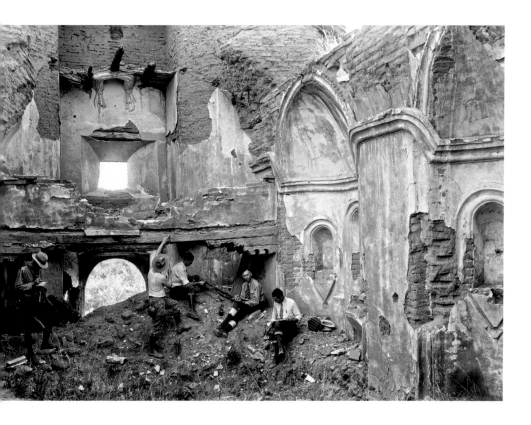

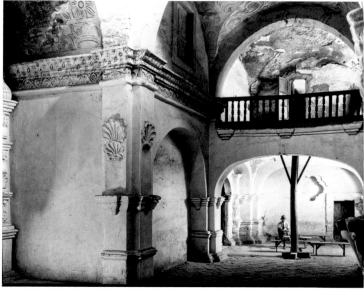

150 The Kino Expedition at work at the Kino Mission Nuestra Señora del Pilar y Santiago de Cocóspera. View is from the altar toward the front of the church. *Left to right*: Robert Rose, Arthur Woodward, Scofield DeLong, Leffler Miller, and J. Howard Tovrea, Sonora Missions Expedition (October 18, 1935).

151 Interior of Mission San Pablo de Tubutama. Image is from the nave, looking east toward the narthex and choir loft, Sonora Missions Expedition (October 24, 1935).

152 Old Spanish iron stirrups in the historical collection at the University of Arizona, Tucson, Sonora Missions Expedition (November 4, 1935).

153 Mission San Xavier del Bac near Tucson, Arizona, was regarded as one of the most beautiful mission buildings in the United States, Sonora Missions Expedition (September 13, 1935).

154 Mission San Carlos Borromeo, Carmel, California (1939).

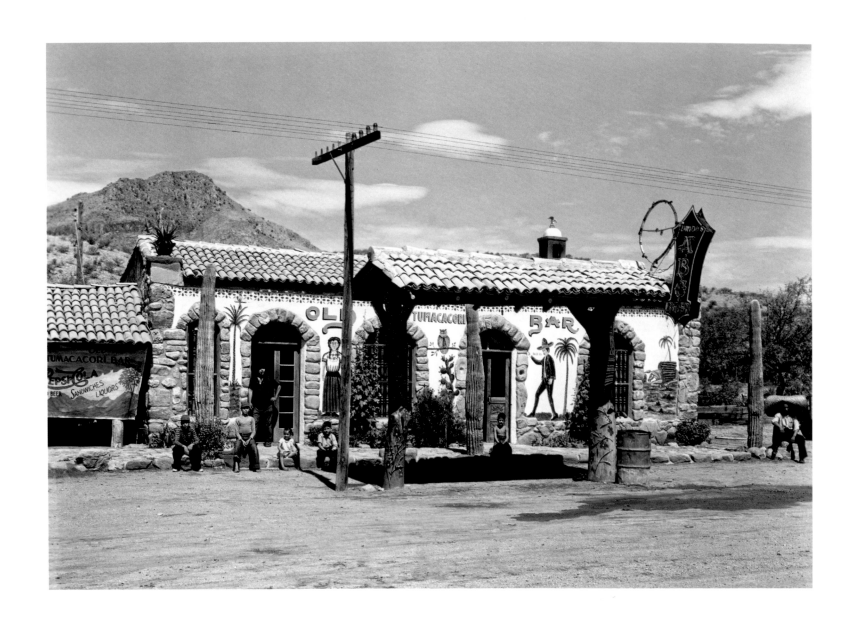

155 Abe's Old Tumacácori Bar is across the road from the Tumacácori Mission. The bar is reputed to have once been robbed by John Dillinger, Tumacácori National Historical Park (1940).

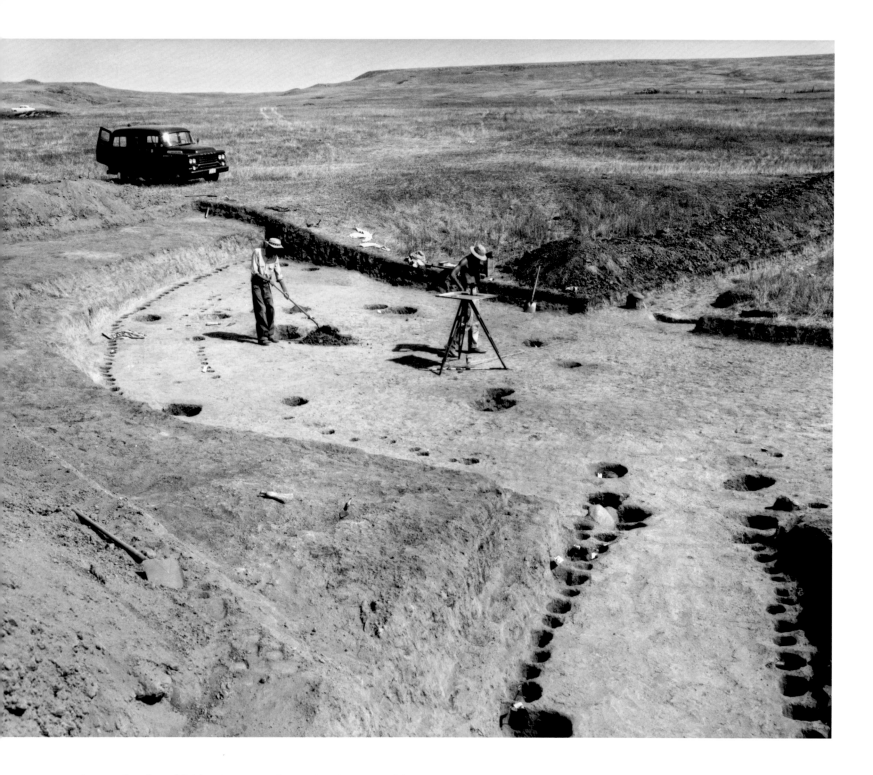

156 Archaeological fieldwork at Fort Sully, South Dakota, part of the Missouri River Basin Project (ca. 1950).

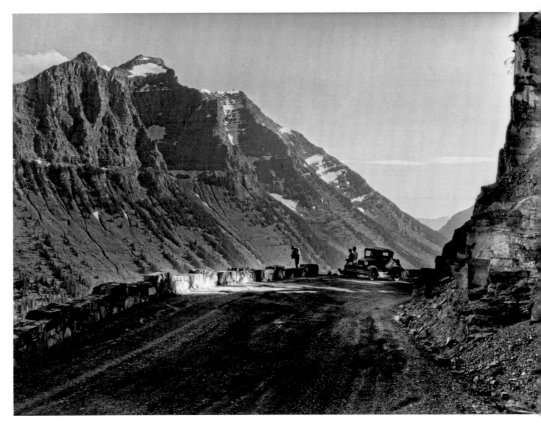

157 Cotton plant inscription on a cliff along
Virgin River below Saint George, Utah. At
the base of the cotton plant and to the right,
the sentence reads, "Jacob Peart, Jr. I was set
her [*sic*] to raise cotton. Marc 1858," Zion
National Park (September 1, 1929).

158 Logan Highway photographer, Glacier National Park (1932).

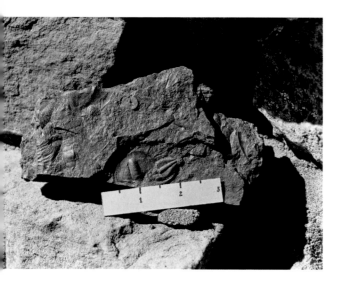

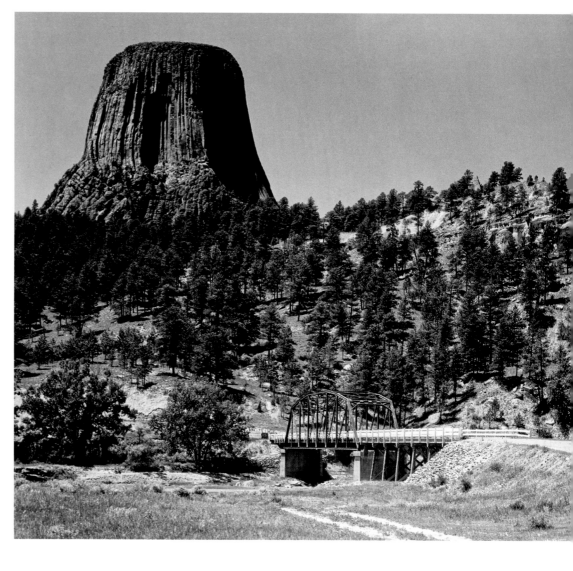

159 Trilobites and one brachiopod from
the lower part of the Bright Angel Shale
Museum collection, Grand Canyon
National Park (October 12, 1932).

160 Devils Tower and the bridge across the Belle Fourche River,
Devils Tower National Monument (June 1933).

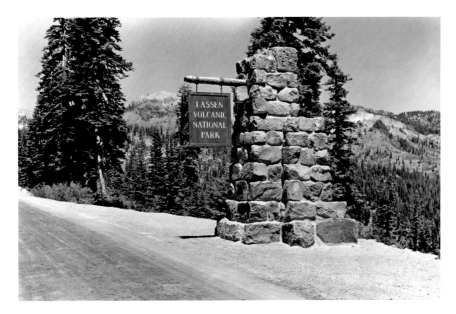

161 The south boundary entrance to Lassen Volcanic National Park, below the Sulphur Works clocking station, on the main loop highway (August 2, 1934).

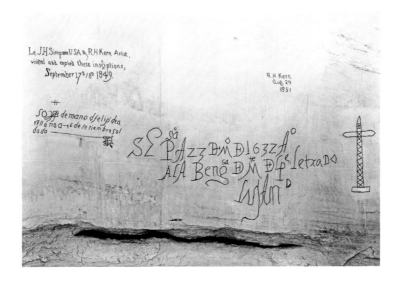

162 The 1632 Lujan inscription reads, "They [a Spanish expedition] passed on the 23rd of March of the year 1632 to the avenging of the death [by Zuni natives] of Father Latredo." Lt. J. H. Simpson left a message in 1849, and Richard H. Kern in 1851, El Morro National Monument (September 29, 1934).

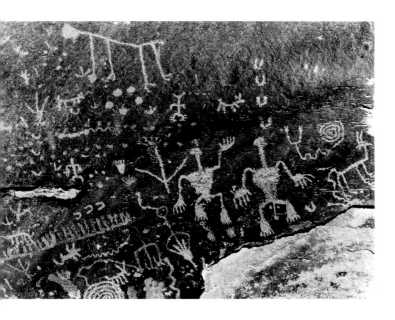

163 Petroglyphs on cliff walls near Newspaper Rock,
 Petrified Forest National Park (October 9, 1934).

164 View toward the utility area and employee quarters from the
 hill in back of the hotel, showing the new post office and many
 other improvements, Mammoth Hot Springs area, Yellowstone
 National Park (August 22, 1939).

165 The new highway bridge under construction over the Gardiner River on the Lower Falls Road, Yellowstone National Park (August 2, 1939).

166 Fossil in Scotts Bluff Museum, found in the Agate fossil beds north of Scotts Bluff. The jaw does not belong to the skull, Scotts Bluff National Monument (1940).

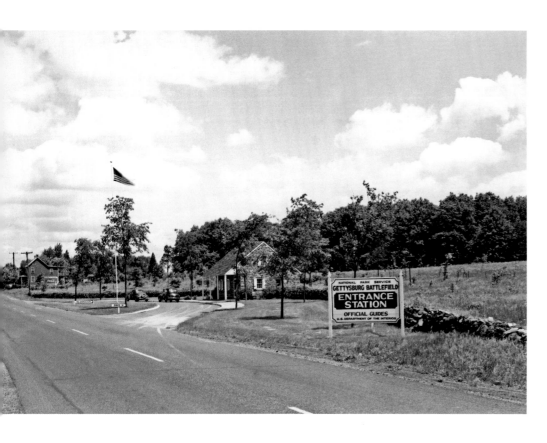

167 National Park Service entrance station on Emmitsburg Road,
 Gettysburg National Military Park (1942).

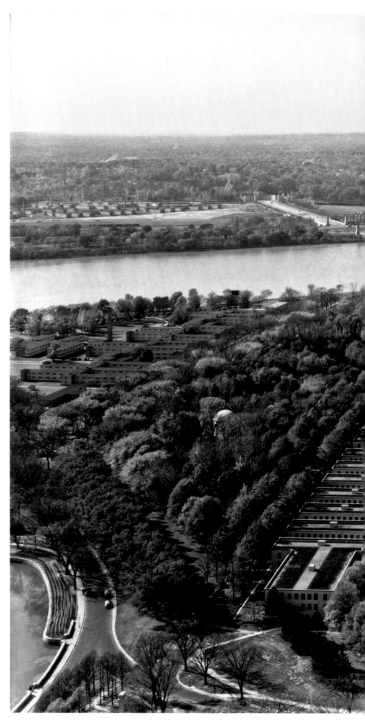

168 The National Mall as it appeared during World War II, showing
 the Memorial Bridge, Lincoln Memorial, Reflecting Pool, and the
 Navy Annex and Barracks. Note the bridge over the Reflecting Pool.
 Arlington Farm is visible in the upper left of image (1943).

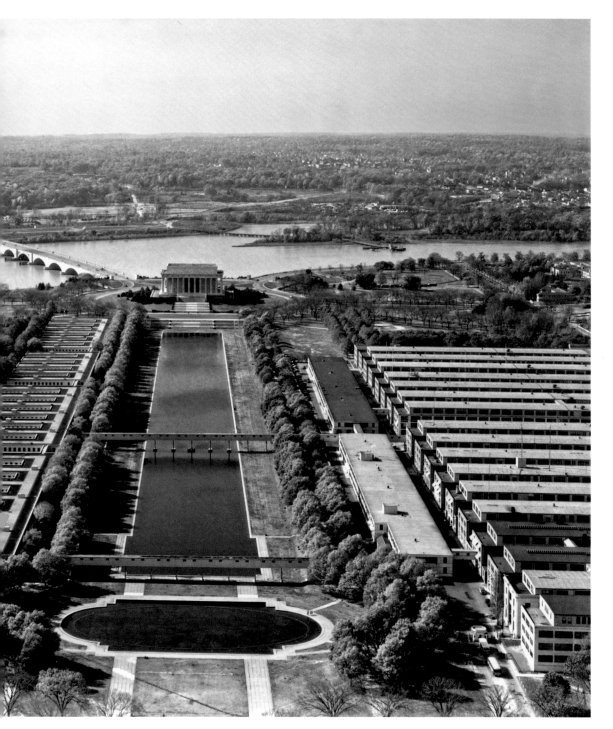

169　The Colter Stone, a rough-carved rhyolite of a human face, is believed to have been carved by John Colter, the first white man to visit Yellowstone, Grand Teton National Park (no date).

It had been known for many years that certain substances containing silver were blackened when exposed to light for some time. Later on it was found that when some of those substances were exposed for a very short time, so short in fact that no blackening could be noticed, nevertheless a change took place which caused them to darken when treated with certain chemicals. The whole art of photography is based on these observations. If we should prepare one of these silver compounds, mix it with gelatin so as to form a thick paste, spread it on a glass plate or film today, what we would have would be practically the ordinary dry plate or film.

A camera must have three elements: A light proof box, a lens to project the image, and a plate holder. We will take up the lens later. But assuming that an image has been projected through the lens from the reflected lights on an object outside the camera and thrown on the sensitive plate, this is what happens. The parts of the image containing the strongest light will make the greatest impression on the sensitive silver plate or film. The weaker lights will make a weaker impression, and so on down to the shadows which will hardly make any impression at all. If we examine the plate after this exposure is made, there will be no apparent change in it. But if we put the plate in a photographic developer we find that in a short time the image as described before will slowly make its appearance. The parts affected by light have been reduced to metallic silver. But it is not yet a negative. If we examine the film after development we will notice that the shadows or weaker parts of the image still possess a creamy-like appearance like the whole plate had before it was developed. This we must remove by fixing, which is done by immersing the plate in a solution of hypo, or more properly, thiosulphate of soda, which dissolves out the unaffected silver salts that gave the

creamy appearance to the plate. The plate is now in all respects, a negative, except that all traces of hypo must be removed by washing. It is then hung up to dry.

This image does not necessarily have to be projected by a lens. If we could imagine a pinhole about 1/1500 of an inch in diameter that would admit plenty of light as well, we would have a perfect lens of any focal length, and a covering power nearly up to 180 degrees. Incidentally, pin holes up to 1/20 of an inch are sometimes used with very pleasing results.

We all know how light rays can be bent through a prism. The ordinary double convex lens is nothing but a series of an infinite number of such prisms. If the surfaces are cut to perfect spheres, the light rays will cross, or come to a focus, a certain distance from the lens, depending on the radius of the curved surfaces and the refractive index of the glass used. The trouble with this lens is that all of the light rays will not cross or come to a focus at the same point. The blues will not converge at the same place with the reds. The main fault with this lens is color or chromatic aberration, although it still suffers from many others.

This fault is removed by the so-called achromatic or meniscus achromatic lens found on the cheaper cameras by combining two different lenses, and cementing them together. This lens has very little speed or light admitting power. And besides this, it will project a square shaped image in a barrel or pincushion form on the plate depending on whether the diaphragm is in front or behind it. This is known as curvilinear distortion. It can be removed by combining two lenses of this type opposing each other with the diaphragm between, which gives us the so-called rectilinear or rapid rectilinear lens. This lens is hard to surpass as an all round pictorial lens, and is usually supplied in speeds up to F8. It still

has its faults, technically. It has not the needle definition of the anastigmat. It has a saucer shaped field, i.e., objects in focus in the center of the plate will not be in focus at the edges or corners; and it sometimes has astigmatism. Also, its covering power is limited.

The good anastigmatic lens is supposed to be free from all the foregoing optical defects. It has remarkable definition—too much in fact. It gives a flat field, is corrected for color, and besides, has more speed. It is an outgrowth of the discovery that glass of different composition has a different refractive index. Quartz glass will not bend the light rays the same as crown and flint glass. By combining lenses made of the different glasses and properly setting them together we get the modern anastigmat. They are made ever many different formulas and are necessarily expensive. The best I have found are the Carl Ziess Tessar, the Bausch & Lomb Tessar, and the Goertz Dagor. It is also a fact worth remembering that the slower anastigmats are the freest from optical defects, i.e., these working at F 6.3 and F 7.7 have more covering power and cut sharper than those working at F 4.5 and F 2.9, etc.

This brings us down to the important meaning of the diaphragm markings found on every good lens. What do we mean when we say we have an F 4.5 lens? It means that the lens works at F 4.5 when the diaphragm is wide open. What does this mean? It means that when the lens is focused on some distant object or infinity, the diameter of the diaphragm opening is 1 over 4.5 or 2/9 of distance from the lens to the plate. What good is it to know this? It indicates that F 4.5 represents the angle subtended by the diaphragm when it is wide open, or in other words, gives us a clue to the amount of light that will pass through it. Some system of marking the diaphragm stops had to be adopted by the lens manufacturers in order for everybody to compare the speed of any lens with another, and to be able to use any lens. If you stop any lens down to 11, 16 or 22, they are all supposed to admit the same amount of light at that particular opening, irrespective of make or size. This is very important in figuring exposures. There must be some standard of comparison, otherwise

it would be impossible to take out a battery of different lenses and use them with any degree of accuracy. It might be well here to say that the light admitting power of these diaphragm stops can be compared one with the other, inversely as the squares of the numbers themselves. That is to say that F 8 passes twice as much light or is twice as fast as F 11, which in turn is twice as fast as F 16 and so on down the line to the end, which is usually F 45 or 64. Now supposing we figure our exposure should be 1/50 of a second at F 8, you can see that the plate will be hit with exactly the same amount of light if we stop the diaphragm down to F 11 and give it 1/25 of a second. Here we must do some figuring. If we stop it down one more, to F 16, we must increase the exposure to 1/12 or 1/10 of a second. We cannot hold the camera in the hand at such a slow shutter speed without the danger of vibration, which will ruin the picture. To overcome this we must resort to a tripod or rigid support together with a cable release, it is oftimes [*sic*] necessary in pictorial work, especially when filters are used, to give an exposure of from three to ten seconds. This is where the Graflex and Kodak usually fall down. They are essentially hand and speed cameras and should be used as such.

What is the advantage of stopping a lens down, under its maximum speed? If my lens works at F 4.5, why not always use it at F 4.5? I can stop a tennis ball at F 4.5 in good sunlight in 1/1000 of a second. The tennis ball will be in sharp focus, but everything on the near or far side of it will be fuzzy or out of focus. I have speed and have stopped fast motion, but I have sacrificed depth in my picture. If one were photographing a field of flowers he would have a different problem. You want the flowers near to the camera as well as those further away to be in sharp focus. This is accomplished by stopping down the lens, sometimes to 32 or 45. Your lens passes very little light at these openings, so you can't stop motion. And be careful that motion stops and the wind is not blowing, or you'll blur your picture. Any ordinary Kodak below post card size set at 25 feet, diaphragm at 32, will give almost universal focus. In this connection, it is well to state that the depth increases as the focal

length of the lens decreases. It is the main reason why such marvelous effects are obtained with the small motion picture lenses. These diaphragm markings and their use should be thoroughly understood before taking up photography at all.

One of the best all round cameras is the 5 × 7, or 4 × 5, or 3–1/4 × 4–1/4 view with a rigid tripod. I mean by this that more results can be accomplished with this type of camera than any other, but I would not care to carry one to the top of Mt. Rainier or across the Grand Canyon. A good portable Kodak of 3–1/4 × 4–1/4 size would be better for this. The Graflex is too heavy, also, and its use is too restricted. For wild animal photographs it is indispensible [*sic*]. It would be well for us all to adopt the 3–1/4 × 4–1/4 size, because it makes a fair sized print; because it will stand enlargement up to 8 × 10 or 11 × 14", and last but not least, because the subject matter on a negative this size can usually be printed on a lantern slide by contact. It is economical, and the lens equipment small enough to insure a high percentage of good results.

I do not advise the use of film packs or glass plates. Use either roll film, or preferably, cut film. The advantage of cut film is the variety of emulsions now available, such as commercial ortho, par speed, super speed, commercial panchromatic and portrait panchromatic. I would suggest that we adopt this size 3–1/4×4–1/4 right now, for the use of field naturalists. The type of camera can be decided upon by the individual who uses it. From what I can gather, [Dorr] Yeager, [George] Ruhle and [George] Collins could get along very well with a Graflex, while [Frank] Brockman, [Edwin] McKee, [Frank] Been and [C. A.] Harwell should have a more portable camera for climbing. A Graflex is always handy to have around if you can afford one. Been and Harwell, I know, could use one to advantage.

Now a word about composition, the best suggestion I can make is for you to study pictures and get in the habit of seeing pictures. You fellows are living in the most beautiful parts of our country. You have pictures almost anywhere you look. If you haven't already adopted photography

as a hobby it is because there must be a screw loose somewhere. A camera in any one of our national parks should soon pay for itself.

Perhaps, without knowing why, our attention is at times attracted and held by a picture. It may be the composition of color that pleases us, or the composition in line and mass. In photography we must see our picture in black and white. We therefore look for line and mass. These must hold us within the picture area and not lead off somewhere else. The lines should always lead the eye to the center of interest. This is not always easy or always possible in photography. The artist can place things where he will and thus has the bulge on us. Have your people or animals moving or facing into the picture and not off of it. Watch the way the animal stands, the position of the head and ears. Look for catch lights in the eyes. All these things are done every day. In photographing groups or individual persons, do not have them face the sun directly. Have them turn a little to one side so as to get one highlight on the opposite cheek. In photographing forests and mountain ranges, have the sun to one side so as to throw them into high relief.

Filters and color sensitive (panchromatic) films are usually necessary to photograph clouds, distant objects, and snow capped mountains against the sky. The ordinary film can render these only at very high elevations in clear weather. The filters most in use for this purpose are the K1, K2, K3, and G. Wratten Filters. When you get a box of panchromatic films the factor or multiplication numbers for the increase in exposure for these filters is printed on a card inside.

Get a good exposure meter or guide, to determine your exposures. The Eastman Kodak Company will be glad to furnish free of charge pamphlets describing in detail nearly every photographic activity. If you are interested, send for the whole set.

There are a million things I haven't touched upon. You'll just have to figure them out for yourself.

Dark room work is fully explained in every box of plates, paper, and chemical sold. All you need is practice. To make it easier still, prepared

developer and fixing powders are furnished. All you do is to add water. In printing it is well to remember that the paper must be fully developed out. That requires from 45 seconds to 1½ minutes. If the image comes up too fast in the developer, and you have to take it out before time, it is because you've given the paper too much light. Throw it away and try another.

It is a wise practice to use only the developer formula recommended for the particular brand of paper or films you are using.

From the Proceedings of the First Park Naturalist Training Conference Held at Educational Headquarters, Berkeley, California, November 1–30, 1929. Published, August 12, 1932. Notable Conference Attendees: Ansel Hall, Chief Naturalist, Educational Division; Carl P. Russell, Field Naturalist, Educational Division; Joseph S. Dixon, Field Naturalist, Educational Division; George M. Wright, Field Naturalist, Educational Division; John D. Coffman, Fire Control Expert, Educational Division; George A. Grant, Photographer, Educational Division; C. A. Harwell, Park Naturalist, Yosemite National Park; Dorr G. Yeager, Park Naturalist, Yellowstone National Park; George C. Ruhle, Park Naturalist, Glacier National Park; C. Frank Brockman, Park Naturalist, Mount Rainier National Park; Frank T. Been, Park Naturalist, Sequoia National Park; Edwin D. McKee, Park Naturalist, Grand Canyon National Park; George L. Collins, Assistant to the Superintendent, Lassen Volcanic National Park; Dr. E. D. Merrill, Dean of the College of Agriculture, University of California; Dr. Joseph Grinnell, Director of the Museum of Vertebrate Zoology, Department of Vertebrate Zoology, University of California; Dr. Frederick E. Clements, Ecologist, Carnegie Institution; Dr. H. C. Bryant, Representative of the California Game and Fish Commission and Director of the Yosemite School of Field Natural History.

In an era of instant digital photography, the challenges that confronted landscape photographers like Ansel Adams and George Grant may seem a distant memory. The work of loading and unloading film, carrying heavy equipment to remote locations, carefully composing the shot, and processing negatives with harsh chemicals in total darkness was the price these artists paid to produce their remarkable images. The information below is offered to give the modern photographer a sense of what was involved in producing these photographs. Not surprisingly, there are still photographers who utilize view cameras and film to produce stunning images this old-fashioned way.

View Camera Design and Operation

View cameras utilize a simple design that is little changed from the nineteenth century. The instrument is composed of front and back parts called "standards," joined by a flexible, light-tight bellows that may be extended along a baseboard or rail to focus a lens attached to an opening in the front standard. The camera also features knobs to swing or tilt the front standard to address perspective (essential in architectural photography) and depth of field. As with SLR cameras, there are interchangeable lenses, from wide angle to telephoto, depending on the desired image. The lenses feature a diaphragm that when adjusted (stopped down by F-stops) controls the amount of light reaching the film. Optional filters are either mounted on the rear of the front standard and behind the lens or attached to the front of the lens.

The back standard features a removable glass focusing screen for viewing the projected image (which would be upside down and reversed). When working outdoors, the photographer often adds a hood over the back of the camera to better see the image on the glass. To compose the picture, the photographer attaches the selected lens to the front standard and moves the standard along the baseboard until the image is focused and composed. Due to the weight of the camera and the length of exposure time, a sturdy tripod is essential. Other important accessories include a bubble level (George Grant used a plum-bob) to ensure that the final image is level.

Taking Photographs

Once the image is composed, the photographer replaces the focusing screen with a light-tight holder containing one or two sheets of unexposed film behind light-tight panels (the film would have been previously loaded into the holder in a darkened studio or workspace). With the holder in place, the photographer removes the panel and, using a shutter button or cable release, exposes the film. A timer or stopwatch offers precision to achieve the correct exposure of the image. The shutter is closed and the panel replaced on the holder. To take a second picture, the photographer reverses the holder and repeats the process. To take several images, it is necessary to have multiple holders preloaded prior to traveling into the field. Once the shooting is done, the holders are taken to a darkroom for processing of the negatives and, if needed, contact printing.

Considerations for Using View Cameras in the Field

The cameras, tripods, lenses, film sheets, and holders used by George Grant in the field would have weighed more than fifty pounds. This weight, when combined with darkroom equipment, chemicals, and paper needed to process and print negatives, makes it readily apparent why Grant, Ansel Adams, and their contemporaries often traveled in specially outfitted vehicles that served as both transportation, storage, and portable photography laboratory.

Benefits of the Large Format

The amount of visual information captured on view camera negatives yields remarkable prints that may be greatly enlarged or cropped without excessive loss of detail. As an example, based on the size of the respective films, a 5 × 7–inch negative is approximately twenty-three times larger than a negative in the 35 mm format.

APPENDIX 3 George Grant's National Park Service Photography Locations, 1922–1954

Units of the National Park Service

Unit	State	Years*
Arches National Park	Utah	1929, 1936, 1939
Aztec Ruins National Monument	New Mexico	1929, 1934, 1940, 1946
Badlands National Park	South Dakota	1936, 1950
Bandelier National Monument	New Mexico	1934, 1940
Big Bend National Park	Texas	1936
Black Canyon of the Gunnison National Monument	Colorado	1935, 1939
Blue Ridge Parkway	Virginia, North Carolina	No date
Boulder (Hoover) Dam (now part of Lake Mead National Recreation Area)	Nevada	1937, 1939
Bryce Canyon National Park	Utah	1929, 1935, 1945
Canyon de Chelly National Monument	New Mexico	1932, 1934, 1940
Canyonlands National Park	Utah	1936
Capitol Reef National Park	Utah	1935
Carlsbad Caverns National Park	New Mexico	1934, 1938
Casa Grande Ruins National Monument	Arizona	1929, 1934, 1940, 1947
Castillo de San Marcos National Monument	Florida	1937, 1947
Cedar Breaks National Monument	Utah	1929, 1935
Chaco Culture National Historical Park	New Mexico	1929, 1934, 1940
Chimney Rock National Historic Site	Nebraska	1932
Chiricahua National Monument	Arizona	1935, 1940
Colonial National Historical Park	Virginia	1934
Colorado National Monument	Colorado	1935
Crater Lake National Park	Oregon	1931, 1935, 1936, 1938, 1941
Craters of the Moon National Monument	Idaho	No date
Death Valley National Park	California	1935
Devils Postpile National Monument	California	No date
Devils Tower National Monument	Wyoming	1930, 1933, 1935, 1947

Unit	State	Years*
Dinosaur National Monument	Colorado, Utah	1935, 1950
Dry Tortugas National Park (formerly Fort Jefferson National Monument)	Florida	1937
Effigy Mounds National Monument	Iowa	1950
El Morro National Monument	New Mexico	1929, 1934, 1947
Everglades National Park	Florida	1937
Fort Bowie National Historic Site	Arizona	1935
Fort Davis National Historic Site	Texas	1953
Fort Frederica National Monument	Georgia	1937
Fort Laramie National Historic Site	Wyoming	1932, 1938, 1949
Fort Matanzas National Monument	Florida	1937, 1947
Fort Pulaski National Monument	Georgia	1937
Fort Smith (now a national historic site)	Arkansas, Oklahoma	No date
Fort Union National Monument	New Mexico	1937, 1939
Fort Vancouver National Historic Site	Washington	1941
Fredericksburg and Spotsylvania County Battlefields National Memorial Military Park	Virginia	1934, 1942
George Washington Birthplace National Monument	Virginia	1931, 1932, 1936
George Washington Carver National Monument	Missouri	1953
Gettysburg National Military Park	Pennsylvania	1942, 1944
Glacier National Park	Montana	1932, 1933, 1934, 1940, 1941, 1948
Glen Canyon (now a national recreation area)	Arizona	1936, 1946
Grand Canyon National Park	Arizona	1929, 1930, 1932, 1935, 1936
Grand Teton National Park	Wyoming	1930, 1933, 1934, 1941
Great Sand Dunes National Monument	Colorado	1939, 1940
Great Smoky Mountains National Park	Tennessee, North Carolina	1931
Hot Springs National Park	Arkansas	1937, 1953
Jean Lafitte National Historical Park and Preserve (formerly Chalmette National Historical Park)	Louisiana	1934
Jewel Cave National Monument	South Dakota	1936
Joshua Tree National Park	California	1936, 1941
Kings Canyon (see Sequoia and Kings Canyon National Parks)
Lassen Volcanic National Park	California	1934, 1941
Lava Beds National Monument	California	1936, 1941
Lewis and Clark National Historical Park (including Fort Clatsop)	Oregon	1938
Little Bighorn Battlefield National Monument	Montana	1933, 1947

Unit	State	Years*
Mammoth Cave National Park	Kentucky	1935
Manassas National Battlefield Park	Virginia	1942, 1943
Mesa Verde National Park	Colorado	1929
Montezuma Castle National Monument	Arizona	1929, 1940
Morristown National Historical Park	New Jersey	1935
Mount Rainier National Park	Washington	1932, 1940, 1941
Mount Rushmore National Memorial	South Dakota	1936
Muir Woods National Monument	California	1933, 1936, 1941
Natchez Trace Parkway	Mississippi, Tennessee	1934
National Mall	Washington, D.C.	1943
Natural Bridges National Monument	Utah	1935, 1936
Navajo National Monument	Arizona	1935
North Cascades National Park	Washington	1937
Olympic National Park (formerly Mount Olympus National Monument)	Washington	1934, 1936, 1938, 1940
Oregon Caves National Monument	Oregon	1936, 1941
Organ Pipe Cactus National Monument	Arizona	1935
Papago Saguaro Monument (now part of Saguaro National Park)	Arizona	1929
Petersburg National Battlefield	Virginia	1934
Petrified Forest National Park	Arizona	1929, 1934
Pipestone National Monument	Minnesota	1950, 1953
Quarai Mission (now part of Salinas Pueblo Missions National Monument)	New Mexico	1940
Rainbow Bridge National Monument	Utah	1946
Rocky Mountain National Park	Colorado	1930, 1933, 1938, 1948
Saguaro National Park	Arizona	1929, 1935
Scotts Bluff National Monument	Nebraska	1932, 1938, 1940
Sequoia and Kings Canyon National Parks (formerly General Grant National Park)	California	1929, 1933, 1936, 1940
Shenandoah National Park	Virginia	1936
Sunset Crater Volcano National Monument	Arizona	1935, 1939
Tumacácori National Historical Park	Arizona	1929, 1935, 1940, 1947
Tuzigoot National Monument	Arizona	1940, 1945
Vicksburg National Military Park	Mississippi	1934
White Sands National Monument	New Mexico	1934, 1936, 1940

Unit	State	Years*
Whitman Mission National Historic Site	Washington	1941
Wilson's Creek National Battlefield	Missouri	No date
Wind Cave National Park	South Dakota	1936
Wupatki National Monument	Arizona	1935
Yellowstone National Park	Wyoming, Montana	1922, 1931, 1933, 1939, 1941
Yosemite National Park	California	1931
Zion National Park	Utah	1929, 1935

Other Sites and Projects

Unit	State	Years*
Arizona Missions	Arizona	1941
California Missions	California	1939
Colorado–Big Thompson Rivers Project	Colorado	No date
Enders Reservoir and Medicine Creek	Nebraska	1951
Fort Bridger (now a state historic site and part of Pony Express National Historical Trail)	Wyoming	1938
Fort Caspar (now a Casper City park and part of Pony Express National Historical Trail)	Wyoming	1938
Fort Macomb	Louisiana	1934
Fort Phil Kearney (now a state historic site)	Wyoming	1933, 1941
Fort Pike (now a state historic site)	Louisiana	1934
Fort Simcoe (now a state park)	Washington	1941
Fort Ticonderoga National Historical Landmark	New York	1942
Goosenecks of the San Juan River	Utah	1935
Hopi Reservation–Walpi Village	Arizona	1932
Hualpai Reservation	Arizona	1940
Jacksonville (not part of Coast Survey)	Oregon	1941
Kofa Mountains	Arizona	1935
Kolob Canyon (now part of Zion National Park)	Utah	1935
Laguna Pueblo	New Mexico	1929
Lincoln County	New Mexico	1934
Missouri River Basin Project Survey	Multiple locations	1948–54
Monument Valley (now a Navajo Tribal Park)	Arizona, Utah	1931, 1932, 1935

Unit	State	Years*
Mount Hood National Forest	Oregon	1941
Oregon Coast Survey	Oregon	1938
Oregon Sand Dunes (now a national recreation area)	Oregon	1938
Oregon Trail sites	Multiple locations	1933, 1938
Pendleton Roundup (annual rodeo)	Oregon	1937
Poston Butte	Arizona	1940
Priest Rapids (now site of Priest Rapids Dam)	Washington	1941
Register Cliff (possibly part of Oregon Trail Survey)	Wyoming	1932
Salinas Pueblo Missions National Monument	New Mexico	1940
Santa Fe Region III Headquarters	New Mexico	1939, 1945
Shadow Mountain and Granby Reservoir	Colorado	1951
Sonora Missions Expedition	Mexico, Arizona	1935
Texas Missions	Texas	1941
U.S. Capitol and Federal Buildings	Washington, D.C.	1936
Williamsburg	Virginia	1934
Wind River	Wyoming	1937
Wyalusing State Park	Wisconsin	1950
Zuni Pueblo	New Mexico	1929

*Dates are based on National Park Service archival documents and records and are not comprehensive.

Adams, Ansel. *Yosemite and the Range of Light*. Boston: New York Graphic Society, 1979.

Albright, Horace M. *My Trips with Harold Ickes: Reminiscences of a Preservation Pioneer*. National Park Service. U.S. Department of the Interior. Accessed September 22, 2014. www.nps.gov/history/history/online_books /npsg/ickes/index.htm.

———. *Origins of National Park Service Administration of Historic Sites*. 1971. Eastern National Parks and Monument Association. National Park Service. U.S. Department of the Interior. Accessed September 22, 2014. www.cr.nps .gov/history/online_books/albright/origins.htm.

———. *The Reminiscences of Horace M. Albright*. New York: Columbia University Oral History Research Office, 1962.

Albright, Horace M., and Robert Cahn. *The Birth of the National Park Service: The Founding Years, 1913–33*. Salt Lake City: Howe Brothers, 1985.

Borah, Leo A. "Utah Carved by Winds and Waters." *National Geographic*, May 1936, 577–624.

Bryant, Harold C., and Wallace W. Atwood. *Research and Education in the National Parks*. Washington, D.C.: National Park Service, U.S. Department of the Interior, 1932.

Clary, David A. *Timber and the Forest Service*. Lawrence: University Press of Kansas, 1986.

Conrad, Joseph. "Geography and Some Explorers." *National Geographic Magazine*, March 1924.

Duncan, Dayton, and Ken Burns. *The National Parks: America's Best Idea*. New York: Knopf, 2009.

Foresta, Ronald A. *America's National Parks and Their Keepers*. Washington, D.C.: Resources for the Future, 1984.

Gareth, John. "Image/Text/Geography: Yellowstone and the Spatial Rhetoric of Landscape." In Patin, *Observation Points*, 140–64.

Glacier Natural History Association. *Trains, Trails, and Tin Lizzies: 1932, Glacier National Park, 1934; Photographic Plates from the George A. Grant Collection with Selections from the Superintendent's Reports, the Glacial Drift, and Historic Ranger Reports*. West Glacier, Mont.: Glacier Natural History Association, 1987.

Glacier National Park Press Kit: Glacier National Park and Other NPS Quotes. National Park Service. U.S. Department of the Interior. Accessed September 29, 2014. www.nps.gov/glac/parknews/upload/press _quotes.pdf.

Good, Albert H. *Park and Recreation Structures*. Washington, D.C.: National Park Service, U.S. Department of the Interior, 1938.

Hall, Ansel F. *Educational Division Report*. Washington, D.C.: National Park Service, U.S. Department of the Interior, 1929.

Johl, Max G. *The United States Commemorative Stamps of the Twentieth Century*. Vol. 1, *1901–1935*. New York: Lindquist, 1947.

Kieley, James F. *A Brief History of the National Park Service*. Washington, D.C.: National Park Service, U.S. Department of the Interior, 1940.

Lewis, Ralph H. *Museum Curatorship in the National Park Service, 1904– 1982*. Washington, D.C.: National Park Service Cultural Resources, U.S. Department of the Interior, 1993.

Lister, Robert H., and Florence Cline Lister. *Those Who Came Before: Southwestern Archeology in the National Park System: Featuring Photographs from the George A. Grant Collection and a Portfolio by David Muench*. Globe, Ariz.: Southwest Parks and Monuments Association, 1983.

Mackintosh, Barry. *Interpretation in the National Park Service: A Historical Perspective*. Washington, D.C.: History Division, National Park Service, U.S. Department of the Interior, 1986.

Maloney, Thomas J. *U.S. Navy Photographs: Pearl Harbor to Tokyo Bay*. Edited by Edward Steichen. New York: Crown, 1956.

McFarland, George. Introduction to Glacier Natural History Association, *Trains, Trails, and Tin Lizzies*, n.p.

Moker, Mollie, ed. *The Official Guide to America's National Parks*, 13th ed. New York: Fodor's Travel, 2009.

Nash, Eric Peter. *Ansel Adams: The Spirit of Wild Places*. New York: TODTRI Book, 1995.

Patin, Thomas. "Introduction: Naturalizing Rhetoric." In Patin, *Observation Points*, ix–xxvi.

———, ed. *Observation Points: The Visual Poetics of National Parks*. Minneapolis: University of Minnesota Press, 2012.

Pickens, Buford, ed. *The Missions of Northern Sonora: A 1935 Field Documentation*. Tucson: University of Arizona Press, 1993.

Pinkett, Harold T. *Gifford Pinchot: Public and Private Forester*. Urbana: University of Illinois Press, 1970.

Roosevelt, Franklin D. *The Public Papers and Addresses of Franklin D. Roosevelt*. Vol. 3, *The Advance of Recovery and Reform, 1934*. New York: Random House, 1938.

———. "White House Statement Summarizing Executive Order 6166." June 10, 1933. American Presidency Project. Accessed September 22, 2014. www.presidency.ucsb.edu/ws/?pid=14660.

Rose, Nancy E. *Put to Work: The WPA and Public Employment during the Great Depression*. 2nd ed. New York: Monthly Review Press, 2009.

Salmond, John A. *The Civilian Conservation Corps, 1933–1942: A New Deal Case Study*. Durham: Duke University Press, 1967.

Sawyer, Mark. *Early Days: Photographer George Alexander Grant and the Western National Parks*. Flagstaff, Ariz.: Northland, 1986.

Silverberg, Robert. *Men against Time: Salvage Archaeology in the United States*. New York: Macmillan, 1967.

Steichen, Edward. *U.S. Camera, 1943*. Edited by T. J. Maloney. New York: Duell, Sloan, and Pearce, 1943.

Thiessen, Thomas D. *Emergency Archaeology in the Missouri River Basin: The Role of the Missouri River Basin Project and the Midwest Archaeology Center in the Interagency Archeological Salvage Program*. Midwest Archeological Center Special Report 2. Lincoln: Midwest Archeological Center, National Park Service, U.S. Department of the Interior, 1999.

Unrau, Harlan D., and G. Frank Williss. *Administrative History: Expansion of the National Park Service in the 1930s*. Denver: National Park Service, Denver Service Center. September 1983. Accessed September 22, 2014. www.cr.nps.gov/history/online_books/unrau-williss/adhi.htm.

U.S. Department of the Interior. *Reports of the Department of the Interior for the Fiscal Year Ended June 30, 1919*. Washington, D.C.: Government Printing Office, 1919.

Welsh, Michael. *Landscape of Ghosts, River of Dreams: An Administrative History of Big Bend National Park*. Washington, D.C.: National Park Service, U.S. Department of the Interior. January 2002. Accessed September 22, 2014. www.nps.gov/history/history/online_books/bibe/adhi/adhi.htm.

"Western National Parks Invite America Out of Doors." *National Geographic Magazine*, July 1934, 65–80.

Workman, R. Bryce. *National Park Service Uniforms: Badges and Insignias, 1894–1991*. Harpers Ferry, W.V.: National Park Service History Collection, 1991. Accessed September 22, 2014. www.cr.nps.gov/history/online_books/workman1/.

———. *National Park Service Uniforms: Breeches, Blouses and Skirts, 1918–1991*. Harpers Ferry, W.V.: National Park Service History Collection, 1998. Accessed September 22, 2014. www.nps.gov/history/history/online_books/workman4/.

———. *National Park Service Uniforms: In Search of an Identity, 1872–1920*. Harpers Ferry, W.V.: National Park Service History Collection, 1994. Accessed September 22, 2014. www.cr.nps.gov/history/online_books/workman2/.

———. *National Park Service Uniforms: Ironing Out the Wrinkles, 1920–1932*. Harpers Ferry, W.V.: National Park Service History Collection, 1995. Accessed September 22, 2014. www.nps.gov/history/history/online_books/workman3/.

———. *National Park Service Uniforms: The Developing Years, 1932–1970*. Harpers Ferry, W.V.: National Park Service History Collection, 1998. Accessed September 22, 2014. www.nps.gov/history/history/online_books/workman5/.

Yard, Robert Sterling. *National Parks Portfolio*. New York: Scribner's Sons, 1916. U.S. Department of the Interior. Accessed September 29, 2014. www.nps.gov/history/history/online_books/nps/yard1/index.htm.

Young, William H., and Nancy K. Young. *The Great Depression in America: A Cultural Encyclopedia*. Vol. 2. Westport, Conn.: Greenwood, 2007.

INDEX